the art of nature photography

the art of nature photography

Perfect your pictures in-camera and in-computer

Niall Benvie

AMPHOTO BOOKS
An imprint of Watson-Guptill Publications/New York

**To Dad,
who made anything possible**

Note: [C] at end of caption titles denotes controlled subjects (ie subjects photographed under controlled conditions).

First published in the United States in 2000 by Amphoto Books,

an imprint of Watson-Guptill Publications, a division of BPI Communications, Inc.,

1515 Broadway, New York, NY 10036

First published in the UK in 2000 by David and Charles

Library of Congress Catalog Card Number: 99-069208

ISBN 0-8174-3311-2

Designed by Paul Cooper Design

and printed in Singapore by C S Graphics Pte

1 2 3 4 5 6 7 8 9 / 08 07 06 05 04 03 02 01 00

Contents

A New Age in Nature Photography

ON ONE LEVEL, nature photography can be viewed as a form of devotion, the expression of a wish to engage with the natural world. And so, if you are anything like me, you'll prefer to be in the field rather than sitting at a computer.

Too often, though, the photograph in our hand does not match the memory of a special day in the field. This may be due to the shortcomings of photography as a way to evoke memory, but more often it is simply as a result of the technical limitations of the medium: film's narrow exposure latitude, the strange rendering of colour or the recording of unwanted detail. Whatever the cause, the consequence is the same – disappointing photographs somehow devalue the original experience. In order to reinforce our commitment to wild nature, we seem to need icons of it in the form of photographs.

Until recently, the majority of photographers working in colour regarded the transparency on the light box as the final product. If it failed to meet expectations, quality control discarded it. But times are changing, and now photographers may regard the film as merely the raw material for the creation of a more complete expression of their experience. Digital technology has made this possible, while the concept of 'finishing' images, as black and white devotees have always done, is quickly taking root in colour photography. Perception and expression are thus finding improved alignment.

Since the computers required to finish images keep nature photographers indoors more than we would like, a large part of this book is devoted to the creation of as good an in-camera image as possible. The remainder describes what to do when the camera fails to deliver, how to bring your vision alive on film or in print, and some of the fun you can have with digitised photographs.

Throughout, I assume that the reader is using 35mm equipment, the ideal format for photographing wildlife. At the time of writing, digital cameras capable of producing images on a par with 35mm film cameras are astonishingly expensive, so we will work with the 'shoot and scan' approach.

It would be convenient to draw a clear line between image *enhancement* (using digital technology to overcome the constraints of the photographic process) and image *manipulation* (using it to create something which was not there in the first place). But no such demarcation exists, and enhancement in your book may be manipulation in mine – and vice versa. I am interested, first and foremost, in

PHOTOGRAPHER, YELLOWSTONE NATIONAL PARK, USA

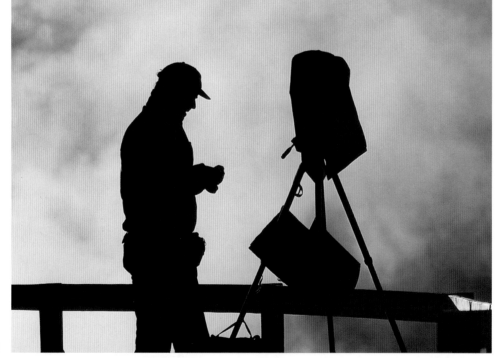

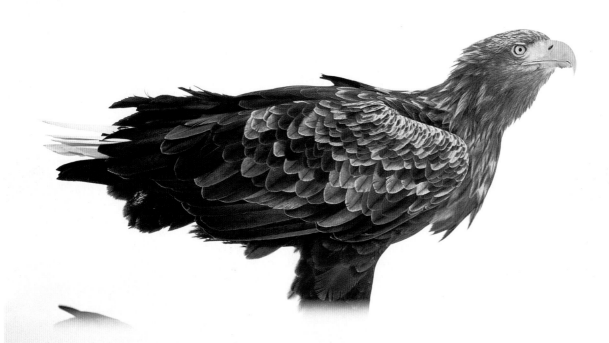

mine – and vice versa. I am interested, first and foremost, in honouring the subjects I work with by getting people to look at the photographs I take of them. Photographic and, by extension, digital techniques are simply ways to achieve this end. There is no absolute 'truth' in photography, but there is misrepresentation of the subject. Our respect for the integrity of the natural world dictates to each of us the appropriate use of digital technology.

I believe that photographers who rely upon their own imaginations for inspiration, rather than upon their experience of the natural world in its unimagined diversity, are up a creative blind alley. Computers do not help us to develop insight any more than cameras allow us to express it fully. There is no substitute for being out there.

The digital revolution should therefore not be viewed as a threat to traditional, in-camera nature photography, but rather as a way to do better what we already do at present. So let us put the technology to work to help us share our passion for the natural world and cultivate respect for it.

SEA EAGLE, TRONDHEIM, NORWAY

'F8 and be there.' For passionate nature photographers, just being there is sometimes enough. Several times I stole a glance round the side of my lens to see this full adult with my own eyes, rather than through that of the camera. 'F2.8 and be there' is rather more appropriate advice for Norway on a dull winter's day. *AF 500mm, Fuji Velvia rated at 100 ISO*

COMPUTER WORKER

Which would you rather be doing? This, or working in the field (far left).

7

1 Personal Vision

Recognising the fundamental differences between what we perceive and what a camera records is an important first step in understanding the limitations of photography as a way to record our experiences.

OPPOSITE: GREY HERON AMONGST SEAWEED

I stalked this grey heron in my amphibious hide, grounding it on a mud bank for stability. With my attention focused on the bird's every gesture, I was unaware of its surroundings. Fortunately, for once, the lighting conditions and a long lens rendered them as obscure as my memory of them.
AF 500mm + x1.4 converter, amphibious hide, angle finder, beanbag, Fuji Sensia 100

WE INVEST a lot of faith in photography. The cynicism which pervades so many aspects of modern life has, until recently, left nature photography pretty much unscathed. The popular feeling persists that photographs represent 'truth', that they passively reflect the world.

We have great faith, too, in the ability of photographs to evoke memory; with sight as our primary sense, we are most aware of the visual aspect of experience and imagine that we can rely on visual triggers alone to recall those moments. Photography is entrusted with providing an imprint of the experience, to be carried forward in time.

We are often a little surprised, then, when photographs fail to live up to expectations, or if the excitement contained in them for the photographer is not communicated to others. This expectation is based on our memory of an experience, which, although we may not have been aware of it at the time, engaged senses other than sight. Not only is a photograph often unable to trigger with any poignancy our own memory of these other sensations, but it treats the visual aspect of the experience in a very selective, dispassionate way.

For one thing, the camera cannot see in three dimensions as we do. Depth in photographs results from the use of techniques such as differential focus, the juxtaposition of advancing and receding colours and the exaggerated perspective of wide-angle lenses. Ultimately, though, we visualise things differently – for instance, we do not see out-of-focus backgrounds, nor do our eyes fix on one spot with the unblinking concentration of the camera lens. Our vision isn't bounded by the hard, defined edges of a rectangle.

The image created on film, the medium of sharing visual experiences, is like a language not quite our own, but similar enough to be recognisable in parts. Film's ability to 'see' detail in highlight and shadow is extremely limited compared to that of our own eyes. It lacks the power to assign colours to known objects, irrespective of the lighting conditions, as our visual system does (see Chapter 5). It is affected by colour casts which we can choose to ignore, rendering hues we were unaware of and which did not form part of the experience.

As photographers, then, we cannot passively aim a camera and expect the resulting image to be any more a reflection of our experience in the field than a testament to the limitations of photography. A process of what the American photography critic John Szarkowski dubbed 'visual editing' must take place. This involves the crucial elements of a scene being distilled so that the viewer's attention is concentrated on them. Well applied technique narrows the gap between the photographer's vision and the final image, and digital technology provides a means to reduce that gap further.

WILD CHERRY LEAF, AUTUMN

Many freshly fallen leaves lay scattered on the frosted ground on this late-autumn morning. There was a lot of searching to do before I could distil a single image which summed up the scene's blues and reds.
MF 90mm, 81a filter, Fuji Velvia

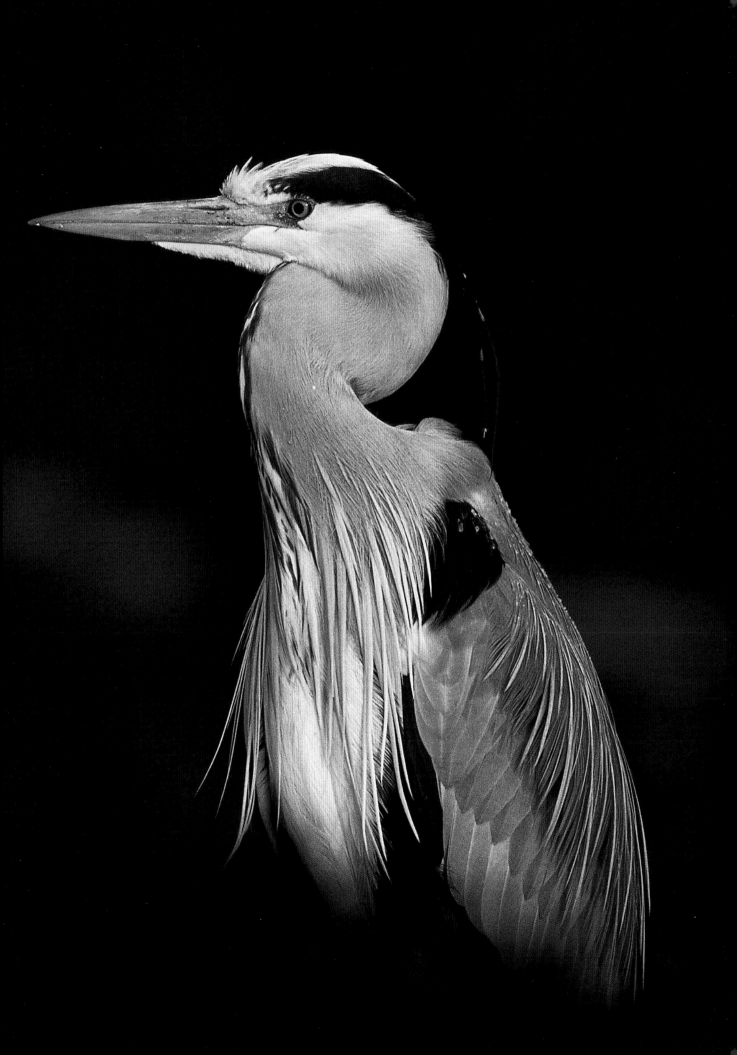

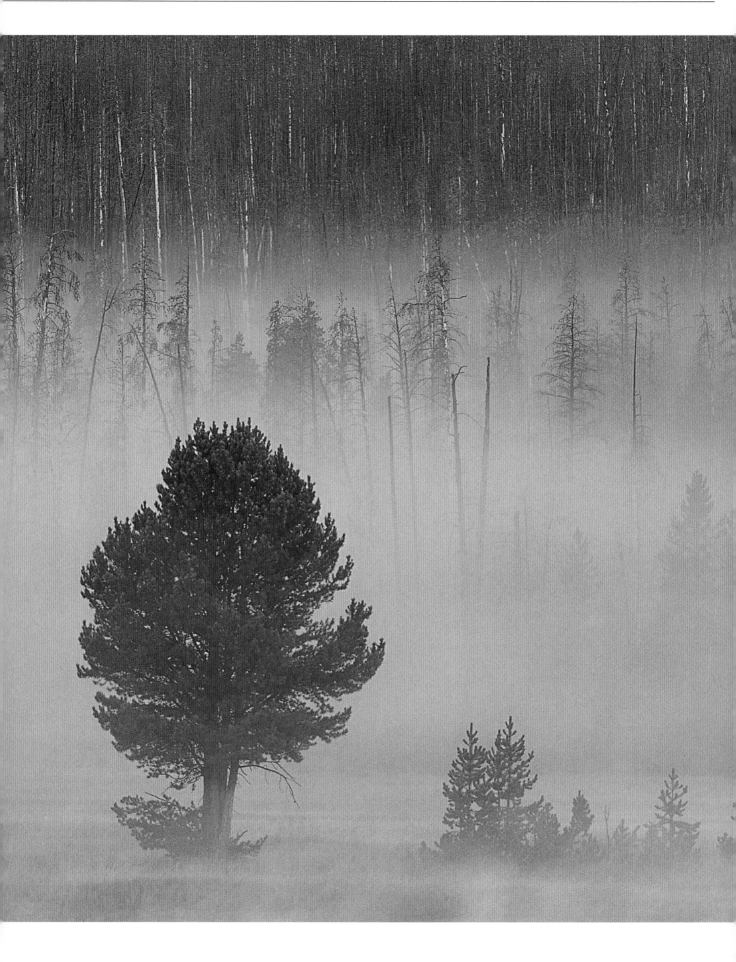

The truth about photography

While in some other fields of artistic endeavour the subject is used merely as a vehicle for the expression of ideas, nature photography is characterised by a preoccupation with subject rather than self. Yet the fact remains, as the respected Canadian photographer Freeman Patterson reminds us, that the camera points both ways: the only 'truth' in photography is the truth revealed about the photographer in his or her pictures. Photographs display our interests, ways of seeing, imagination and life experience. Though principally concerned with the natural world, each image carries the watermark of the photographer. Style, far from being something you have to struggle to develop, is endemic and shines through as soon as you can photograph by feeling as well as seeing.

The quality of his or her wildlife and landscape images reflects the degree of the photographer's engagement with the natural world: on the physical level, of actually getting out there, and on the emotional one, of empathy. Success depends in part on not allowing photography to become a substitute for seeing. I once watched in amusement as another tourist systematically 'vacuumed' each room in Heraklion's Archaeological Museum in Crete with a video camera, not taking time to look at any of the exhibits. I guess he'd fallen prey to the belief that he could relive the experience later on his television, when it suited him better.

Such a process is pernicious and can lead to alienation from the subject which, in the absence of an emotional connection, is given meaning only through the second-hand medium of photography. To the photographer working this way, wild creatures become merely 'subject matter', a moment of special light on the landscape, a 'photo-opportunity'. The photograph itself is then required to corroborate, even to validate, the experience. This is the *photo ergo sum* mentality – 'I photograph therefore I am'. Sometimes, if you can, it's better to just put the camera down and *enjoy*. Only then will the good pictures become apparent.

Top tips
- Cameras and film do not see the world the way we do, so don't invest too much faith in their ability to evoke memories accurately.
- Be aware of how your perception and the camera's differ, and employ the appropriate technique to reduce the divergence between experience and photograph.
- Photography which respects wild nature is ultimately about the subject first and the photographer second.

PINE, YELLOWSTONE NATIONAL PARK, USA

This apparently tranquil Yellowstone scene fails to tell the viewer about the detachment of heavily armed photographers ranked alongside me, each of us intent on making our own wilderness photograph while comparing exposure readings and sharing coffee. It also fails to convey how cold it was.
AF 300mm, Fuji Velvia

2 Tools for the Job: Photographic Hardware

Modern 35mm equipment makes the capture of images faster, more accurate and more consistent than ever before. But before investing, identify what you need it to do for you. You may not need a Ferrari to go to the supermarket...

LOOK AT AN OUTSTANDING wildlife photograph from the pre-1990s and the chances are that the contribution of equipment to its success was relatively minor. The photographer's knowledge of the subject, his technical expertise and visual sense were pre-eminent. Today, although 'being there' and then 'seeing' the picture remain central, it is often the equipment which has made the realisation of the picture possible. Modern gear lets you nail the shot, and do it more often.

When I changed to autofocus lenses and camera bodies in the late 1990s, not only did my percentage of sharp images increase dramatically, but whole new fields of action photography opened up. I now have many pictures on file which would not exist were it not for the ability of the lens and camera to focus faster and more accurately than I can. Speedy, dependable autofocus also makes it possible for photographers whose eyesight has become less acute to continue to enjoy action photography. The technical playing field has been levelled, in this respect at least.

But none of this clever equipment comes cheap. And while action photography benefits from hi-tech tooling, money spent on fast motordrives and autofocus lenses and bodies is wasted if your primary interest lies in close-up and landscape work. Technological advances have made less dramatic contributions to these fields, and high-quality, manually focused lenses on basic bodies work just fine.

FULMAR IN FLIGHT

Fulmars follow a loose figure-of-eight flight circuit as they ride the thermals pushed up cliff faces. While it is possible to pre-focus on part of this circuit and, if you are lucky, obtain a sharp picture, an autofocus lens mounted on a fluid tripod head, levelled to ensure a straight horizon, greatly increases the hit rate.
AF 300mm, fluid head, Fuji Sensia 100

FAR RIGHT: AMERICAN TOAD, PENNSYLVANIA, USA

I chose to photograph this toad with my 300mm on a 52.5mm extension tube, so as to render the background devoid of distractions and to maintain a comfortable distance from the animal. Working at the first blink of dawn along the edge of the forest, I was glad of the light-gathering powers of my f2.8 lens.
AF 300mm + 52.5mm extension, Fuji Velvia rated at 100

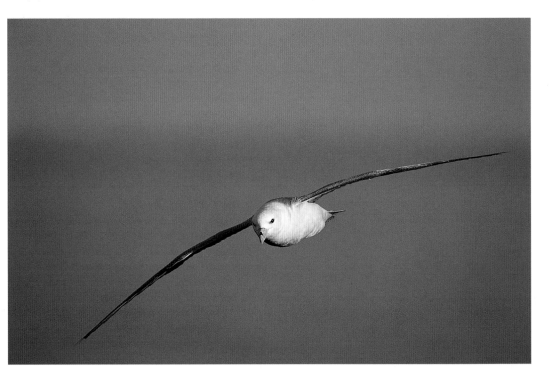

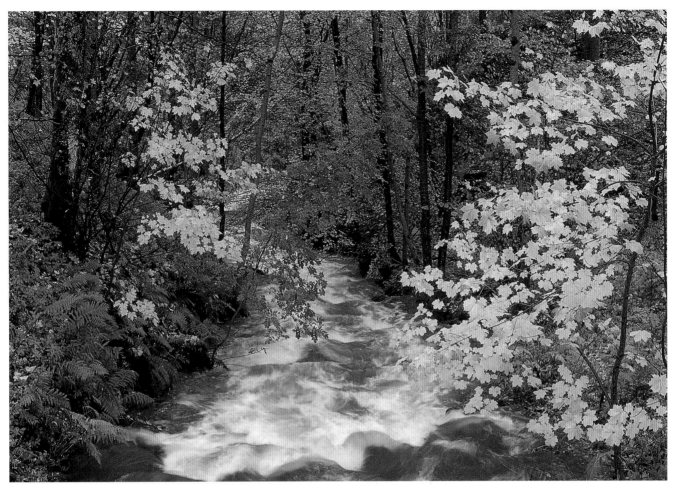

The 15-year-old lens used for this picture is one of the sharpest I own, and I expect to use it for another 15 years. This type of work doesn't require complex autofocus lenses – just sharp ones.
55mm, 81a filter, Fuji Velvia

It sometimes pays to be circumspect about new photographic products; often their launch price drops considerably after a few months, and any problems are eliminated for the next version.

Money is best spent on those pieces of gear which enable you to do something you can't currently do, rather than those which just make it a little easier. In this respect, new top-quality lenses, be they for action or still-life photography, often show the best return – fancy bodies are nothing without good glass. But what will you use the lens for? A 300mm f2.8 costs more than three times as much as one which is only 1 stop slower (f4). If both feature low-dispersion glass (see below) the optical performance will be indistinguishable. If you normally shoot with medium-speed film, in bright conditions, and rarely photograph action, you don't need an f2.8. Indeed, the benefits of a smaller lens's portability may outweigh those of having that one extra stop, unless you plan to use teleconverters frequently.

Top tips
- Some innovations, especially in the field of autofocus, relegate the technical considerations of picture-making to their rightful place – behind aesthetic ones.
- Different subjects demand different types of equipment; identify what you want to photograph to avoid buying excessive gear.
- Wait a few months after new products are launched before you buy.
- Consider buying second-hand: there is plenty of quality equipment available at good prices.

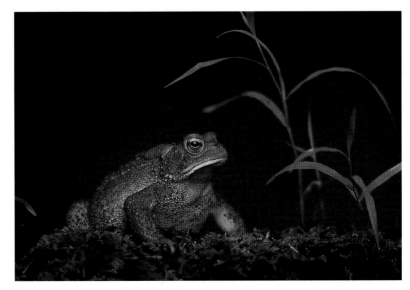

What you really need

In the realm of photographic equipment, refinement often masquerades as innovation. In fact, 35mm gear is now so highly developed that true innovations are rare. Here are the ones worth having.

Cameras

Perhaps more than any other innovation, fast, accurate autofocus systems have brought enormous benefits to wildlife photographers. In particular, their ability to track moving subjects, holding them in sharp focus even at speed, makes this type of work possible for more people than ever before.

Autofocus technology is still evolving, in terms of speed and focus-zone flexibility. Some cameras can follow the subject as it moves from one set of focus brackets to another, but once it leaves the broad zone defined by several pairs of brackets, focus cannot be guaranteed. Compositional freedom is compromised if subject placement must always be dictated by the position of pairs of fixed focus brackets. You can normally lock the focus by half-depressing the shutter release or a focus lock button and then recompose, but this will slow you down. If you plan to finish most of your pictures in-computer, then sloppy in-camera composition is not a problem.

You can shoot with a slightly shorter lens than you might normally, then crop the image to a more satisfactory composition in the computer. Working this way broadens the effective zone of autofocus but, to my mind, creates unnecessary work.

The ideal autofocus method, still awaited at the time of writing, will feature a cross-sight which moves to wherever you look in the viewfinder. The priority is always to ensure that the eye of the subject is in sharp focus, and it is not every time that the eye and a pair of brackets coincide. A cross-sight which follows the eye will remove the need to lock focus and recompose.

Autofocus technology can work because it has a simple problem to solve: to bring light to the point of focus on the film plane. Disregarding the 'false sharpness' created by depth of field, sharp focus is an absolute: the image is either in focus or it is not. Not so with exposure, where – according to personal taste, the type of lighting and film characteristics – a range of readings can give the 'right' exposure. This makes it almost impossible to devise an automatic system which will deal with anything but flat lighting on a mid-toned subject filling the frame. Built-in exposure meters are highly accurate but, as we will see in Chapter 4, give the most consistent results when used in manual metering mode. Those with a spot-meter function are now common and I would not like to be without this.

MALE EIDER DUCK IN HOT PURSUIT

Engrossed in their courtship display, male and female eider ducks swam all around my amphibious hide, sometimes only a few metres away. As they did so, they set up ripples in the otherwise calm water. The combination of the bobbing hide and the movement of the birds made an autofocus telephoto essential.
AF 500mm, amphibious hide, angle finder, beanbag, Fuji Sensia 100 rated at 200 ISO

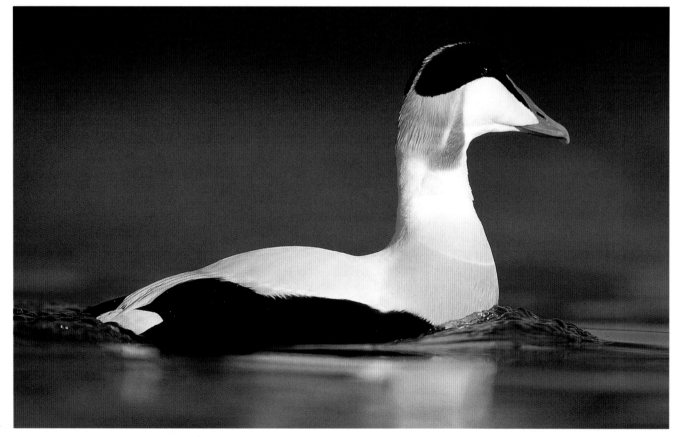

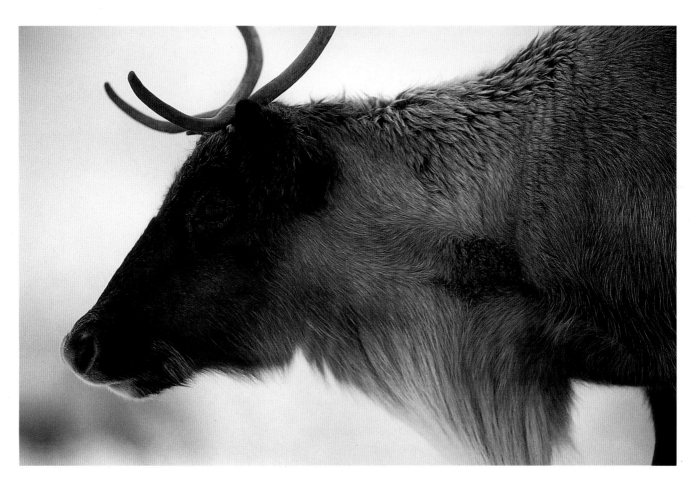

Other indispensable features include: a depth-of-field preview (think twice about buying a camera which doesn't have one); a mirror lock (although this is less important with the heavily dampened mirrors on some professional models); a means of overriding the DX film speed coding so that you can set the film speed to what *you* want it to be; an electric release socket so the camera can be fired without touching it; and a user-friendly manual exposure system.

Lenses

If you photograph mainly landscapes and still lifes, it makes little sense to replace the top-quality manual-focus lens you bought 15 years ago unless it is worn out. The real advances have been made in the field of long telephoto and zoom lenses, especially in respect of autofocusing capabilities and optical quality. The use of low-dispersion glass (ED, L, APO and other suffixes) is now common and is no longer reserved for fast (large maximum aperture) telephotos. A lens acts as a prism, splitting white light into its component colours. Since these components naturally come to focus at slightly different distances from the film plane, it is difficult to achieve image sharpness with ordinary glass. The longer the focal length, the worse the problem. Low-dispersion glass is highly efficient at bringing these wavelengths back to a point of common focus, and lenses which employ it can produce extremely sharp images free from chromatic aberrations.

Zoom lenses can deliver images indistinguishable in clarity from those made with prime lenses, although due to the large number of elements they contain, they are more prone to flare. A wide zoom range, say 100–300mm, can be accommodated in a compact design by the use of variable maximum apertures: when the lens is set at 100mm, that might be f4.5, but at 300mm, it is reduced to f6.7. If exposure is set manually, such lenses can be exasperating, as exposure must be adjusted every time the focal length is altered. Fixed maximum-aperture zooms (most manufacturers produce a 70–200mm or 80–200mm f2.8) are less compact, more expensive, but much more convenient.

Although high-quality long telephotos featuring low-dispersion glass have been around for years, they have always demanded skilful handling. Autofocus versions are much easier to use, and when these have built-in focusing motors they operate very quickly indeed. The focus lock buttons on the barrel of a Nikkor telephoto are especially useful when the viewfinder's focus brackets don't coincide with the point you want to be in focus. For a description of the method, see Chapter 7. The principal problem with telephotos, however, has always been one of keeping them still, since any

REINDEER AGAINST SNOW

A dark animal against snow can be tricky to meter accurately. However, the camera's built-in spot meter made the job easier; I took the reading from the darker patch of hair on the reindeer's neck.
AF 300mm, Fuji Velvia

15

ROBIN

A brilliant, frosty morning made for attractive conditions but excessive contrast. Since I knew that birds perched regularly in these branches before flying to a feeding station, I set up a 'smart' flash on a tripod to the side of the camera to fill the shadows.

MF 300mm + x1.4 converter, TTL flash set to -1.7ev, Fuji Sensia 100

camera movement is more apparent in the image. Canon employ an image-stabilising system which compensates for camera movement, allowing the photographer to produce sharp pictures with the lens hand-held at quite slow speeds. Beware if you have the lens mounted on a tripod: in the absence of movement, the early models set up their own. If this happens, the I-S mode should be turned off.

The range of fixed focal-length telephotos is increased with teleconverters. The optical degradation caused by x1.4 models matched to particular lenses is negligible, although it can be noticeable with a x2 converter. Autofocus cuts out on many cameras when the effective maximum aperture is smaller than f5.6 (a f2.8 lens with a x1.4 converter has an effective f4; with a x2, f5.6).

Flash

Using flash, especially as a source of subtle fill lighting, was once such a complicated business that few wildlife photographers ever bothered with it in the field. The arrival of the so-called 'smart strobe' in the late 1980s heralded a new era in convenience, control and reliability, in turn encouraging the creative use of flash in outdoor photography. Today, flash is generally considered to be fun.

The genius in the design of a smart strobe is the facility to adjust the output of the flash in relation to daylight, while working with the convenience of automatic TTL flash metering. The method is fully described in Chapter 6, but essentially involves setting the exposure for the ambient daylight and then modifying the flash's output by dialling in compensation so that it lightens shadows rather than removes them. Smart strobes are often quite

OPPOSITE: COMMON SEAL

In order to obtain the low perspective I favour, I slithered over the seaweed-covered rocks, seal fashion, until I found one free of weed near water level. Since it was impossible to see directly through the camera, I fitted an angle finder. When long lenses are placed on beanbags, their focusing rings sometimes snag; using autofocus, which moves groups of elements around inside the lens, overcomes this problem.

AF 500mm + x1.4 converter, angle finder, beanbag, Fuji Sensia 100

powerful, too, and although more expensive than less refined models, they increase productivity to such an extent that you won't want to use anything else after you've tried one. However, clever though they are, most models seem to be designed with pixies in mind, for the buttons are not easily operated by human-sized fingers.

Tripods, heads and other supports

A good tripod and head are *the* crucial accessories. Economise on them and it will be reflected in the technical quality of your pictures. Carbon fibre, with its favourable strength-to-weight characteristics, is often used to manufacture tripod legs, but a light tripod, no matter how finely engineered and well coupled, lacks the inertia required for stability. Carbon fibre comes into its own when it is used to make chunky tripods with thick legs; these sturdy models compare in weight with more modestly proportioned alloy ones but are more robust.

Mass alone does not guarantee stability. Mass coupling – how well the components in the tripod, from the feet to the head, link to each other – must also be maximised. In selecting a tripod, look for one with as few joints as possible: a two-stage leg extension is better than a three-stage one. I'm not keen on models with central columns; not only do these get in the way when you want to spread the tripod flat, but they are a source of instability when extended. Ensure that the head sits at the apex of the legs and is not supported off to one side. The base on which the head is supported should be broader than the point of load attachment – where the camera bolts on to the head.

Having tried a great variety, I believe there is no one

head that is ideal for all types of nature photography. I alternate between two, depending on whether I'm shooting active subjects with telephotos or photographing landscape and close-up work. Gitzo's 'R' designated tripods have no central column, and by slackening a nut, the plate on to which the head is bolted can be quickly removed. Swapping between a heavy ball-and-socket and a Gitzo fluid-action head used for action takes seconds.

Fluid or video heads come into their own when you need to track active subjects that never stay still for long enough to allow you to lock the head. The dampened action of good video heads, such as those from Sachtler and Gitzo, is such that lock-up is unnecessary. Used in conjunction with autofocus lenses, they are ideal for action photography, combining smooth panning with firm support.

Video heads, of course, cannot be flipped on their sides, so if the lens lacks a revolving collar, vertical compositions are out of the question. If your tripod is not fitted with a bowl for the head, levelling horizons is tricky. In choosing an alternative, look for one with as low a centre of gravity as possible, as this increases stability. My personal preference is always for one with a quick-release mechanism, to allow speedy removal of the camera from the head. Quick-

release Arca types are free from the cork which is a death knell to solid mass coupling.

No matter how well coupled a tripod and how steady a head, the fact remains that the lens is supported at only one point – where it screws onto the tripod head or quick-release plate. While this is acceptable for lenses up to 300mm, with longer lenses the unsupported overhang is a problem. Given the opportunity, I prefer to support my telephotos on a beanbag filled with polypropylene granules (see p.19). This moulds to the shape of the lens, allows it to be moved quickly and provides support along its whole length. This is the standard accessory for shooting from a vehicle. Since focusing rings can sometimes snag on the surface of beanbags, they are most successful with autofocusing lenses, where all the focusing action takes place within the lens.

Other useful tools

Photographers are notoriously susceptible to gadgets, many of which are of such specialised application that after one or two airings, they disappear forever into the depths of the camera bag. Below are described some of the truly useful accessories and consumables which help make

RED DEER STAG, KINCRAIG, SCOTLAND [C]

Unable to leave the road with my camper van, I needed to use all the focal length I had to make this stag's portrait. It was during the autumn rut, so as he spent a good deal of time herding his harem, I was glad of autofocus to follow his movements. Here he is lip-curling in response to stimulating smells.
AF 500mm + x1.4 converter, beanbag, Fuji Velvia

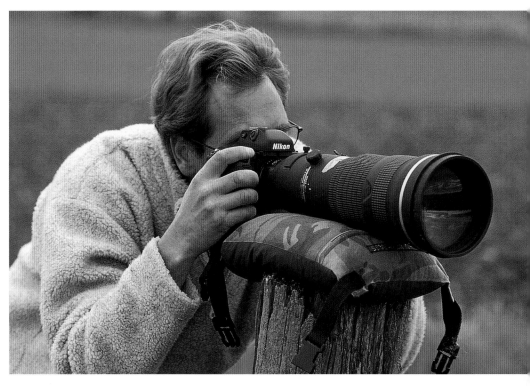

Supporting the lens with a Ben-V Beanbag.

shooting that bit more enjoyable and productive.

Autofocus cameras and lenses have a great appetite for batteries, and in cold weather standard alkalines are quickly exhausted. Although you can work with a battery pack in your jacket wired to the camera, this is inconvenient. An alternative is to swap between two packs of lithiums; when one shows signs of failure, return it to the warmth of your jacket and replace it with the one there already. In really cold weather, I put chemical heat packs into my mittens, so that when I clutch the camera some of that heat is transferred. Rechargeable nickel cadmiums perform well relative to alkalines, and I always use them to power strobes on chilly days.

Alloy tripods are painful to handle in sub-zero temperatures and the legs are best wrapped in pipe insulation or some of the ready-made leg wraps that are available. Ensure that the padding is thick enough, so that it still provides cushioning for your shoulder when a heavy lens is on the tripod.

Braces which cradle long lenses at front and rear (they attach to the tripod bush) reduce the risk of shake by increasing mass coupling. Several were developed for Nikon's 80–200mm f2.8 zoom, which formerly lacked a tripod collar. There remains a dearth of braces for longer lenses, and your best bet may be to provide an engineering shop with a design to make especially for you. Braces which link the camera body to a tripod leg are slow to operate and unsuitable for active subjects.

Steady support doesn't come any firmer than a beanbag resting on a rock. The Ben-V Beanbag is filled with polypropylene granules and features short straps with quick-release buckles, which make it easy to clip around the shoulder of a tripod to provide extra ballast when necessary. Like a tripod, a beanbag needs a certain amount of mass to be stable; a filling of polystyrene beads not only fails to mould to the shape of the lens but is also too light. Split peas mould well but are too heavy (about 50 per cent heavier relative to their volume than polypropylene granules) and rot when they get wet. Another useful feature of these beanbags is that several different sizes can be clipped together for supporting very long lenses

The burden of heavy equipment can be eased by using neoprene straps on big lenses and waist pouches. Quick-release buckles on OpTech straps let you remove the straps quickly and easily when they get in the way.

Top tips

- If you want to photograph action, take a look at camera bodies featuring 'dynamic' autofocus systems; they offer faster operation and more compositional flexibility than ones with fixed focus points.
- Always buy the best-quality lenses you can afford – they make the picture, the camera only records it. Lenses with designations such as APO or ED contain one or more elements of low-dispersion glass; these are especially important in optimising the performance of zooms and long telephotos.
- Do not overlook the importance of 'old-fashioned' features such as depth-of-field preview, mirror lock and manually adjustable ISO (film speed) setting.
- 'Smart flashes' – the most recent generation of dedicated TTL flash units – are more expensive than old-style flashes, but are much more versatile and offer superior control. They are worth saving for.
- Heavy, well engineered tripods are more stable than light, well engineered ones. Oversized tripods made from carbon fibre offer the best combination of mass and portability.
- While video heads are great for action photography, ball-and-socket (or pan-and-tilt) types are more suitable for work on static subjects. Models with a low centre of gravity are most stable. The firmest support for a long lens is a beanbag.

3 Tools for the Job: Computer Hardware

It has become something of a cliché that even before these recommendations appear in print, they will have become outdated. That's how it has always been with computing hardware and software, and how it will continue to be into the foreseeable future. The point is, though, that today's tools are now up to the job; further developments will just make it faster and easier. Your key consideration when you set up a digital desktop should therefore be its forward compatibility and expandability.

NIALL'S OFFICE

Computers and monitors

Macintosh or PC? The debate about which is the superior platform is as futile as it is tedious. I have used Macs from the outset simply because when I originally sought advice about which platform to buy, I spoke to friends who were designers. Macs were developed originally with imaging professionals in mind, and at one time dominated the desktop publishing and design sectors. Though still very popular, their position has been eroded by PCs which emulate the user-friendly interface of the Mac. Nevertheless, if you are dealing with a photo lab, whether it scans or makes digital prints for you, the chances are that they will be using Macs. Not only will there be fewer compatibility problems to cope with, but they may be glad to provide technical help, too. Mac users tend to stick together, just like any other minority!

When you select a machine, there are several key features to look at.

OPPOSITE: PERIWINKLES
A good 'bit depth' is essential to help differentiate between the subtle colours in this image of shore-line blunt periwinkles. The sun had set a moment before this picture was taken, so the sky was still fairly bright.
MF 90mm, 81a filter, Fuji Velvia

Random Access Memory (RAM)
The Random Access Memory is where the work gets done; the more you have, the more easily and quickly the job can be accomplished. The issue here is expandability; a machine which comes with only 32Mb of RAM but can be expanded to 256Mb is a better option than one supplied with 64Mb that cannot be expanded beyond 128Mb. Many programs today need a considerable chunk of RAM (and free hard disk space) to operate smoothly, and

looking ahead it is reasonable to assume that this demand will increase. RAM is something of a commodity; manufacturers find it hard to anticipate demand, sometimes making too much, sometimes failing to make enough. As a result the price fluctuates, but on average it is much, much lower than it was just a few years ago.

Adobe Photoshop is the industry-standard imaging program and sooner or later you will probably want to work with this professional application. Although it can chug away on 32Mb of RAM on a Mac or PC (an allocation of 64Mb is recommended), the size of the image it is working on naturally augments the RAM requirements. Your image may start off as an 18Mb scan, but as levels are adjusted, layers created and filters applied, its size can increase rapidly. Best performance is achieved when the amount of available RAM is four or five times the size of the image file being worked on. This allows the operations to be done in 'real time' – that is, within the RAM memory. Should more memory be required, Photoshop then borrows all the available space on the hard disk. However, operations take place more slowly in this so-called 'scratch disk' space, and this is also why it is important to keep your hard disk as clear as possible. In short, you can never have too much RAM if you are running Photoshop.

Hard disk size
If you plan to store even a small number of images within your computer, you will need a big hard disk, especially if part of it is used by Photoshop as

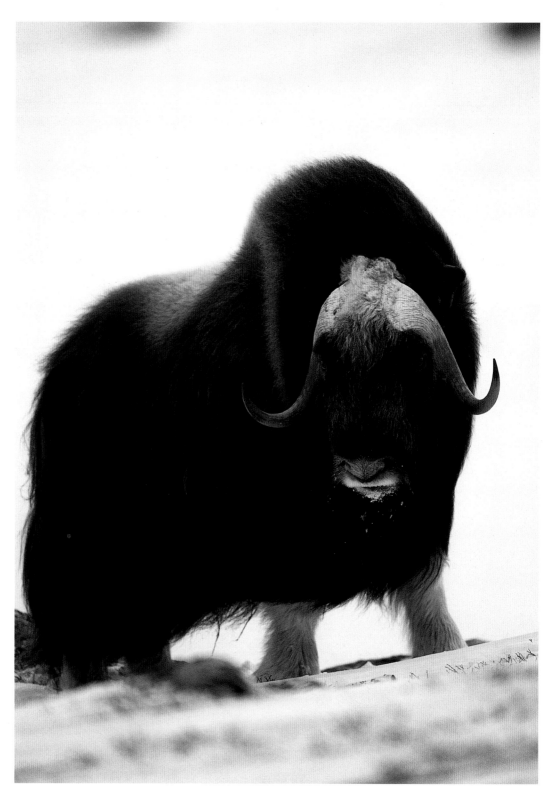

MUSKOX, DOVREFJELL, NORWAY

Here is a real challenge for a scanning device: deep matt browns and a pale horn boss all need to be recorded in detail. Desktop scanners often lack the dynamic range to do this successfully. *AF 500mm, Fuji Velvia rated at 100 ISO*

scratch disk space. Anything less than 4Gb is not recommended. The hard disk is best regarded as a temporary storage facility for images, not an archive.

Speed

The faster your computer can process information in its CPU (central processing unit, also known as 'the chip'), the better. This capability is determined by a number of factors, including the type of processor, the particular series to which a chip belongs, and the rate of transfer between the chip and the Random Access Memory ('the bus speed'). In Macintosh computers, starting with the G3 series, chip speeds in excess of 256Mhz give adequate performance.

This can be further enhanced by specifying a 512K cache memory, a facility which allows programs to work more quickly.

Monitor

Big is best here, with the caveat that the monitor should also have a flat screen (so that the image is not distorted) and a Trinitron tube; 17in is the minimum recommended size for working on images. It needs to be capable of displaying 'millions of colours' – '32 bit' or true colour, at a resolution of at least 1152x870 lines. The other specification to be aware of is 'dot pitch' or 'grille aperture pitch'. This describes the size of the gap between the dots which make up the screen image. The smaller this gap, the better; 0.26mm is good, higher than 0.32mm is not. Trinitron screens employ a different technology from conventional monitors and the gap is referred to as 'stripe pitch'. You may need to buy additional video memory (for Macs, known as SGRAM) to be able to work in millions of colours at high resolution. I need 4Mb for my 17in monitor to display 32 bit colour at a resolution of 1152x870.

Graphics tablet

While a mouse is fine for scrolling your way through text, it is clumsy when you need to draw complex selections, or work on an image as a painter would work on canvas. A graphics tablet is the solution. Using a pen-like stylus instead of a mouse, pressure is applied to the tablet. Since they are usually pressure sensitive, these devices offer a high level of creative control. They do, however, take up quite a bit of space on a desk; an A5 (6x8in) tablet (whose overall dimensions are actually closer to A4 [8½x11in]) is a convenient size. A graphics tablet is by no means essential, but will speed up your work rate and make the job that bit more enjoyable.

Other considerations

If you need access to the Worldwide Web and want to e-mail your photographs, make sure there is a port available for connecting a modem. Check, too, that your computer's operating system is compatible with the connection software supplied by your Internet Service Provider, particularly if you are using an older machine. Macintosh, beginning with their colourful G3s, dispensed with the SCSI socket into which devices such as scanners and CD writers were connected to the computer, replacing it with the FireWire port. Faster though it is, adaptors to allow the connection of old SCSI devices are not cheap.

Scanners

At the time of writing, desktop film scanners based on CCD (charge-coupled-device) technology cannot match the quality provided by a high-end drum scanner or the FlexTight machine in the hands of a skilled operator (see Chapter 14). Importantly, too, the software developed for these scanners enables the very best performance to be obtained. Nevertheless, even desktop drum scanners and FlexTight machines are too expensive for all but the most prosperous photographers. Desktop film scanners are perfectly adequate for producing scans for inkjet prints, for lower-quality reproduction, for posting images on the Web or for sending them as e-mails. Listed below are the key features to look for when selecting a scanner.

Resolution

This is normally expressed in dots per inch (dpi). Pixels (picture elements) per inch (ppi) is a more accurate term, since dpi is more applicable to printing devices. Pixels are the little blocks containing colour and tonal information which make up a digital image (see Chapter 14) and the more there are, the more finely detail is resolved, up to a point. What you need to know is the optical resolution of the machine: that is, how much detail it can resolve without resort to interpolation – inventing pixels – (see Chapter 14) to get the resolution you need for the final output. Machines which can scan at 2700dpi without interpolation can produce files large enough for printing up to A4 size at high resolution. The maximum file size at 2700dpi is about 24.5Mb, in RGB (red, green and blue) colours.

Bit depth

This indicates the scanner's ability to produce a wide range of colours. It is expressed in 'bits' per red, green and blue colour channels. A 36 bit scanner therefore takes 12 samples per channel, then selects the 8 bits per channel required for output to a 24 bit digital file which are the most evenly distributed. The result is better differentiation between colours. While only so much bit depth will be seen once images are printed in books or magazines, if the output is to be as film or digital prints, then 36 bit depth is preferable.

Dynamic range

Dynamic range refers to the ability of the device to record highlight and shadow detail and to differentiate the subtle tones in these areas. Drum scanners remain ahead of CCD desktop scanners on this front, although the gap is narrowing. High-end drum and FlexTight scanners typically have a dynamic range in excess of 4.0, compared to the best current CCD desktop scanners which remain standing at 4.0. A disappointing aspect of the PIWs (Photo Imaging Workstations) that are used by bureaux to make Kodak CD scans is their relatively limited dynamic range (about 3.2), although this is not always evident once the pictures appear on the printed page.

Finally, make sure that not only can the scanner deliver scans quickly, but that your computer has sufficient RAM and is correctly configured to allow it to work at full speed.

Storing digital files

Over the years, various methods of relieving your computer's hard disk of enormous image files have come and gone. The CD and, more recently, the DVD are the two most attractive options for long-term storage. Zip and Jaz disks are ideal for moving files between machines (see Chapter 14). CDs are cheap, so making several back-ups of archived images is an affordable hedge against losing files. You can also back up your hard drive and save yourself a great deal of heartache when it crashes. Their capacity is substantial, typically 650Mb – plenty of room for several high-resolution files, flattened or with the different layers still intact. CD drives are ubiquitous, so it is fair to assume that the medium will be with us for a few years to come, at least. Importantly, too, CDs – if correctly written – can be read on both Mac and PC platforms. The cost of the machines which write the files to CD has come down considerably and most are now capable of rewriting CDs, assuming that you load up a rewritable CD (these are considerably more expensive than the standard CDs). Floppy disks are fine for moving small (under 1Mb) files around between computers but are unsuitable for long-term storage.

Software

A lot of software comes bundled with scanners, printers and so on – it is supplied as part of a package deal. It's worth checking these out, since it is sometimes a much cheaper way to acquire the software you want than simply buying it off the shelf.

As I indicated earlier, Adobe Photoshop (version 5.0 at the time of writing) is the industry-standard program for image editing, used widely by professional and amateur photographers, graphic designers, image bureaux and repro houses. The economy version of it, Photoshop LE, is frequently bundled with scanners. While this is adequate for simple image adjustments, retouching, scaling and sharpening, it is only a taster of the full version. Photoshop is a deep program. It is complex and allows you to do just about anything you can conceive of with a photograph. Learning it is a bit like hanging a door: if you try to do it in a hurry, you may be able to open the door just far enough to see into the room of Photoshop delights, but then it jams and you can't enter. You then have to start again from scratch. Some excellent, in-depth guides to the program are available, as well as tutorials on CD. Photoshop has many features which most of us will never use, and indeed, if you do not plan to carry out any work on your scanned images other than scaling and sharpening for output, then it is a Ferrari where a Dodge would do. Adobe's Photo Deluxe is one good option, as is LivePicture. If, however, you want to have maximum control over your images, including being able to prepare them as CMYK files for publication, then Photoshop is the first choice.

When you buy a scanner, if you have a choice of bundled software, go for the more expensive one, because the more control that you can exercise over the scan as it is being made (rather than altering it afterwards), the better.

If your interest in computers and software is simply as a means to an end, then the best advice is to find out about the latest developments from the photographers who are using the technology for their work, and to go with their recommendations. A number helpfully post hands-on information on their websites (see Website Addresses).

Output devices

It's all very well having a beautiful image on screen and then writing it to CD for storage, but at some stage along the way you are going to want to hold that picture in your hand, as either a print or a transparency. While machines to produce good-quality, 'photo realistic' prints from digital files can be very reasonably priced, those which write the image to transparency film are extremely expensive and the job is best taken to a bureau.

Printers

One of the most exciting developments of recent years has been in the field of inkjet printers for the consumer market. For less than the cost of a budget-priced autofocus camera, you can buy a printer capable of producing photographic-quality images, so long as it is provided with good-quality RGB files. Some photographers (myself included) are using inkjet printers, such as those in the Epson Stylus Photo series, to assemble book dummies to submit to potential publishers. Steve Bloom's book *In Praise of Primates* was presented to its German publisher in this way, and the images themselves were supplied to the repro house as RGB TIFFs on CD (see Chapter 14 for information about image formats). This meant that no film had to leave his office. Since printers work with CMYK inks they prefer to see reference proofs in this form – those produced by a desktop printer are ideal. These printers are also great for making your own, targeted business cards (who needs 1000 cards with the same picture?) and for making layouts of magazine proposals. For personal use, they are an excellent way to make greetings cards and postcards of a quality superior to those produced by conventional printing.

The three main drawbacks with inkjet printers at the moment are their speed, the high cost of consumables (paper and ink) and the rate at which the inks fade in sunlight. Experience has indicated that even in my sunless office, deterioration is evident after only about six months. It seems likely that in time, some of the benefits of high-end inkjet printer technology will filter down to the popular market, and with that we should see UV-protected inks.

An inkjet print isn't continuously toned like a photograph; it is comprised of tiny dots of ink sprayed onto the paper. From a normal viewing distance, however, the effect is the same. Select a model capable of delivering a high number of dots (of ink) per inch – more than 250 are required for a crisp print; 300 plus is better. The more dots per inch that can be applied, the better, although the improvement may not be evident on smaller prints.

Inkjet printers use cyan, magenta, yellow and black inks, but work best when supplied with an RGB file – the sort produced by your scanner. The fact that a conversion has to take place means that it is impossible to match the print perfectly with what appears on screen, but with practice the results can be very close indeed. Some of the better models employ print with black ink plus five coloured inks (two tones of magenta and two of cyan, and yellow) for improved distinction of subtle tones. A3 models are sometimes not that much more expensive than their A4 counterparts, but you should take into consideration that you will need a large file and a lot of ink to get the very best out of it.

The other types of printer used commercially include the Fujix Pictrograph machine – I shall discuss this further in Chapter 14.

Film writers

Most outdoor photographers are used to looking at transparencies on a light box, and the idea of a file on a CD or even a print suitable for reproduction (such as a Pictrograph) is alien. We want to see film; it is somehow more reassuring. Well, the good news is that we can have it, and in astonishing quality. The bad news is that it costs a lot of money. The LVT (Light Valve Technology) machines which write reproduction-quality images to 100 ISO transparency film are very expensive (about the cost of a new small car) and having 5x4in transparencies written is itself costly. There is little point in writing to anything smaller than 5x4in, since only at this size is the grain no longer a problem. Grain size is constant irrespective of how big the piece of film; the bigger the film, the smaller, proportionately, the grain. For best results, the pixels need to be smaller than the film grain (see Chapter 14).

Analogue film recorders, employing a cathode ray tube, are crude in comparison and produce inferior-quality transparencies.

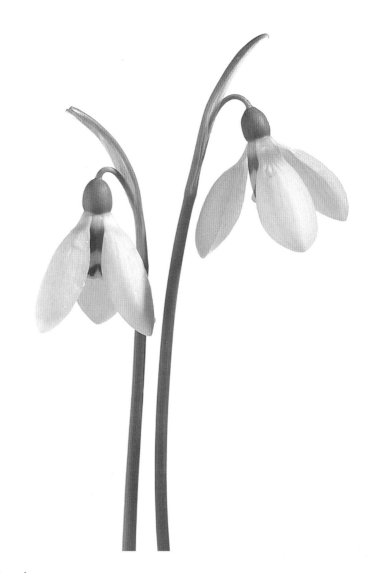

SNOWDROPS

High-key pictures such as this studio shot of garden-grown snowdrops lend themselves well to output as inkjet prints. The brilliance of the paper contributes to the airy appearance of the image. You also save a lot on money on ink.
AF 180mm + 52.5mm extension, 2 x TTL flash, Ikelite Lite-Link, Fuji Velvia

Top tips

- When choosing a system, ensure that it can be expanded to keep pace with your developing needs.
- You can never have too much RAM or hard-disk space. The machine should be able to accommodate at least 250Mb of RAM and have a hard disk of 4Gb or bigger.
- Buy as big a monitor as you can afford; 17in is the minimum recommended for imaging work.
- Look for a scanner which can scan at 4000dpi (enough for high-quality reproduction to A3 size), with a dynamic range of 4.0 or more and which takes 12 samples or more per channel (a 36 bit scanner).
- CDs and DVDs are ideal for cheap archival storage of images. Zip disks are handy for temporary storage of uncompleted images.
- Inkjet desktop printers are now capable of producing photographic-quality images but currently the inks have a short life.
- Digital files can be written successfully to film, but the cost of LVT transparency outputs is comparitively high.

4 Exposure – Consistency Through Control

Sharpness and good exposure are the two main technical requirements of a successful photograph. Modern autofocus systems, for much of the time, free the photographer from the chore of finding the point of focus. But determining a good exposure is a less exact procedure, and because often it depends upon the result you want, it is one which you, rather than the camera, are best placed to take charge of.

DE'IL'S HEID, ARBROATH, SCOTLAND

By setting the exposure manually I was able to record this sea stack as I wanted it: as a silhouette. An intelligent automatic system would have tried to strike a compromise between all the tonal values in the scene and introduced detail into the rock, which I didn't want. I took a centre-weighted reading from the sky just to the left of the rock and used that.
MF 20mm, Fuji Velvia

DURING THE EVOLUTION of popular 35mm cameras from the 1970s onwards, a great deal of work has gone into the development of foolproof automatic exposure systems. Today, many are extremely sophisticated, with cameras programmed to recognise thousands of different lighting situations and to compensate accordingly. Why, then, do many photographers still prefer to set their own exposure rather than simply let the camera get on with the job itself? The answer has a lot to do with control. While

there is one point at which the image is in absolute focus (and another zone in front and behind which appears sharp – the depth of field), exposure is open to more interpretation, according to the subject, the lighting conditions, the film being used and the feeling the photographer is after. Indeed, it is better to think in terms of 'good' rather than 'correct' exposure; sometimes two or three slightly different exposures can each look as good as the other.

In the field, I sometimes flick between manual and

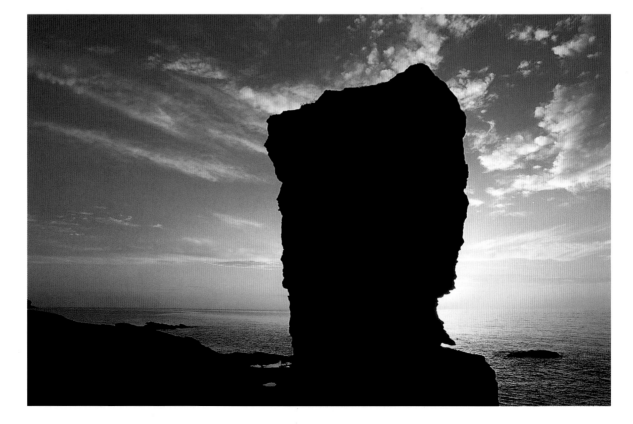

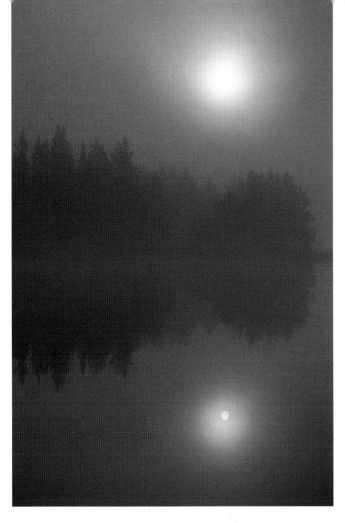
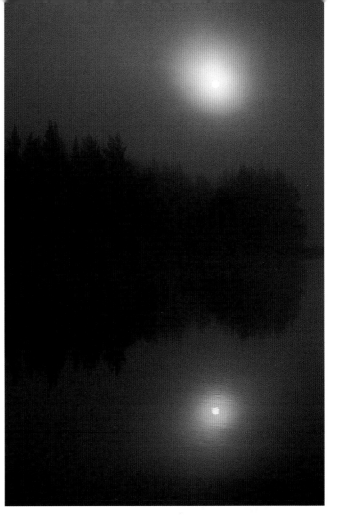

automatic exposure modes once I have set what I know, through practice, will be a good exposure. There is frequently a disparity, and I would rely on the automatic reading in only the most unambiguous lighting conditions with mid-toned subjects. Learning to meter manually for consistent success does take time, but the rewards come when you are faced with a complex lighting situation – the sort that is most likely to confound an automatic system.

Whether you choose to set the exposure manually or allow it to happen automatically, regular over- or under-exposure of mid-toned subjects (see next section), may indicate that the camera's meter is incorrectly calibrated. It is worth running a test as soon as you buy a new camera, to check. Find a suitable, evenly lit mid-toned subject (perhaps a brown tree trunk), set the ISO dial to the film speed and then take a manual meter reading. Adjust the aperture and shutter speed manually until a 'correct' exposure is indicated in the viewfinder. Having taken the picture, vary the ISO setting by ⅓ stop at a time without adjusting shutter speed or aperture. If I were running the test with 100 ISO film, I would try at 100, 64, 80, 125 and 160 ISO settings. On seeing the processed film, you can determine which ISO setting gave the best exposure; stick to this in future. Many photographers make a practice of using more than one camera body in the field and life is made much simpler if both meters agree.

Recognising mid-tone

The ability to recognise a mid-toned subject, whatever colour it is and whatever the lighting conditions, is central to the success of manual metering. Technically, it is one with an 18 per cent reflectance, the Kodak grey card being the standard reference. This is the value used to configure metering systems: take a meter reading off a black subject and adjust the aperture until the meter indicates 'correct' exposure, and that black becomes grey. Do the same off a white surface and it, too, is rendered grey. Black and white represent the extremes of reflection; how much of these achromatic colours are mixed in with the colour (or hue) of a subject determines its shade (or tone) and therefore how far it is removed from the 18 per cent value. That in turn dictates how much, if any, compensation (see p.28) you need to apply to the meter reading to render that colour in its true tone (rather than simply an 18 per cent reflectance tone).

Mid-tones are all around us in nature, but recognising them precisely can take a bit of practice. I would like to be able to say that green grass or rocks or bark provide good mid-tones, but in reality their tonal values vary widely. A grey card held alongside particular subjects can help you to assess

MIST AND SUN, LOCH BEINN A' MHEADHOIN, GLEN AFFRIC, SCOTLAND

When the subject is mid-toned and the lighting even, bracketing exposures is a waste of film. If exposures are poor under these circumstances, the chances are that the camera's meter is incorrectly calibrated. In a situation like this one, however, I always bracket widely since no one exposure is better than the others.
MF 90mm, -2 stop graduated ND filter (soft step), Fuji Velvia

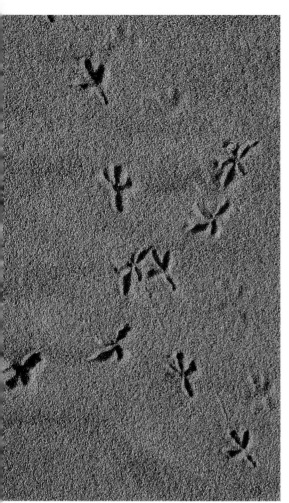

ABOVE: **PRINTS IN THE SAND**
TOP RIGHT: **FROSTED BRACKEN**
RIGHT: **GOLDEN EAGLE NAPE**
[C]

Here are four brown tones
varying between 1½ stops
less than mid-tone and 1
stop brighter. The dark eagle
feathers represent the lower
end of the scale; use this
particular brown as your
mid-tone and you can
expect an over-exposed
photograph. The sand,
however, in evening light,
was about 1 stop brighter
than mid-tone; make this
your mid-tone and the
picture will be too dark. The
frosted bracken has the best
mid-tones.
All MF 90mm, Fuji Velvia

their tonality, and some photographers tack a card just out of frame at feeding stations so that they have a reference point for exposure in the same light as the subject. If you want to meter from a grey card, be aware that if its surface is coated for protection this may adversely affect your meter reading. I find that a square of mid-toned fleece stuck to a small board and angled to the light the same way as the subject is more reliable. After a while, however, you will come to recognise reliable mid-tones in the landscape for yourself. If I am photographing something that is completely lacking in mid-tones, such as a snowy landscape, I use the sky's zenith as my mid-tone (assuming it is cloud-free) and then work out my exposure from there. Over time you will come to recognise consistent deviations from mid-tone: dried grass in bright overcast light is ⅔ stop over mid-tone; backlit green grass is 1 stop brighter; a particular camera bag is ⅔ stop darker and so on.

The 'sunny 16' rule states that with the aperture set to f16, the correct shutter speed is the one which corresponds most closely, numerically, to the film speed. In other words, if you have loaded 50 ISO, the correct exposure on a sunny day would be ⅟₆₀ second at f16. Although this rule holds true in some parts of the world where skies are crystal clear and the sunlight brilliant, it fails whenever even light cloud takes the edge off the sun's brilliance, or the sun is low in the sky. The times when it would be most useful – round about midday – are often the least attractive for photography.

Film latitude

If manual metering is beginning to sound a bit intimidating, take heart: there is a little leeway for error. This is especially so with colour negative films, where a deviation of even 2 stops from the good exposure may be corrected during printing. Modern E6 emulsions, however, are relatively unforgiving and with some, such as Fuji Velvia, even ⅓ stop can make the difference between a good and bad exposure.

In Chapter 5 I expand on the similarities and differences between our visual system and film. In the meantime, let's establish that, for various reasons,

film does not 'see' the wide tonal range that our eyes 'see'. In fact, taking mid-tone as a 0 value, the darkest tones in which high-contrast slide film can record detail are about 2 stops less (-2), and the palest in which detail is rendered are about +2. We therefore have to work with a total tonal range of about 4 stops (more with negative film) which can be recorded satisfactorily.

If there are detailed highlights in the picture which are more than 2 stops brighter than mid-tone, a straightforward mid-tone reading will not provide a good exposure – the details will be burned out. To compensate for the brightness, we have to reduce the exposure if these highlights are 3 stops lighter than mid-tone by closing the aperture down by 1 stop. This allows the highlight details to be shown (by bringing it within the +2 stop range), but it also means that mid-tone detail is more obscure, and shadow detail more than 1 stop below mid-tone disappears entirely. The film's exposure latitude is thus like a fixed pair of brackets which can be slid backwards and forwards on a scale around zero (mid-tone), with a move in one direction always having an effect at the other end.

Learning how much to compensate from the given light reading is the central skill in manual metering and this only comes with experience. I confess that I have never been very diligent about keeping note of my exposures, preferring instead to follow my instinct;

since it doesn't change, I know that if the exposures are good for 95 per cent of the time, I compensate according to what I feel is the right amount. I bracket the other 5 per cent of the time – unscientific maybe, but effective.

Top tips

- Often there is no single 'correct' exposure; for maximum control, decide what *you* want to be the mid-tone in your photograph and select the exposure accordingly.
- Ensure that your meter is correctly calibrated by running a test which involves adjusting the ISO setting without resetting aperture and shutter speed.
- Practise recognising mid-tones as defined by their tonality, not simply their colour.
- Appreciate the limits of film latitude; what you may initially think is a badly exposed picture may actually be well exposed but simply very contrasty.
- Compare light readings from a known mid-tone with the shadow and highlight areas of the subject to determine if any exposure compensation is required.

Taking meter readings

When you spend a lot of money on a sophisticated camera body, it seems a shame not to use its built-in light meter. Some photographers still prefer to take an incident light reading (measuring the amount of light falling on a subject) with a hand-held meter, but this approach is slow. Using the camera's built-in meter (which measures the light reflected from the subject) may require compensation to be applied, depending upon the reflective characteristics of the subject, but used skilfully it is more reliable since it takes account of filters and extension, and is directed at only the part of the scene you wish to photograph.

Many cameras now come with the choice of three light-metering systems (not to be confused with automatic and manual exposure modes): centre-weighted or average; spot; and matrix or evaluative. Centre-weighted, which concentrates its attention on the tonal values in the middle of the frame, and spot metering (limited to a much narrower area) have been around for a long time, but matrix is a more recent development. At its simplest, the viewfinder is divided

OVERLEAF: SCOTS PINE, GLEN LYON, SCOTLAND

Sometimes, the best way to use harsh lighting is to find a subject to silhouette, then set the exposure to record detail in only the brightest parts of the scene – in this case, the sky and snow-covered mountains. Shooting into bright light like this allows you to use fast shutter speeds – in this case ½₅₀ second – which was essential on this occasion because of the strong wind blowing up the glen.
MF 90mm, beanbag, Fuji Velviaa

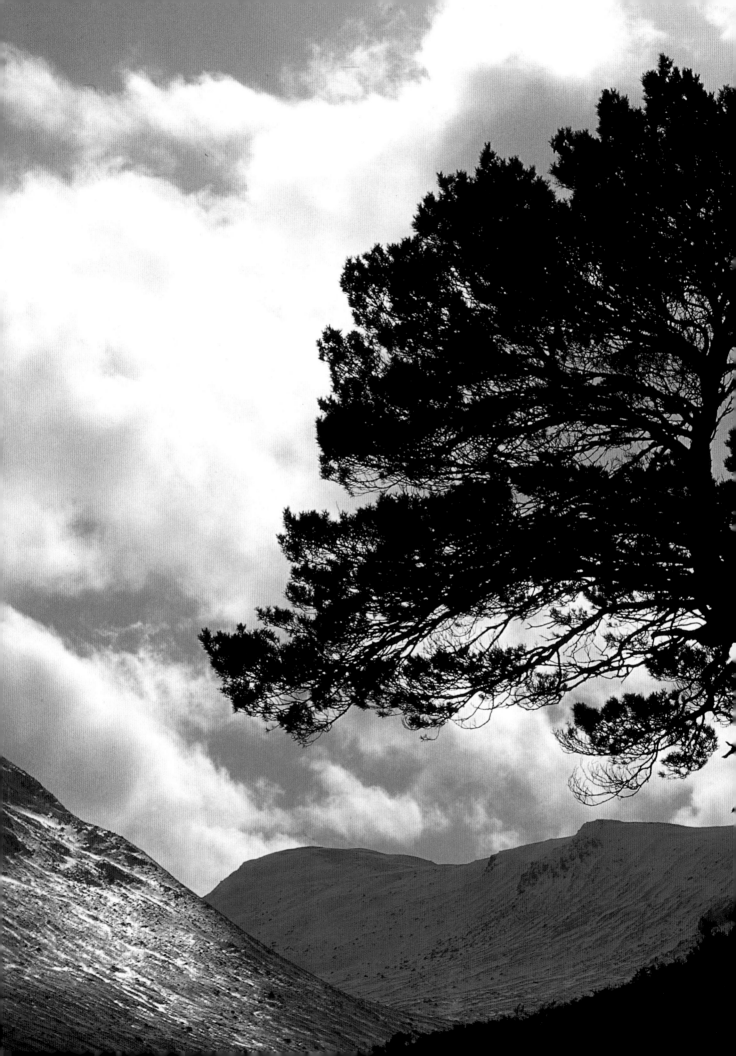

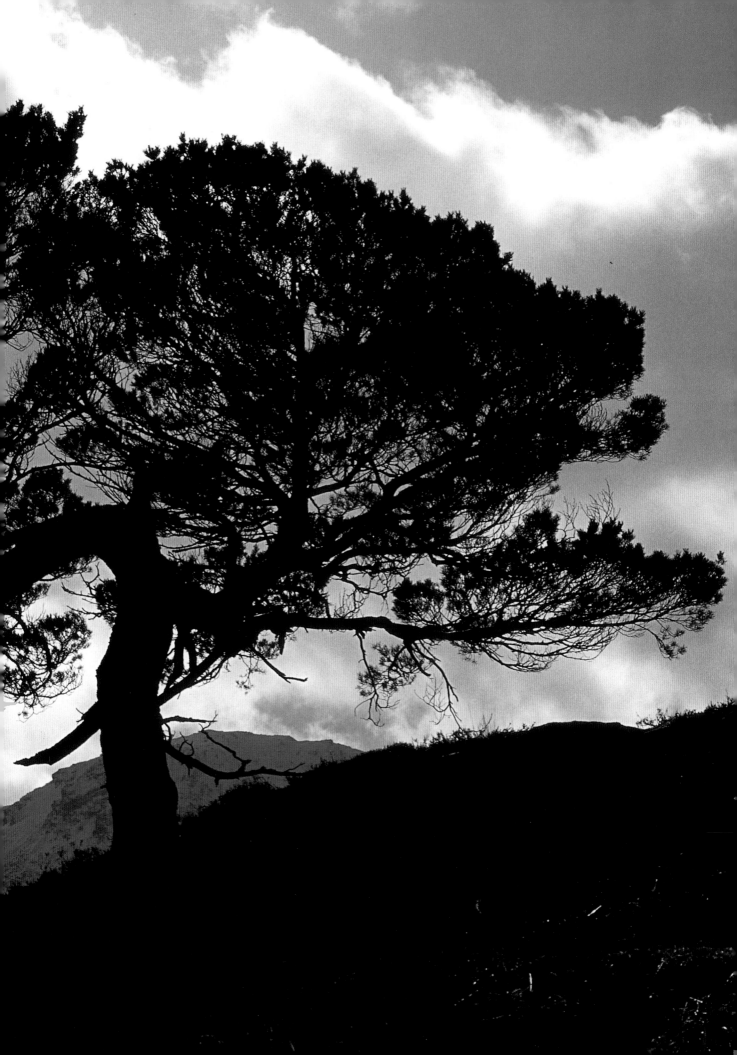

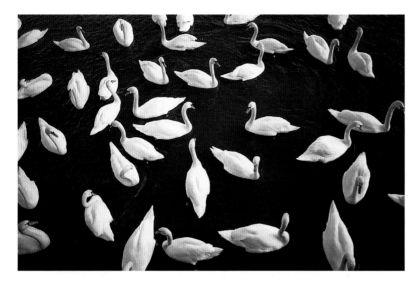

MASSED MUTE SWANS

The bright light required me to close down the aperture by 1 stop from the mid-tone reading to retain detail in these mute swans. As a result, the already dark water turned black, adding some useful contrast to the scene. *MF 28mm, Fuji 50*

MUTE SWAN INCUBATING

Owing to the heavily shaded background and paleness of the swan, I was struggling to find a mid-tone to read. In the end I pointed the camera towards the zenith and took my reading from there. Since the early-morning sun hadn't yet struck the bird, it was still within the 2 stops range of mid-tone, so no compensation was required. *MF 300mm + x1.4 converter, beanbag, Fuji Velvia*

into a number of sections, the light is read from each of these and then the camera's software calculates the correct exposure. In some cameras, thousands of picture-taking situations are written into the software so that, in theory, the camera should never be fooled by an unusual lighting situation. However, my personal preference is to use centre-weighted and spot metering exclusively, for maximum control.

There are two main approaches to taking light readings with the camera's built-in meter. You can read directly off the subject, or you can refer to a mid-tone in the same light as the subject. If the subject is decidedly lighter or darker than mid-tone, I prefer the latter method. Otherwise, it is just as easy to meter directly from the subject itself.

It is important to appreciate that exposure compensation applies in opposite directions, according to the metering method you use. Here's a common scenario: it's a sunny day on my local estuary and I'm there to photograph mute swans. The sky is blue, the rocks are grey and the swans are above-average brightness. A centre-weighted meter

reading from a nearby bird indicates that it is 3 stops lighter than the mid-toned rocks nearby. I confirm this by taking a reading of the sky directly overhead (the zenith). If I go with the exposure recommended by the camera when I read off the bird, I will get detail into the highlights but those whites will become grey. I therefore need to make the aperture 1 stop wider to turn that grey back to white.

The opposite happens if I take my reading off the mid-toned rocks instead. If I apply no compensation, the bird, which is about 3 stops brighter than the mid-tone, will be burned out, since its highlights are a stop greater than the film's latitude can handle. So, in this case I would have to make the aperture smaller to compensate for the bird's brightness.

The net effect of both methods is the same: the bird is well exposed, but the surroundings are rendered darker than their tonal value. The effective latitude of film can be extended by using fill lighting, from either flash or a reflector. The technique, described fully in Chapter 6, involves selecting an exposure which retains highlight detail and returning detail to the shadows with supplementary lighting.

Were I to return to the same group of swans on an overcast day, I might find that they were only 2 stops lighter than the mid-toned rocks, in which case no exposure compensation would be required. You can apply this scenario, in reverse, to subjects which are appreciably darker than mid-tone.

For much of the time I use the centre-weighted metering system, especially if the subject is evenly toned and occupies a large part of the frame. Excessively light or dark parts of the scene are excluded as I take the reading. Spot metering comes into its own in a scene with excessive contrast – such as a dark animal against snow. In this instance, I identify a mid-toned part of the animal and then use my spot meter to read that part alone. I normally take a number of readings from elsewhere in the scene to confirm that my choice is indeed a mid-tone. A spot meter requires very precise use; allowing even a sliver of sky or snow to creep into the narrow metering zone will throw the reading. An animal which appears all mid-toned, such as a red deer, actually has quite a wide tonal range, which becomes apparent only as spot readings are taken. In time, you will come to recognise the best parts of particular animals from which to take spot readings: I target a red deer's shoulder; I find a red squirrel's head is reliable (its blond tail is more than 1 stop lighter); and a bighorn's forehead works best.

Perhaps the auto-exposure route seems the more attractive one, especially if the camera gets it right 90 per cent of the time. The chances are, though, that the 10 per cent of the time when it gets it wrong affects the very pictures you wanted most. Leaving the camera on auto makes it hard to analyse and correct poor exposure.

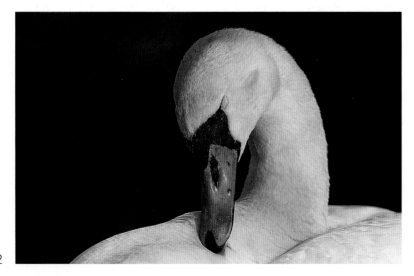

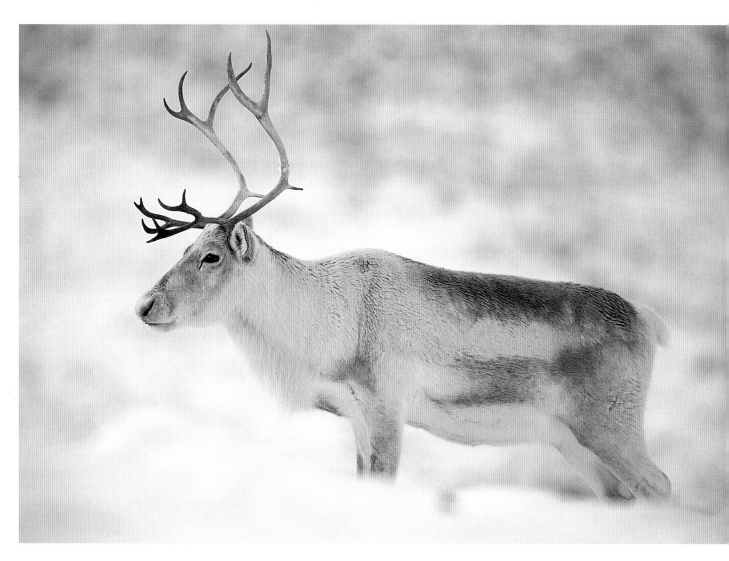

Reciprocity failure

At very long shutter speeds (typically more than one second), the normal reciprocal, where doubling the speed requires the aperture to be opened by 1 stop, breaks down. Additional exposure (over and above the good exposure) is needed and often a colour cast appears. Each film has its own characteristics, and for precise information about your preferred stock you should refer to the data book published by the film's manufacturer.

As a guide, the normal reciprocal applies between $\frac{1}{4000}$ second and one second with Fuji Velvia. A 4 second exposure requires an additional $\frac{1}{3}$ stop of exposure, and a filter with 5 units of magenta needs to be fitted to the lens to compensate for a green cast. At 16 seconds, $+\frac{2}{3}$ stop is called for, and 10 units of magenta. Exposures longer than 64 seconds are not recommended. Fuji Sensia/Provia 100 has slightly different characteristics and is generally more suitable for long exposure work. It can be used at up to 16 seconds without reciprocity failure occurring. At 32 seconds, an additional $\frac{1}{2}$ stop should be applied

to the exposure, but no filtration is needed. At two minutes, open up 1 stop and fit a 2.5 red filter.

Top tips

- Centre-weighted metering systems are fine in undemanding lighting situations, but sometimes the built-in spot meter is more useful. Use with care!
- Decide whether it is better to read off the subject or off a mid-tone in the same light as the subject; if the animal is very light or very dark, a reading from a nearby mid-tone is usually more reliable.
- Remember that while exposure compensation may ensure that the subject is rendered well, its surroundings may come out much lighter or darker than they are. With manual metering you can choose what is to be the mid-tone.
- With long shutter speeds – more than a few seconds – exposure is often unpredictable and colour shifts may occur. Check reciprocity characteristics with the film's manufacturer.

REINDEER IN SNOW

A white sky, white subject and white surroundings meant an absence of mid-tones in this scene. Had I taken a reading from the reindeer and used that, it would have come out grey. I would then have opened up by 1 or 1½ stops to restore its whiteness, but without a mid-tone to compare the exposure difference between the two I would have been struggling to know just how much compensation to apply. Fortunately another reindeer with brown on it wandered nearby, so I was able to take a spot reading from that!
AF 300mm, Fuji Velvia

5 Natural Light for Nature

Top-quality high-speed films and long, fast telephoto lenses have introduced a new era in wildlife photography where a high value is placed on natural lighting and atmosphere.

OPPOSITE: BULLFINCH, SNILLFJORD, NORWAY

Snow acts as a reflector, putting light into shaded areas. Even on quite gloomy days, as this one was, light levels are boosted sufficiently to photograph active subjects. The brightness of the light brought out the bullfinch's colours without creating excessive contrast.
AF 300mm, + x1.4 converter, Fuji Sensia 100 rated at 200 ISO

THE INUIT, WE ARE TOLD, have many words to describe snow in its various forms and states. It is a vocabulary born out of a need to define, not for intellectual reasons, but for practical ones. And just as their lexicon for snow is rich, ours to describe light is poor. Perhaps this is not surprising: the subtle distinctions of natural light are pretty incidental in most people's lives today. We have light on demand. We can manufacture it to our own specification and direct it where and when we want it. The *need* for a vocabulary to describe natural light just doesn't exist in the modern world.

But not so for outdoor photographers. We probably each have our own words to describe particular types of light which appeal to us: 'wood-edge' – that gently contrasting light with softly feathered shadows which arises on an overcast day where open shade meets deep shadow; 'buttery' – the yellow light of a clear, frosty winter's morning

when the sun rises into a cloudless sky. However, there is no commonly understood set of words I can use here to pinpoint in your mind the type of light I am referring to, though if you spend much time out of doors, I reckon you'll know anyway.

A photographer's response to light is partly physiological, partly emotional. It is widely recognised that, all other things being equal, we feel better on sunny days than on gloomy, overcast ones. This is manifest in the condition known as Seasonal Affective Disorder (SAD), where the prolonged deprivation of sunlight leads to lowered levels of serotonin in the brain, accompanied by feelings of depression. It is the emotional response which the photographer has to learn to tap into. By doing so, you can be guided by a gut feeling as to whether a particular type of lighting will be successful; this is especially important as we have no vocabulary with which to describe these conditions adequately, so

MONTROSE AT DAWN, SCOTLAND

The sun on this early spring morning rose into a clear sky, gilding the whole scene with an extraordinary yellow light.
MF 300mm + x1.4 converter, beanbag, Kodak Panther 100x

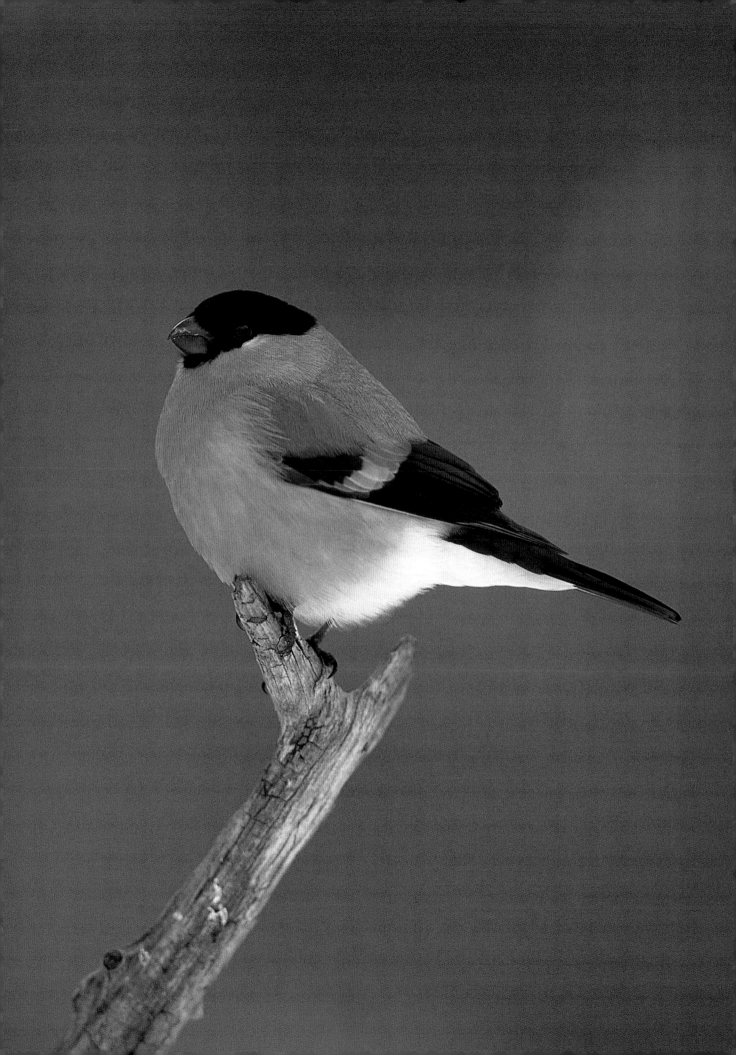

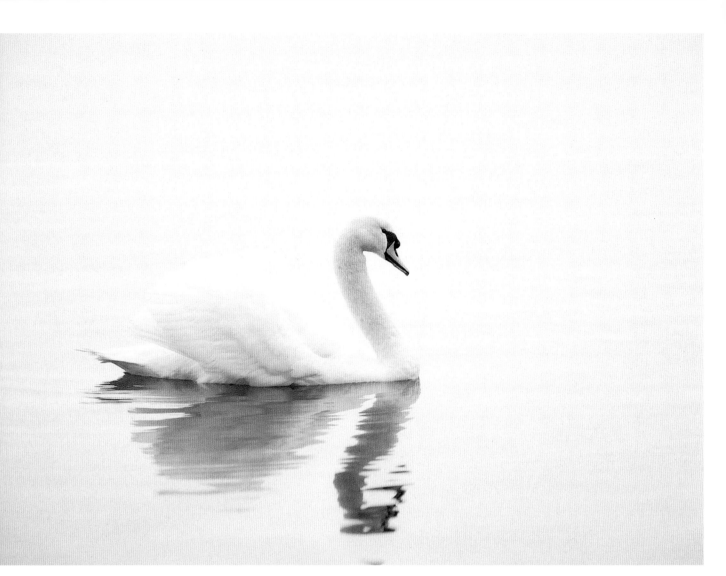

HIGH-KEY MUTE SWAN

The combination of a pale bird and brightly lit fog made for a high-key scene. In order to convey the light, airy feeling, I made the swan's reflection my mid-tone, allowing everything else to be rendered thinly on the film.
MF 300mm, Kodachrome 64

there are no lists of lighting types which work. It is not enough simply to recommend, 'Shoot at the edges of the day'. It's true that there is often lovely light then, but by restricting yourself only to these times, you ignore a range of other moods expressed at different times.

Film's response to natural light

Our work as photographers would be so much simpler if film mirrored our perception of light. But as we have already established, that is far from the case. It is worth keeping in mind the following two considerations: firstly, the range of contrast which film can record is much narrower than the one we perceive: thus where we can register a brightness ratio of approximately 2000:1, Fuji Velvia can manage only 8:1 (see Chapter 4). Secondly, film is unable to assign colours to known objects in the way that our visual systems do (see Chapter 10). What is recorded

on film is an interpretation of the light rather than a record of our memory.

As the uptake of digital technology increases, the subtle differences between various types of slide film may come to be seen as less relevant, since the characteristics of different film stocks can be replicated in the computer. Nevertheless, the fact remains that the closer you can come to making the initial piece of film what you want, the better.

The trend today among outdoor photographers is to shoot on high-contrast, highly saturated slide film. This sort of material comes into its own on overcast days, when even a super-saturated emulsion such as Fuji Velvia looks fairly neutral. Since many of these films have a tendency to enhance subtle tones, they can make a subdued sunset look spectacular. Their colours, however, though attractive, cannot be described as accurate. Nevertheless, most people prefer the rich colours every time, and if you plan to sell your work you have little option but to work on this type of film stock. Once pictures are in print, when the conversion from the transparency's RGB

Using a graduated ND filter.

LIMES

During dark winter days, most of us yearn for the relief of brilliant sunshine. Making photographs with it is another matter, but one approach which works is to hide the sun behind a tree. This way, flare doesn't occur, and if there is some mist in the air, the scene takes on an ethereal feel.
MF 90mm, Fuji Velvia

colours to CMYK inks (see Chapter 13) has taken place, the differences are much less noticeable and, indeed, intense colours shot on more neutral film are less liable to 'block' (lose detail).

One reason that many photographers put their cameras to one side in the middle of the day is because of the loss of colour saturation in harsh sunlight, as well as the disappearance of shadow detail. Reflections off shiny surfaces may also obscure an object's colour. The task of finding a good exposure and rendering colours well is much easier if the sky is lightly overcast – although like this, if you plan to include it in a landscape composition it may turn out lacking in colour and detail.

Too much cloud, however, and contrast vanishes, resulting in a flat image where form is poorly defined and colour understated. As a rule of thumb, I find that if I have to screw up my eyes as I look at an overcast sky, it is just right to subdue shadows while retaining brightness in the image, and with it, contrast.

Filters to compensate for film's shortcomings

The idea of using any filters at all is anathema to some nature photographers. True, starbursts and graduated tobaccos have no place in photography of the natural world, but some, used with care, solve problems associated with slide film. Although the effects of these filters can be achieved more precisely and in a more targeted fashion in the computer, it is much simpler to make the corrections in-camera.

In choosing your filter system, consider how many different sizes of lens filter threads you have. If it is only two or three, you may wish to go for a traditional screw-in filter made from glass. By using one or two step-down rings (it's best to buy the filter to fit the largest thread) it can be accommodated on each of your lenses. Alternatively, square filters slot into holders which themselves slide onto rings screwed

onto the lens. Long telephotos, owing to the huge size of their front elements, normally take little filters which slot into the back of the lens. Many photographers, myself included, prefer the square systems, such as those from Cokin and Lee, because of their versatility (they are ideal for positioning graduated ND filters – see opposite), economy (the rings and holders are inexpensive) and suitability for use with wide-angle lenses. With careful alignment, the Cokin P filter holder can be used with 35mm lenses as wide as 20mm before vignetting (darkening at the corner of the frame where the filter encroaches) becomes evident. I have managed to increase the leeway for alignment error by hacksawing the front section of the holder away, since I use only one filter at a time.

FALLEN TULIP TREE LEAVES, PENNSYLVANIA, USA

Fallen leaves are a perennially popular subject – these were arranged on a piece of old wood close to where they had fallen. Overnight rain had boosted the colour of the wood, but the morning legacy of grey skies called for an 81a warm-up filter to restore warmth to the scene.
MF 90mm, 81a filter, Fuji Velvia

There are two types of filter which I find indispensable: graduated neutral density and warm-up filters.

Graduated ND filters

When you take landscape photographs, you will often be faced with a situation where the good exposure for the sky is markedly different from that for the foreground. Perhaps the sky is filled with dramatic storm clouds, but they cannot be recorded without the foreground being badly under-exposed. Graduated NDs help to even up the contrast by reducing the exposure value for the sky (through the grey part of the filter) without affecting the remainder. Sometimes fill-flash can be used to open foreground shadows, but it is seldom sympathetic to the prevailing natural light.

Professional-quality graduated ND filters are colour neutral – they simply reduce the amount of light reaching part of the film and do not introduce any colour cast. Extra-long square (actually, rectangular) filters are best; they can be slid up and down in their holders to match the position of the bright zone

SNILLFJORD, NORWAY

The exposure is the same for each of these pictures, as can be seen from the foreground. But for the picture on the left I fitted a -2 stop graduated ND filter, which brought the hill and sky into the exposure range in which the film could record detail. Since there was a simple transition from shade to highlight, I used a hard-step filter. Note how blue shadows become on a sunny day, especially when ice is featured.
AF 28mm, -2 stop graduated ND filter, Fuji Velvia

SCOTS PINES IN MIST, GLEN AFFRIC, SCOTLAND

The blue cast in this photograph results from water vapour absorbing most of the red wavelengths of light and transmitting only the blue ones. It matches the mood of the autumn morning. It would have been even more pronounced had I not used an 81a filter.
AF 180mm, 81a filter, Fuji Velvia

which needs to be held back, even if it is very near the top or bottom of the frame. This is impossible with screw-in graduated filters.

A depth-of-field preview on your camera is essential to make the most effective use of a graduated ND filter. The correct position for the zone of transition (between clear and grey) is not the same at f4 as it is at f16, since the smaller aperture 'sees' through a different part of the filter. While holding down the preview switch, slide the filter up and down in its holder until the right part of the picture is shaded. If you are still unsure about the position of the gradation, run through the aperture settings and see how the darkening effect recedes as the aperture

widens. So long as the appropriate filter (soft or hard step – see Chapter 8) is chosen for the composition, there is no reason to avoid small apertures.

Metering is best done without the filter in place. I generally set a good exposure for the foreground, then recompose and slide the filter down into position, using the depth-of-field preview to determine the correct position.

Warm-up filters

It's a matter of personal preference of course, but most people seem to be attracted more to warm hues than cool ones, especially if the known colour of an object is reddish in the first place. It is easy to overlook how much blue there is in shadows on a sunny day, since our perception of a colour is also relative to those around it. The effect is most easily observed at dusk. Let's assume the room you are in is lit by tungsten light. This has a lower colour temperature (that is, it's redder – a warmer hue) than daylight, yet as you look at things in the room, they appear naturally coloured. Now glance outside and notice how blue everything seems, even though it is all in daylight.

Warm-up filters in the 81 range are good not only for restoring a more neutral colour balance in shaded areas on sunny days, but also for enhancing a subject's warm tones. They are not, however, selective, and they affect cool tones, too. In the days when Kodachrome 64 was the standard emulsion for wildlife and landscape work, an 81b worked well, increasing warmth without overdoing it. With modern emulsions such as Fuji Velvia, however, a 'b' is often too strong and an 81a is better.

One situation where the need for a warm-up filter is not immediately apparent is on misty days. Moisture in the air absorbs red wavelengths, transmitting the blue ones. Although a cool bias may be desirable, it can look too strong, unless a warm-up filter is used.

Other filters

Polarisers remain popular with many outdoors photographers, and with good reason. They remove unwanted glare from vegetation, revealing its colours. They increase the contrast between blue skies and white clouds. Detail beneath the water's surface is also more clearly revealed. But they have their downside, too. They cost up to 2 stops of light, depending on the degree of polarisation that is set. Unless they are of a slim design, they can cause vignetting with wide-angle lenses, especially if used in conjunction with other filters. And if you want a polariser for a long telephoto, to fit into the rear filter holder, the cost is considerable.

The need for a polariser in respect of colour enrichment has been negated to some extent by modern, highly saturated films – often with these when a polariser is used the effect is just too much and colours block. Nevertheless, they retain their usefulness when photographing water.

Light metering and autofocus systems which employ beam-splitting technology are incompatible with traditional linear polarising filters. Use a 'circular' polariser instead; this refers to the way it polarises light, not to its shape. And if you are in doubt, opt for this sort anyway.

Colour-intensifying filters are a relatively recent innovation. Some models boost specific colours while others aim to increase the saturation across the spectrum, especially the reds. Earlier models, though effective at enriching reds, also introduced an overall magenta cast to a scene, adversely affecting subtle colours and whites.

Colour intensifiers are probably the most expensive filters you will be tempted to buy and you have to consider if they are really worth the investment. The intensification may be lost when the pictures appear in print and, conversely, colours in a neutral picture are sometimes boosted during the printing process. I have many times looked in wonder at pictures of mine which appear in print considerably better than the original transparency!

Top tips

- **Be guided by your instinct as to whether or not the lighting is suitable. Tap into your emotional response and try to let that come through in the picture.**
- **In doing so, remember film's limitations in terms of ability to handle contrast and to render colours as we perceive them.**
- **Use filters to help you overcome these limitations, rather than invent something which wasn't there in the first place. However, their use should not be obvious.**
- **Square filter systems are the most versatile option, but buy quality filters to put in the cheap holders. Filters made of optical resin, such as CR-37, are very good.**
- **Graduated ND filters are a must for the landscape photographer. If you can afford to, buy both a hard- and a soft-step -2 stop, oversized filter such as those from Singh-Ray.**
- **Polarisers are great for removing surface reflections but can cost a lot of light. Use a circular polariser with autofocus cameras.**

BEECH TREE SHADOW

In order to improve the contrast between sky and clouds, I fitted a polariser over my lens for this picture. It was taken in the days before I used Velvia; now I probably wouldn't find it necessary.
MF 28mm, polarising filter, Kodachrome 64

6 Flash Can be Fun

For photographers who relish the subtleties of natural light, flash seems a crude weapon against the dark. Sometimes, however, it is the only one at our disposal. This chapter explains how to make the best of it.

SCOTCH ARGUS BUTTERFLY,
GLEN STRATHFARRAR,
SCOTLAND

To light this picture, I held a single flash fitted with a small 'softbox' (to diffuse the light) as close as the butterfly would permit. Since this was the only source of illumination in the picture, I made sure that the background was close enough to benefit from some of the flash; had it been too far away, it would have appeared black.
AF 180mm + 52.5mm extension tube, TTL flash set to 0 ev, softbox, TTL sync lead (hand-held), Fuji Sensia 100

MANY OF US were put off flash in our early days of photography because the exposures never looked right. As we grew to appreciate the beauty of natural light, so the old manual flash was pushed to the back of the cupboard and stayed there.

With the advent of TTL flash and then 'smart' TTL strobes, achieving a good exposure with flash as the only source of light became much simpler – but still the lighting in the pictures lacked character. So although flash provided the solution to a problem, it contributed nothing towards elevating the picture from a mere record.

There are times when you have no choice but to plug in a flash – at night, for example, or to capture high-speed action through small apertures: there is no natural light bright enough to do this. Sometimes it is simply more convenient, especially when you are attempting insect photography in the field, to carry your own personal sun around with you. If it is used with some imagination, the origin of the light is not so obvious.

The problem with a flash gun is that, compared to the sun, it is a very small source of light. You can see why this is a problem by directing an angle-poise lamp (to represent the flash) at a vase of flowers. When it is very close, the shadows are feathered and open. As it is moved further back, effectively making it a smaller source of light, the shadows grow darker

FIELD GRASSHOPPER

An undiffused flash, held about 12cm from this grasshopper, was big relative to the size of the insect. This meant open shadows and a softer character to the lighting. It also provided me with the large amount of light I needed for this near life-size (1:1) image.
MF 90mm + 52.5mm extension tube, manual flash (hand-held), Kodachrome 64

and develop hard edges. So, with the flash positioned just a few centimetres from, say, an insect, near-shadowless illumination results, since the size of the light source is large relative to the size of the subject. The further back it is moved, the smaller and harder the shadows become.

Clearly it is only practical to get a flash so close with small, tolerant subjects. An inflatable diffuser box, which fits onto the front of the flash, makes it a bigger light source, but this is only effective up to about 50cm from the subject. 'Diffusion' caps which fit over the flash's lens do nothing to increase the size of the light source and serve only to cut its output. With bigger subjects, the only sure way to get diffused, studio-quality lighting is to place a diffuser sheet beside the subject and direct a flash through it from a distance at least twice that of the sheet from the subject. The logic of having the flash placed far away can be proved by moving a diffuser sheet backwards and forwards over a subject on a sunny day. The closer the sheet to the light source (in this case, the sun), the harder the shadows.

Given no option but to use undiffused flash, the obvious solution to the problem of shadows is to use a second flash to fill them. Technically, this is straightforward with TTL guns and the Ikelite Lite-Link (see p.47), but the picture can easily become over-lit. Distracting twin catchlights also appear in subjects' eyes, although these are easily removed in-computer. As flash has the same colour temperature as the midday sun – about 6500K – you may want to use coloured filters on the flash heads to improve colour balance: a warm-up for the main flash and a cooler filter on the fill one. If so, you should bear in mind that the filters used on flash heads need to be stronger than those for lenses since the subject itself, unless it is white or otherwise reflective, absorbs some of the coloured light.

I have always found it difficult to evoke the atmosphere of low-light situations by relying on flash as the only source of illumination, and now prefer to mix daylight with flash, or simply enhance the image in-computer (see Chapters 13–15).

Fill-flash and the joy of smart strobes

As we saw in Chapter 5, slide film cannot record all the detail in very contrasty scenes. When the contrast range exceeds about 4 stops (2 stops either side of mid-tone), detail in both highlights and shadows is lost. Reflectors, diffusers and mirrors even up contrast for close-up photography but are impractical for active subjects at a distance. Fill-flash is the field alternative to the process of adjusting contrast in-computer.

Fill-flash relies for its success on being subtle, on lightening shadows without obliterating them. Only with the recent generation of TTL flashes – 'smart

LONG-TAILED FIELD MOUSE

The neighbourhood population of long-tailed field mice soon realised that I actually wanted them to visit my basement after I'd been leaving out oats on a work surface. This was a food-for-photos deal, and after a few nights this battle-scarred mouse entered my set. A red-filtered tungsten light allowed me to focus, while the illumination for the picture came from two diffused flashes, one at each side of the set.
AF 100–300mm, 2 x TTL flash, TTL sync cord, Ikelite Lite-Link for second flash, Fuji Sensia 100

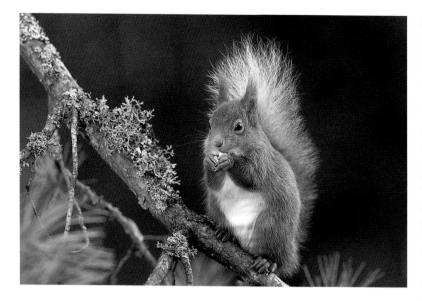

RED SQUIRREL IN PINE

Diffused backlighting helped to show this red squirrel's tail to advantage, but did nothing to illuminate the side of the animal facing the camera. A flash, attached to the camera by a TTL synchronisation lead, was set 1.5m to the side to avoid 'red eye'.
MF 300mm + x1.4 teleconverter, TTL flash set to -1.7ev, TTL sync lead, Fuji Sensia 100

strobes', with the facility to adjust their TTL output independent of the camera's settings – has this become a straightforward operation.

The compensation buttons on a smart flash allow automatic daylight exposure (if you prefer it to the manual method) and automatic flash exposure to be compensated independently, thus giving the photographer precise control over the balance between the two.

The starting point for a TTL fill-flash exposure is a daylight reading. Set the aperture and shutter speed for the ambient light so that highlight detail is retained. If the subject is pale and the light very bright, shadow detail disappears. At a -1ev (the equivalent of minus 1 stop) setting, the shadows are lit to within 1 stop of mid-tone (the flash is too weak to affect mid-tone or to highlight areas of the picture); this normally looks too bright. Instead, with a mid-

toned subject, I dial in a compensation of -1.7ev (-1⅔ stop), just enough to show a little detail in the shadows. The effect of anything less than this scarcely registers in the shadowed areas, especially on a sunny day.

Like any automatic light metering system, that for TTL flash is unable to distinguish between light and dark subjects; it merely reacts to the amount of light reflected and adjusts the output accordingly. If the subject is white, much light is reflected, the flash cuts out quickly and inadequate illumination is provided. The exact opposite happens with a very dark subject, but the net result is the same – mid-tone grey. When you use TTL flash to provide fill lighting, the same rules of compensation apply for subjects which aren't mid-toned.

Take, for example, a gannet. A straight daylight meter reading off the bird on a dull day, if trusted, would produce a photograph under-exposed by up to 1 stop, depending on how much of the frame it occupied. Do the same on a sunny day and the picture could be 1½ stops or more under-exposed. Translate this to TTL flash metering: even when the compensation dial is set to 0ev, the flash would effectively put out roughly -1ev. To achieve the desired -1.7ev result, only -0.7ev need be dialled in. A black grouse, on the other hand, 'soaks up' light, so to prevent flash from overpowering daylight, a setting of -2.3ev or even -2.7ev (as low as most flashes go) is better.

It is worth mentioning that although many of these smart flashes claim foolproof auto-balanced fill, you cannot always rely on these default settings. In the TTL mode, I always deselect the auto-fill option and adjust compensation manually. The manufacturer's concept of the ideal fill ratio doesn't coincide with mine. Over-lit shadows just don't look right in natural history photographs.

Well, that's the theory, but there are always things in the field which catch us unawares. Reflective surfaces, such as leaves or stems between the camera and the subject, are rendered as burned-out blurs unless they are close to the subject. Rather than hot-shoe mounting the flash, it can be corded to the camera and held so that it beams around the obstruction. A subject that is small in the frame surrounded by a lot of empty space is normally over-lit, because the meter disregards it and instructs the flash to light

BLACK GROUSE, ANGUS GLENS, SCOTLAND

Each year that I photographed black grouse at their communal display site ('lek'), I was always disappointed with the pictures taken on overcast mornings. Then I tried adding some flash. Now I always use it to show detail in their rich, dark blue plumage. Black they are not.
MF 300mm, beanbag, TTL flash set to -2.3ev, Fuji Sensia 100

the background. This problem can be overcome by dialling in a lower minus ev setting. Another way around the difficulty is to use the spot flash-metering facility offered by some cameras (you can then use your familiar minus ev settings), ensuring that the correct zone in the viewfinder is selected and that you reset the camera's flash meter options to matrix or average afterwards. I'm sorry to say it, but in such situations it is almost easier to use the flash manually (if you have five minutes or so to work out the right power output).

Making the most of fill-flash

There are three other main uses of fill-flash. On heavily overcast days, when any surface not tilted upwards is in deep shade, I use flash to add a sparkle and to invigorate colours. Having set the camera and lens for a correct daylight exposure, I simply dial in -1.7ev or -2ev (if the subject is mid-toned) on the flash. On days like this, direct flash brings iridescent plumage to life. We do not always encounter great subjects in fantastic light; flash can help to make the most of a bad day and to increase the range of conditions in which attractive images can be made.

The second benefit relates to colour balance. Every year, thousands of photographs are taken of gannets on Scotland's Bass Rock, but many of those taken on sunny days are ruined by a blue cast, reflected from sea or sky, which appears on the shaded side of the bird facing the camera. Fill-flash not only reduces sharp contrasts but also restores a colour balance to something closer to what we perceive, bringing out the beauty of the pale orange feathers of the bird's head and neck. The degree of colour correction can be altered, if necessary, with the addition of filters over the flash.

Other seabirds, such as razorbills and guillemots, present a different problem which smart flash can also solve. Without sunlight, the dark eyes of these birds merge with the rest of their head, giving them a lifeless look. On an overcast day, TTL flash, whose normal practical range is less than about 10m, can animate subjects by adding a catchlight from 20m away (and further with a Fresnel screen focuser – see p.46). Set the ev compensation to -2ev.

A word of caution to converts: once you discover the usefulness of smart flash, you'll wonder how you ever managed without one. You may, as I did, go overboard with it for the first six months. Keep this in mind: smart flashes do nothing more than allow photographers to salvage pictures in less-than-perfect conditions. They do not create atmosphere or interesting pictures all on their own. Their light is undiffused and frontal. It is therefore important to assess the quality of the daylight carefully before plugging in a flash. Even when used subtly, the delicate character of the light on which the

photograph relies for its effect may be ruined. Flash used in snow or in rainstorms reflects from precipitation as streaks and blobs – interesting for novelty only. Try to use flash intelligently: is it appropriate to fill subjects which are completely silhouetted? Are you using the flash to solve a problem or simply for its own effect? Smart flash can be a great tool, but only when used with a critical eye.

Top tips

- Use fill-flash to reduce contrast on sunny days, to add brightness on gloomy days, to restore a natural colour balance and to add a catchlight to a subject's eye.
- The current generation of smart flashes, whose TTL output can be compensated independent of the camera, make fill-flash easy and relatively predictable.
- In TTL mode, deselect auto-balanced fill and dial in your own compensations rather than relying on the manufacturer's defaults.
- For mid-toned subjects, a setting of -1.7ev

GREAT SPOTTED WOODPECKER
When this male bird appeared in my viewfinder, I was immediately struck by the vibrancy of his red vent feathers. The day, however, was overcast and they were shaded (top). By adding a little flash to the scene (bottom), the contrast on the stump has been lowered but, crucially, the feathers now show as I remember them. *MF 300mm + x1.4 converter, TTL flash set to -1.7ev, Fuji Provia 100*

provides an adequate level of fill without over-lighting the shadows. A -0.7ev setting provides better results with white subjects, while dark ones demand -2.3ev or less.

- Beware of foreground obstructions which the flash might catch.
- Assess the quality of light carefully before using fill-flash; remember, it's there to get you out of a fix rather than to create an atmospheric image.

Rear-curtain synchronisation

This feature appeared with the early smart strobes of the late 1980s, and has spawned a popular technique which conveys a sense of movement while retaining some sharpness in the image.

Although a camera's flash synchronisation speed may be as fast as ½₅₀ second, the duration of the flash itself is often less than ¹⁄₁₀₀₀ second (but not on full output, when it may be as slow as ¹⁄₅₀₀ second). With a camera/flash combination performing rear-curtain sync, that ¹⁄₁₀₀₀ second flash takes place at the end of ½₅₀ second, rather than at the start as with standard flash. This means that any movement of the subject during the exposure is recorded as a blur which precedes the flash-lit part, which is itself sharp. In the photograph, the blur appears to follow the sharply defined subject, giving an impression of motion. In practice, the technique works best at slower shutter speeds, often less than ¹⁄₃₀ second.

Since the flash is relied on to provide more light than in a normal fill-flash exposure, a setting of -1ev for a mid-toned subject is more appropriate. Any less compensation (between 0ev and -1ev) and the subject will be over-lit. Since daylight provides the principal source of illumination, we are spared the 'nocturnal' backgrounds often associated with daylight flash.

Making your smart flash smarter

There are two accessories guaranteed to increase the versatility of a smart flash: a Fresnel screen and a TTL slave unit. Fitted with these, your smart flash acquires brawn to add to its brains.

Fresnel screens

A Fresnel screen is held by two arms several centimetres in front of the flash lens, focusing its output into a narrow beam. The one I have is designed for lenses 300mm or longer. As the beam is focused, so it is concentrated, resulting in a gain of approximately 3 stops over the flash at its 50mm setting. This greatly increases its useful working range and effective power, since much less light is wasted through scattering.

It is important that the screen is properly aligned with the flash, and you can check this by sticking small self-adhesive dots in the middle of the flash's lens and the screen itself. With the flash switched off, align the dots and the flash should be centred behind the screen. Lightweight designs are best, since they

STRETCHING MALLARD, BRAEMAR, SCOTLAND

The day was an especially gloomy one in the Highlands, but watching a group of mallards at a village pond I noticed that they paused for a moment while stretching, allowing me to fit in an exposure. Camera-mounted fill-flash not only added brightness to the picture but also highlighted the iridescent sheen of the bird's head and neck.
MF 300mm, TTL flash set to -1.7ev, beanbag, Fuji Sensia 100

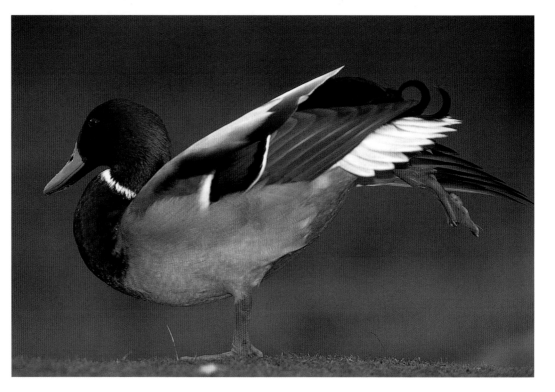

place less stress on the flash's foot where it couples with the camera hot-shoe.

With many species, hot-shoe mounted flash works well; not only is this more convenient than holding it off-camera, but alignment with the subject is assured. Do this with some animals, however, and eye-shine is guaranteed. Many mammal species and owls are especially prone to retinal reflection (the problem is worse in poor light), unless the flash is moved away from the axis of the camera and lens. The further the subject is from the camera, the further to the side the flash needs to be. While 0.5m is adequate when photographing squirrels 5m away, it becomes a stretch when an owl is 15m away. Alignment, especially with a Fresnel screen in place, then becomes crucial and sometimes a few test flashes are needed to check that the subject is catching the light.

TTL slave units

Using two or more TTL flashes in tandem once required lots of expensive cables and connectors, and it was not feasible to have them distant from the camera. The Ikelite Lite-Link TTL flash slave is a clever device which frees you from these limitations.

The Lite-Link is a little black box to which the second TTL flash is attached via a hot-shoe. It has two sensors, one which detects the start of the output from the parent unit and a second which recognises the decline of that output towards the end of a flash. This information is relayed at the speed of light to the mounted gun, telling it when to start and finish. At its simplest, the result is a mimic of the operation of the parent, whether that is set to provide fill light or full illumination. Yet the operation is a little more sophisticated than that.

The camera's TTL flash metering reads the accumulation of the blasts from the two guns and cuts off the parent when enough has been produced for a correct exposure. Hence, if the second unit is closer to the subject than the parent, it provides the main source of light. Nevertheless, the *combined* output of the two guns, since they are metered simultaneously, does not exceed the final total requirement.

What this means in practice is that a flash can be set, on the Lite-Link, at anything up to 60m from its parent flash, to illuminate a remote subject shot with a telephoto lens. Although the parent flash alone doesn't have enough power to provide adequate illumination at that distance, it triggers the remote flash; the camera's TTL flash meter then reads the *combined* output from the two and cuts off the parent and therefore the remote unit when there is enough on the subject. The number of flash units you can use is limited only by the number of Lite-Links you have, a boon if you need to use a bank of flashes for high-speed work.

Top tips

- Rear-curtain synchronisation, which features on many smart flashes, allows daylight and flash to be mixed to portray movement while retaining some sharpness in the picture. Using an exposure based on ambient light prevents the background from blacking out.
- Fresnel screens are devices which focus a flash's beam, concentrating its power (sometimes with an effective 3 stop gain in output) and increasing the range over which it can be used. They are designed to be used with telephotos.
- The easiest way to use two or more TTL flashes simultaneously, at anything up to 60m apart, is by way of a TTL slave such as Ikelite's Lite-Link. The combined output of all the flashes is measured, and the relative importance of each flash is determined by its distance from the subject.

KITTIWAKE AMONG THRIFT

Fill-flash helped to counter three problems in this picture: it lightened the shadows on the side of the bird facing the camera; the blue cast picked up from the sky behind me has been reduced; and the bird's eye has been animated with a catchlight. While the catchlight could not naturally have been there, because of the direction of the sun, it is a choice between this inaccuracy or a lifeless picture.
MF 300mm + x1.4 converter, TTL flash set to -1ev, Fuji Velvia

7 Techniques for Active Subjects

Getting close to wild creatures is one of the most exhilarating aspects of nature photography. While some allow an open approach, others are shy and require the photographer to find ways of crossing that invisible barrier known as the 'fear circle'.

OPPOSITE: RED DEER STAG, GLEN LYON, SCOTLAND

While many deer in the Highlands are extremely shy, in some places additional forage is provided by the estates to help them through the winter. One such location provided me with the opportunity to work from the roadside, out of my camper van.
AF 300mm, beanbag, Fuji Velvia

THERE ARE SEVERAL basic ways of getting close to wild creatures. The first involves finding those individuals or groups which have become habituated to people – or have never seen them before. You can work with these animals without fear of causing disturbance, so long as you read their behaviour with care and keep a respectful distance. Such creatures act as a veritable honey pot for travelling wildlife photographers, whose international itinerary may include the Masai Mara for leopards, Borneo for orang-utans, Baja for grey whales, Yellowstone for buffalo, South Georgia for king penguins – the list goes on. But if you are unenthusiastic about having to compete for tripod space and want to focus on your home area, the chances are that your local wildlife subjects will prove more shy and elusive.

A long telephoto (400mm plus) is not the answer. While long lenses can help, they are no substitute for proximity to your subject. There are also the practical considerations of carrying and supporting extremely long optics (800mm+), and the prospect of a loss of image quality caused by shooting through a lot of air, especially if conditions are dusty or humid. Add to that their sheer expense. For years, my only long lens was a 300mm f2.8 with x1.4 converter, and today this combination remains my first choice. The addition of a 500mm opened up a few more possibilities, but I still need to be near to the creature, especially for portraits.

DUNLIN, INVERNAVER, SCOTLAND

This dunlin belongs to the *arctica* subspecies and probably hadn't seen a person all summer until it landed on a remote Sutherland beach in early autumn and met me. It proved to be unusually approachable and allowed me to crawl to within 8m.
MF 300mm + x2 converter, camera and lens resting on the sand, Kodachrome 200

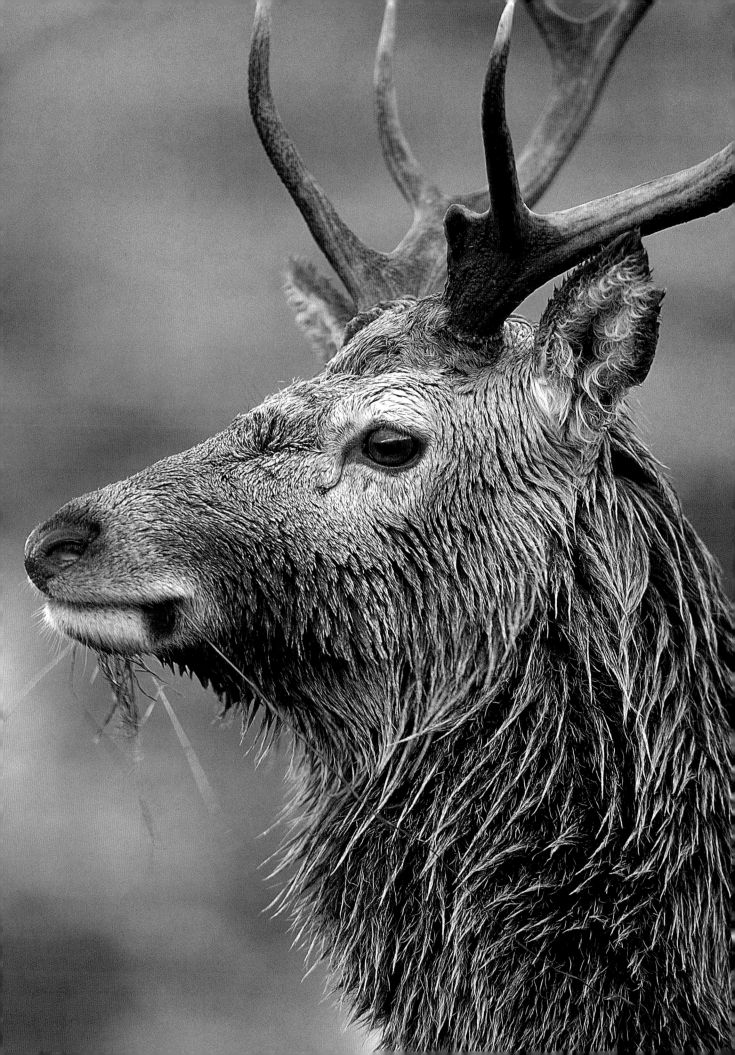

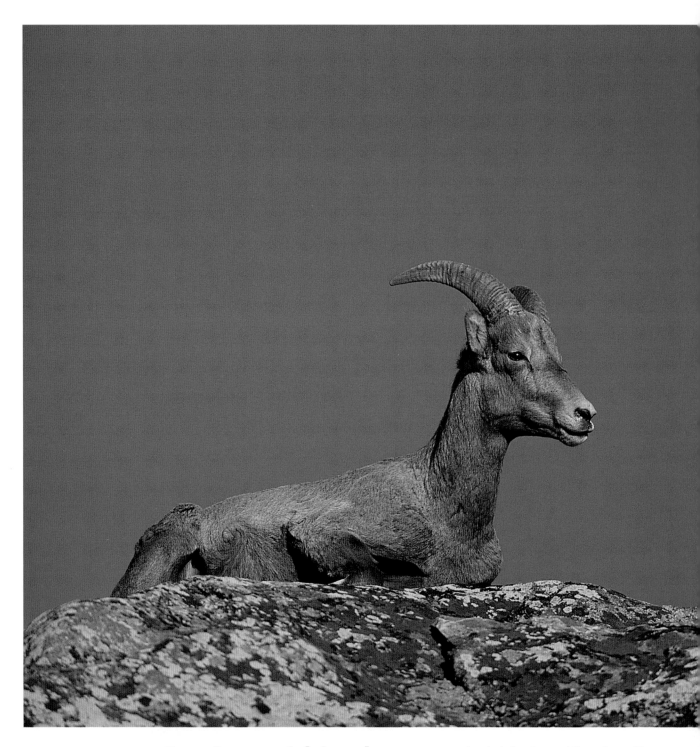

Getting within the fear circle

Most animals move within their own 'fear circle' – remain outside its boundaries and they are unconcerned. But as soon as you approach the perimeter, the subject becomes alert and prepares to take flight. How big is a fear circle? That depends upon a host of factors: the species involved; the individual animal's tolerance; your method of approach; wind direction and time of year. There are no absolute rules. Be assured, however, that the radius of the circle is almost always too wide to be bridged by your longest lens. If you want a frame-filling portrait, you are going to have to find a way of getting within the circle without being detected.

Stalking

Stalking is part hunting, part photography. If hours on end cooped up in a hide don't appeal, then this approach may be for you. A successful stalk,

Stalking is all about being mobile while remaining unobtrusive. It is almost impossible to approach shy subjects with your camera and lens mounted on a tripod. Where circumstances permit, I swap the tripod for a beanbag and, having determined wind direction, plan my approach around the rests I can find. For obvious reasons, any fabric which rustles is unsuitable; jackets and trousers made from wool mixes (such as Loden cloth) or cotton are *de rigeur*. I look back in embarrassment to the days when I went stalking in full camouflage. It may have hidden me from other people, but considering that wild mammals use so many clues other than sight to detect predators, it is not surprising that it made little difference to my success. Nowadays I wear clothes whose natural colours blend with the environment, just as the animals do.

Stalking involves meeting the conflicting demands of remaining hidden while keeping an eye on the subject's body language. Many of us are guilty of rushing a stalk; in some sorts of terrain it can take, literally, hours. Having eventually slithered within camera range and eased the lens onto the beanbag, uncovered hands (especially if you have white skin) immediately signal your arrival to the subject. Thin, tight-fitting gloves reduce this risk without too much loss of dexterity.

This covert approach is not always necessary. Indeed, if you try it with a group of bighorn sheep in Yellowstone, they will become very suspicious and fleet-foot it further up the hill. Where wild animals are more tolerant, it is better to remain in the open, to approach from down slope (any mountain animal can move faster up slope than we can and they know it), avoid eye contact (that includes the 'eye' of your telephoto) and gradually zigzag towards them. On the occasions that I have worked with wild goats in

WILD GOAT AND KID, TOMATIN, SCOTLAND

I approached a group of wild nanny goats with young kids in the Monadhliath Mountains from down slope and, over a period of time, gradually narrowed the distance between us. They were deeply suspicious for the first hour, but all of a sudden seemed to drop their guard. Nevertheless, I continued to move cautiously; I don't think that this nanny quite trusted me. *MF 300mm + x1.4 converter, beanbag, Kodak Panther 100x (Lumière)*

LEFT: YOUNG BIGHORN SHEEP, YELLOWSTONE NATIONAL PARK, USA

We spotted a party of bighorns on a ridge about 1km from the roadside. Since there was no prospect of a covert approach by the party of photographers I was with, we approached openly and quietly, taking care to avoid our scent being blown towards the animals. The sheep repaid our respect by staying put. Shooting from a low angle introduced a rich blue part of the sky as backdrop. *AF 300mm + x1.4 converter, Fuji Velvia*

experience teaches, is more testament to the tolerance and curiosity of the subject than the stealth of the photographer. Many mammals have a very keen sense of smell. Most diurnal birds can see extremely well. Consider, too, that even mammals which hunt by stalking live prey tend to have a pretty low success rate, often targeting weak or old animals (not the alert ones we want to photograph). The only thing we can count in our favour is the fact that we need not get quite so close, although we do need an uninterrupted view of our quarry.

51

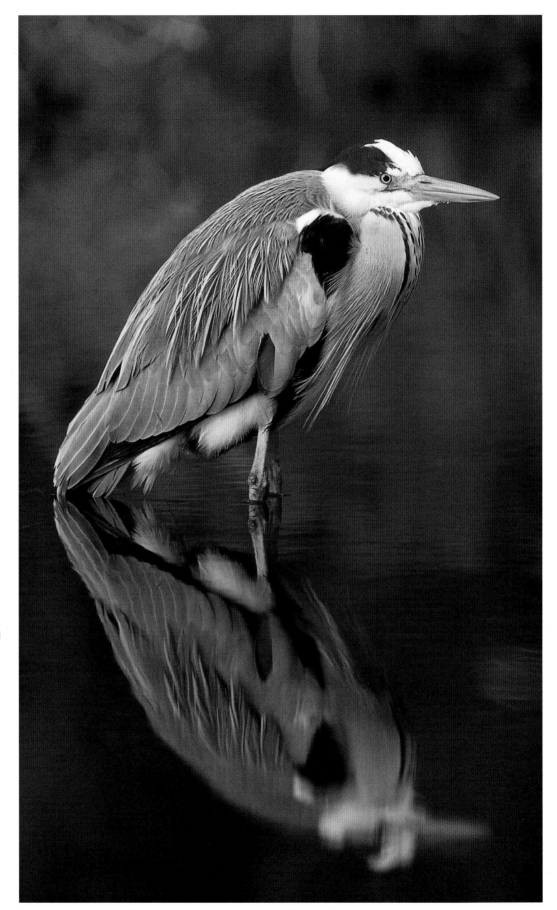

GREY HERON REFLECTION

I discovered a small pond near home used by some grey herons as a 'loafing ground'. Once I was sure that they were there on a daily basis, I sought the permission of the farmer who owned the pond to build a wooden hide into the bank beside it. The solid construction of the hide, along with its low profile, meant that it was accepted the day after it was installed.
MF 300mm + x1.4 converter, Kodak Panther 100x (Lumière)

Scotland, I made soft, reassuring noises which seemed either to calm them or to arouse their curiousity.

Wind direction is a crucial consideration when stalking mammals, since even short-sighted ones such as otters can pick up an airborne warning from a long way off. We need to be aware, too, how wind direction can be changed by cliffs and gullies and in woodlands, where unexpected eddies can thwart a successful stalk at the last minute.

Hides/blinds

Fixed hides are fine if you put them in the right place. Determining just where that should be requires much observation and forethought. Display grounds, roost sites and drinking pools all offer the possibility of regular visits. Alternatively, you can bring the subjects to where you want by providing food or, in dry climates, water. Either way, hides offer the best prospect of spending time with wild creatures within their fear circle.

Hides can be made from local materials, incorporating a waterproof sheet to keep the inside dry. They should be dense enough for you to move around inside without being detected. It is only worth going to the trouble of making one once you are sure that subjects will show regularly. There are a number of well designed hides on the market which use shock-corded poles to hold the fabric taut, along the lines of modern tents. These can be set up and taken down in minutes and are ideal for shorter projects. Make sure that the one you choose has a slot at the front for a tripod leg to poke out; this will give you more room inside. I use this type when the subject is likely to be more than 1.5m above the ground. Otherwise, I opt for my amphibious hide.

I have built this hide around two parallel blocks of polystyrene, approximately 120cm long by 30cm wide by 18cm deep. These blocks are slotted into a wooden frame hinged on the underside, so that when I sit in the gap astride the hide's sling seat to

DISPLAYING MALE EIDER

My amphibious hide allowed me to join a raft of eider ducks engaged in courtship displays on a local estuary. With activity on all sides, I was glad to be able to manoeuvre the hide with ease, following the action through an angle finder and leaving focusing to the camera and lens. Although it was a bright day, I was working with the hide unstabilised in open water, so I uprated my 100 ISO film to 200 ISO, allowing me to shoot at faster than 1/1000 second.

AF 500mm, amphibious hide, angle finder, beanbag, Fuji Sensia 100 rated at 200 ISO

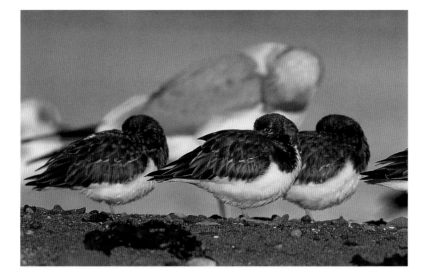

TURNSTONES

Having taken the amphibious hide out onto the mudflats some hours before high tide, I waited for the water to float it and then gradually moved towards the birds on a shingle bank. Once in position, I waited again for the water to drop until the hide became steady. The roosting birds showed little interest when I edged the hide back into the water.
MF 300mm + x1.4 converter, beanbag, Fuji Sensia 100

paddle the hide, the frame is held flat. Rubber chest waders (or neoprene for winter work) are essential in all but the warmest waters. Plastic pipes crossing from diagonal corners support a waterproof nylon cover. Even with a total weight of about 25kg, the hide can easily be carried by the rope handles inside.

The camera and lens are supported on a beanbag, itself resting on the frame of the hide. Since the lens is quite close to water level (about 20cm above), an angle finder is needed on the camera if the waders are not to flood. Autofocus cameras and lenses come into their own in this mobile hide, making it much easier to track swimming subjects while maintaining a composition.

The hide is very buoyant (even with me on board, it can float in 5cm of water), and with its low centre of gravity it is very hard to tip and almost impossible to fall out of. The main limitation of this type of hide is that the photographer must not work out of his or her depth; paddling through open water in an upright position is very inefficient, and without contact with solid ground the hide is extremely hard to manoeuvre.

The amphibious hide works simply because most wild creatures expect a human threat to come from the land, not from the water. If the hide appears to them from the water, they are usually unperturbed.

At a wader roost on a tidal estuary, I take the hide onto the mud about three hours before high tide, when there are few birds about. As the tide rises, the hide begins to float and gradually I paddle it towards the gathering birds. If the light is very bright and the weather calm, it is possible to shoot in open water, using at least ⅟₈₀₀ second to stop the action of the hide as it moves in the water. Four legs with large platform feet stabilise the hide in water up to 20cm deep – these can be

raised and lowered from inside. In all but the best light, I move the hide to a position close to my subjects, so that when the tide drops it will be grounded on a gravel bar from where I can shoot with absolute stability. Some birds even allow me to edge the hide towards them after it has grounded, but more importantly, most are undisturbed by a retreat to the water, which means that I can move over to another group.

On land, the response is similar to that produced by any other hide, although the low profile and taut fabric of this design mean that it is less conspicuous. For prolonged use on land I dig a hole for my legs, which generally makes the stay more comfortable.

Getting close to a subject, even swimming with it, is very exciting, but floating hides are potentially dangerous – especially in tidal estuaries – and care should be exercised. It is important to know the depth of water which is likely to cover the mudflats and if there will be a piece of dry land to which you can easily escape. My golden rule is never to work out of my depth. This is not as restricting as it sounds, as the majority of birds in estuaries are found on the mud or in shallow water. Remember that chest waders can be extremely dangerous if they fill with water; I carry a knife with which to slit them open should this happen. It is sensible to wear a lifejacket, although this is not always practical in the confined space of the hide. It is also a good idea to carry a grappling hook and long rope, should you get stuck among vegetation and need to pull the hide free.

Using your vehicle as a hide

Many wild creatures are attracted to roadsides. Red grouse come to take fine grit, used in their gizzards to aid digestion; pheasants and pigeons are drawn by grain spilled from passing trucks; and vultures, buzzards and crows feed on road kills. Snakes enjoy basking here, and many animals use roads as corridors.

Shooting from your vehicle combines the advantages of mobility with concealment; most creatures are less wary of a car than a human shape. It is best to keep the interior of the vehicle as dark as

Taking photographs out of a van, using a beanbag and home-made window mount.

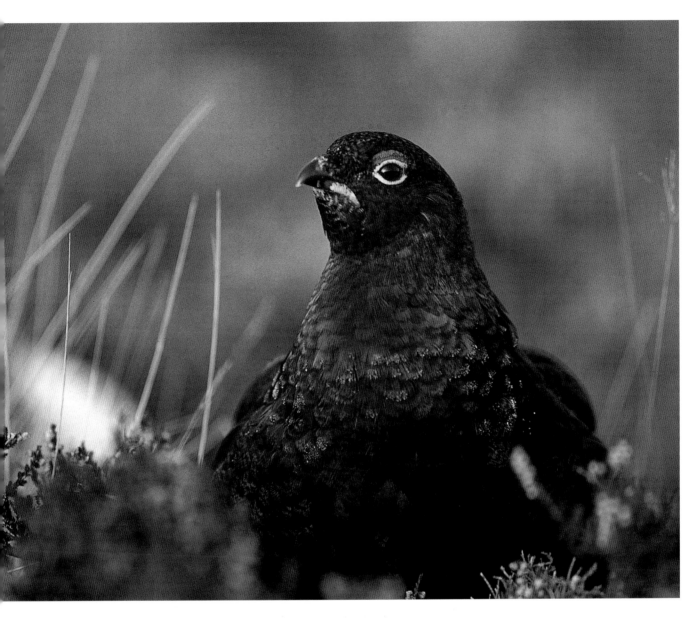

possible so that your outline is not visible. I seek out quiet roads with banks, which bring the subject closer to camera level. There are many supports on the market which allow you to shoot from a vehicle. Most clamp, jam or stick to the side window and sill. However, any design which relies upon the window for support is flawed, simply because car windows are not designed to take this sort of loading and aren't rigid enough. It is much better to make a wooden tray which clamps snuggly over the sill when the window is wound right down, and place a beanbag on top to support camera and lens. If you are concerned about your car's paintwork, line the inner surfaces of the clamping blocks with butyl rubber, which is thin but very strong.

A vehicle makes for a more comfortable working environment than a hide in winter, but beware: that lovely warmth from the fan heater sets up a shimmer where it meets the cold air outside, and if you try to photograph through this layer, image quality suffers; it is therefore important to ensure that the end of the lens is beyond it. Windy days also cause problems by rocking the vehicle around. The engine, of course, always needs to be switched off if your image is not to be ruined by vibration.

Top tips
- Most animals have a 'fear circle' around themselves; as soon as an unconcealed photographer crosses its perimeter, they are inclined to take flight. Normally you need to be within the fear circle in order to take frame-filling photos.
- With care, an inquisitive subject can be stalked to within camera range. The success rate of stalking is often poor, but the photographs can have a distinctive, uncontrived look to them.

RED GROUSE
This unusually aggressive young male red grouse was guarding a roadside territory in a local glen, fending off anything and anyone who entered. For once I remained in the car, not to avoid detection but so as to avoid injury.
MF 300mm, beanbag, Fuji 50

55

Using a 300mm on a ball head.

Using a 500mm on a fluid head.

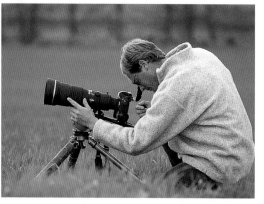

- Hides make it possible to spend time in the fear circle, but it is only worth using a fixed one once you are confident that subjects will appear, either because they habitually use that location or because food or water has been used to bait them in.
- Amphibious hides and vehicles combine concealment for the photographer with mobility. When used in the water, an amphibious hide provides a low, intimate perspective and often narrows the distance between photographer and subject better than a land-based one.

Techniques for sharp pictures

Long lenses only give of their best when they are handled skilfully. Keeping them steady is no easy task, and what you may think is disappointing optical performance may actually be shake caused by poor technique or an inadequate tripod and head.

Uprating film

Action photography demands faster shutter speeds than still-life work; that much is obvious. But getting a fast enough shutter speed is often the problem. Not only is there subject movement to contend with, but long lenses magnify even the slightest camera shake,

and achieving sharp focus is difficult at full aperture as you try to gain the speed to stop this movement.

In the past, uprating films by 1 stop (50 ISO to 100 ISO, 100 ISO to 200 ISO and so on) was regarded as a last resort in the face of failing light. Modern emulsions, however, can be uprated very successfully with a scarcely perceptible loss of quality. Indeed, some 100 ISO films uprated by 1 stop are superior to the standard 200 ISO version. In poor light I prefer to use uprated Fuji Velvia to Fuji Sensia 100, since it delivers more punchy colours and contrast. And I don't reserve uprating just for dull days. For instance, you can never have too much speed for stopping birds in flight, and uprating a 100 ISO film on a sunny day also allows for the use of smaller apertures.

It is essential, as I know to my cost, to be methodical in handling uprated films so that your processing lab can identify them. Since my cameras' meters are calibrated to the nominal film speed, I leave the ISO dial set to DX most of the time. When I uprate, I place a green self-adhesive dot over part of the DX code on the film canister. This way, if I forget to reset the ISO dial to the speed I want, I'm alerted to the fact by the camera. Another dot goes on the back of the camera to remind me to reset to DX once I've finished with uprated film. Before going to the lab, both film cassette and canister are labelled to indicate that the film is uprated, and by how much.

Using a tripod

In Chapter 2, I expressed a preference for supporting the camera and long lens on a beanbag whenever I can. Often, however, there is not a suitable rest at the right height, and there is no option but to use a tripod. Camera shake can be minimised by extending the tripod as little as possible and leaving the central column (if it has one) unextended. Spikes attached to the tripod leg ends make it much more stable, especially on soft ground, but once in the ground they discourage you from moving from that spot. Strong winds buffet tripod and lens around, so if you are not shooting into the sun, remove the lens hood to reduce the surface area exposed to the wind.

Handling methods

There is a divergence of opinion between those photographers who, for their long lenses, favour a 'hands-on-ball-head' method of handling and those who prefer the 'hands-off-fluid-head' one. Holding on to the camera during exposure and panning on a ball head works fine at speeds greater than $\frac{1}{125}$ second, especially since a hand helps to dampen camera movement caused by mirror slap. But at slower speeds even a small amount of hand movement, such as triggering the shutter, reduces sharpness, especially with lenses longer than 300mm.

Having experimented with many different systems, I now use one which allows me to shoot action smoothly and sharply, even at quite slow shutter speeds. I favour the 'hands-off' method, starting the autofocus and triggering the shutter by electric release. I use a Gitzo video head, the G1380, whose smooth action is achieved by springs rather than hydraulic fluid. Once it is levelled in its 75mm bowl, I can pan without making horizontal readjustments. In common with fluid heads, this model is self-righting; when the lens is tilted up or down, it returns to the horizontal when pressure on the bar is released. The bar itself is crucial to the success of this set-up because it can be revolved to jam under the camera, providing a second point of support. To switch to vertical format, I simply slacken the lens's tripod collar, loosen the bar and turn the camera. Working with an AF lens with focus lock buttons on the barrel, the whole process of panning, placing focus brackets and then, if necessary, recomposing, becomes effortless, allowing me to concentrate on the image. For low-level work, an angle finder contributes to the ease of use. Since angle finders can be revolved, they are better than the 'waist-level' finders available for some professional models; flip a camera with one of these on its side and you'll find it hard to see the image. This set-up is similar to that used by movie cameramen.

Top tips

- Good handling technique is essential to get the best results from long lenses, especially when fitted with teleconverters. While autofocus solves some problems, it is essential to support the lens properly, even at moderately fast shutter speeds ($\frac{1}{125}$ second).
- Modern films can be uprated to obtain faster shutter speeds. With most films, unacceptable grain, contrast and colour casts appear if they are uprated by more than 1 stop.
- If the camera and lens cannot be supported on a beanbag (due to a lack of suitable rests), the tripod should be extended as little as possible to maintain a low centre of gravity. Stability can be improved by fitting its leg-ends with spikes (which limit your movement) or ballasting the tripod with your camera bag.
- Long lenses attach, via their tripod collar, to the tripod head, leaving the camera hanging in the air behind. If you can support the camera, too, perhaps by fitting a brace between it and the head, stability will improve.
- At slow speeds, when there is a risk of unsharpness anyway through subject movement, the risk of that being caused by camera and lens movement can be reduced if the camera is triggered by an electric release.

OVERLEAF: OTTER ON EDGE OF ICE, OTTER PARK AQUALUTRA, LEEUWARDEN, THE NETHERLANDS [C]

At this captive breeding centre I had the chance to work more closely with the animals than I'd ever had in the wild. Low temperatures had frozen parts of the otters' large pond, so I went out onto the ice and set the tripod with fluid head as low as possible. Autofocus allowed me to follow some of their energetic behaviour. *AF 300mm, Fuji Velvia rated at 100 ISO*

GANNET IN FLIGHT, BASS ROCK, SCOTLAND

Getting close to gannets on the Bass Rock is not a problem; they nest right up to the side of the path. Catching them in flight and separating one from the hundreds of others in the air is another matter. When the opportunity arises, rapid reaction is called for; autofocus saves time and helps to secure the shot. *AF 300mm, Fuji Sensia 100*

8 Techniques for Inactive Subjects

Don't imagine that just because your subject can't flee, it will make for an easy picture. It is precisely because close-up work offers such opportunity for control that it is so challenging. Knowing how best to exercise that control is the key to success.

OPPOSITE: BOLETUS
This looks too good to be true, and indeed I assumed that someone had set the mushroom among the *Polytrichum* moss when I first saw it. But it is genuine, providing a fine example of the contrasting textures, colours and lines which make for an eye-catching picture.
MF 90mm, Fuji Velvia

IN CLOSE-UP photography, the success or failure of a picture is directly related to the choices you make. This is not the case in action photography, however, where chance plays a larger part. Close-up work is a slow, absorbing discipline. Where are the best conjunctions of colours, the most contrasting textures or dynamic lines?

Controlling the light

As a general rule, direct sunlight is bad news for close-up work, as the very details you want to portray disappear in a mosaic of shadow and highlight. Slide film can record only a narrow tonal range, so the light often needs to be diffused. While simply casting a shadow over the subject does this, the light is then often too flat, and brightness disappears. The closer the shade is to the subject, the more pronounced the effect. A better option is to modify the light by using a sheet of opaque plastic. This preserves the brilliant quality of sunlight, but lightens shadows and suppresses highlights. The old mattress protector I use lifts shadows by about 2 stops while taking about 1 stop off the highlights. The degree of diffusion is altered simply by having the sheet folded single or double. These sheets, as they age, become warm in tone – the effect of mine is the equivalent of using an 81a filter. Unlike a solid shade,

SEA SANDWORT
Direct sunlight is normally unsuitable for close-up work, where the intention is to render as much detail as possible. To achieve a greater degree of detail in the picture on the left, I used the diffuser sheet folded double (the sunlight was very bright), holding it about 40cm from the plant.
MF 90mm, diffuser sheet, Fuji Velvia

the closer the material is placed to the subject, the brighter the illumination but the darker the shadows. Since the effect is visible, you can easily judge the best position for the diffuser. Attempting to fill shadows caused by direct sunlight with reflectors or even flash is a poor alternative since neither affects highlights, which still burn out.

Reflectors come into their own when the subject is backlit. Although fill-flash is fine for active subjects, it lacks subtlety. A reflector positioned at just the right distance is better. Place it too close, however, and shadows are over-lit; too far, and the effect is negligible. Silvered reflectors add a sparkle and are especially useful when sunlight is weak. Gold ones are most suitable for warm-toned subjects. In full sun, I find that a plain white reflector is best. Incidentally, don't overlook the usefulness of reflector boards for holding down vegetation around the subject without destroying it.

NORTHERN MARSH ORCHID

Soft, overcast lighting produces low contrast, but sometimes it can be just too subtle. Here I sought to increase it without losing shadow detail, by employing a long lens to pull in a distant, dark background. A silver reflector was then introduced just 30cm from the plant, in order to add some brightness.
AF 300mm + 52.5mm extension tube, beanbag, Fuji Velvia

Lighting close-ups is easy on an overcast day when clouds act as a giant diffuser. But if that diffuser is too thick, the image lacks brightness and any surface not angled upwards is cast into shadow. On a heavily overcast day, colours are rendered dull and flat. Brightness can be reintroduced into a close-up without overwhelming the delicate quality of the light

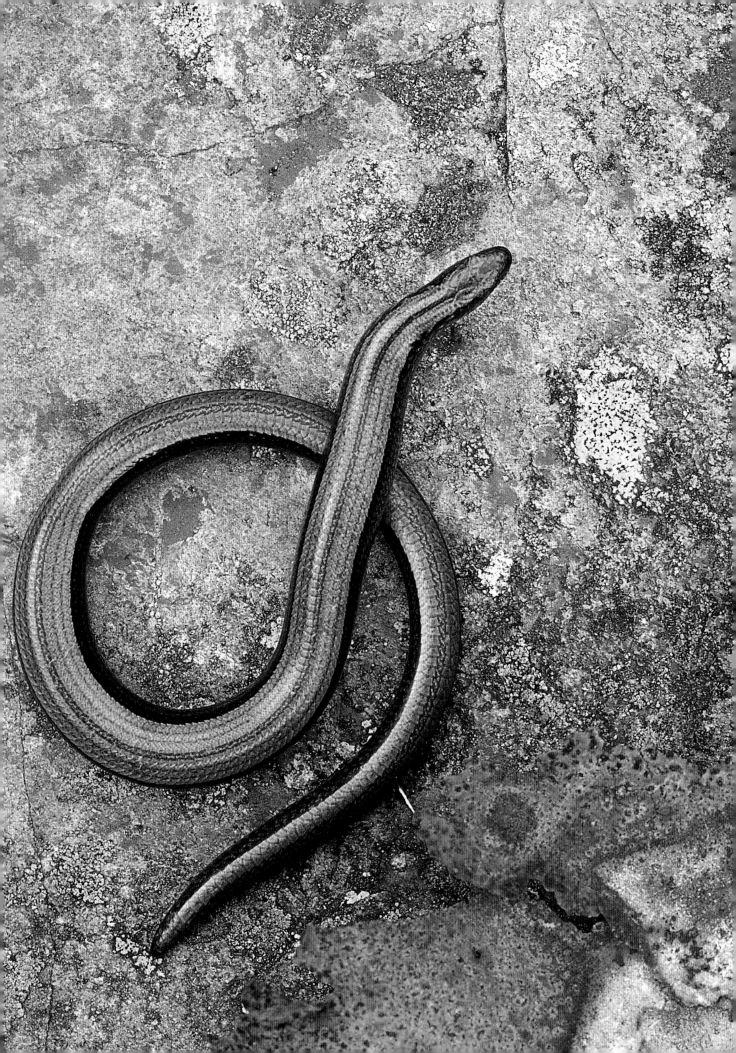

STINKHORN

The combination of a heavily overcast sky with the shade along the woodland edge meant lifeless lighting for this fungus. With a diffuser sheet in position, about 30cm to the left of the stinkhorn, I took a daylight meter reading to provide good exposure for the highlights in the picture on the right. Brightness was added by firing a single flash through the diffuser sheet from 1m away.
AF 180mm + 52.5mm extension tube, angle finder, beanbag, Fuji Velvia

by using fill-flash through a diffuser. Holding the sheet close to the subject, take a daylight meter reading. This forms the basis of the exposure; flash is only a supplement. Set on TTL, the flash's output is then dialled back to -1.7ev for a mid-toned subject (see Chapter 6 for more specific information on compensation for light and dark subjects). For best results, the flash must be positioned at least twice as far from the sheet as the sheet is from the subject. The further back it is held, the softer the lighting effect. Just don't go too far or the sparkle is lost.

Achieving magnification

There are several ways to achieve magnification for close-up photography. The most popular and convenient with fixed focal lengths is by extension. Macro lenses have extension already built in; a 105mm lens capable of focusing up to 1:2 – a subject 20mm long will occupy 10mm on the piece of film – uses 52.5mm of internal extension. Tubes on non-macro lenses do the same job but may result in the loss of some of the automatic functions. Old, manual-focus lenses are generally more straightforward in this respect.

Whenever extension is added, light is lost. The new effective aperture (as opposed to the one shown on the lens) is calculated by dividing the length of the extension (resulting from a tube and/or internal

extension) by the focal length of the lens, to give the extension factor value. This value is then introduced into the equation $f = f(1+ef)$, where the second f is the f stop indicated on the lens. Taking the example of a 60mm f2.8 macro lens racked all the way out to 1:1:

$$\frac{60 \text{ mm extension}}{60\text{mm focal length}}$$

Extension factor = 1 (extension factor equates to magnification)

Effective aperture = 2.8 x (1 + 1) = 5.6

This information is relevant only if you plan to take readings with a hand-held light meter and need to know how much compensation for extension is needed. But it should also highlight the attractiveness of macro telephotos which use internal focusing rather than extension to alter magnification. With these, a group of elements is moved backwards and forwards to achieve focus, rather than the lens changing its physical length through extension. They therefore do not cause light loss.

Bellows work on the same principle as extension tubes, and offer greater magnification but are very awkward to use in the field. In practice, rarely do subjects or conditions permit you to shoot at greater than life size. There are other complications, too, once you enter the macro world. Most lenses are designed on the assumption that the distance from

PREVIOUS PAGE: SLOW-WORM [C]

Few animals, ourselves included, enjoy having a camera thrust in their face. Although this female slow-worm (a type of lizard, lacking legs) may have allowed a closer approach, I opted for my usual 'from above' lens for close-up work, the 90mm, for a more comfortable working distance – for both of us.

64 *MF 90mm, Fuji Velvia*

the subject to the lens will be greater than between the lens and the film plane. But as magnification passes 1:1, this is no longer the case. Fitting a normal lens back-to-front, with the appropriate connectors to maintain automatic function, is an easy way to get lots of magnification without loss of optical quality. You will, however, be hampered by a very short working distance. If you decide you need a set of bellows, make sure that the lens can be reverse-mounted easily.

The second main problem concerns light diffraction. There is a temptation at 1:1, when depth of field is tiny, to stop all the way down to f22 or f32 to maximise what little there is. But when light passes through such a small aperture it spills around the edges of the iris blades in a way which causes a noticeable loss of sharpness. The more extension there is between the iris and film, the worse the problem becomes, as the iris becomes ever smaller in relation to the film. That is why it is always best to rack a lens out as far as it can go before adding extension, then use as little as you can get away with. Remember, too, that an indicated aperture of f11 is actually f22 when the lens is extended to 1:1. In practice, if you are working around life size, maintain sharpness by stopping down no further than f11.

Many of the problems associated with extension can be avoided by using screw-in dioptre lenses, sometimes inaccurately referred to as close-up filters. Indeed, they are the most practical devices to gain magnification with zooms, though rarely to the same degree as is possible with extension tubes on fixed focal lengths. They cause no light loss, nor do they change the effective aperture of the lens. With a dioptre fitted, the maximum working distance of different focal lengths becomes the same. With a +1, that is 1m, with a +2, 0.5m and so on. This gives an advantage to telephotos, but in practice most dioptre lenses are designed for use with a 50mm lens. Some manufacturers offer specially corrected dioptres for focal lengths up to 200mm – at a cost. Buy only the best-quality dioptre lenses if you want to go down this road because the price for their convenience is optical degradation.

Creating working space

Close-up work divides neatly into two categories: that done from the side and that done from above. Either way, you need space to introduce reflectors and diffusers. If you are photographing something delicate such as a spider's web or frost crystals, you do not want to be so close that your breath moves it

LICHEN

When the light is poor and conditions stormy, I look for subjects which won't run away or blow about. They don't come much steadier than lichens. In order that I could fill the whole frame with this small one, I racked out my 90mm macro lens as far as it would go and then added only as much extension as I needed. I stopped down to f11; since the subject is life size on film, a smaller aperture would have caused a loss of image quality through the effects of diffraction.
MF 90mm + 52.5mm extension tube, Fuji Velvia

EARLY PURPLE ORCHIDS

When I came across these orchids, I was struck not only by the fortuitous arrangement of the three stems but also by the sharp colour contrast between the green of the fresh grass and the magenta of the flowers. A low viewpoint rendered the foreground out of focus and a long lens emphasised the soft background.
AF 300mm + 52.5mm extension tube, beanbag, Fuji Velvia

or melts them. You also need space to use a tripod without knocking over the subject. Frankly, a 50mm macro lens is more trouble than it's worth.

For 'above' shots, I find a 90mm lens ideal, giving enough working space without having to extend the tripod too far for larger subjects. There is rather more choice for side shots. The object here is normally to render a completely diffused background, something which becomes easier as focal length increases (see Chapter 9). My first choice is a 300mm on a 52.5mm extension tube. This lets me fill the frame with a subject 15cm in height. If I need more magnification, I change to a 180mm and fit it with a 52.5mm tube. Both these lenses feature internal focusing so that the light lost through extension is minimised.

Techniques for sharp pictures

In close-up work, subject, rather than camera, movement is often the most difficult technical problem to overcome. Nevertheless, working at high magnification with long exposures also demands careful attention to your photographic technique.

Achieving camera stability

You may not be able to prevent your subject from swaying in a breeze, but you do have complete control over the stability of camera and lens. This is relatively easy with short lenses, but a 300mm lens on a big extension tube is another matter. If circumstances permit, I set the camera and lens on a beanbag, which provides front-to-back support. This is especially important during long exposures. Failing that, ballast the tripod with your camera pack or beanbag. For low-level work, the tripod's legs should be able to spread so that it lies flat on the ground; models with central columns are therefore not recommended unless they can be detached. Don't be tempted to suspend your camera from underneath the tripod; not only is it hard to work upside down but, more importantly, the camera receives no support. The load is most efficiently supported at the apex of the tripod and not hung off to one side. Angled, 10cm-long spiked feet greatly increase the efficiency of mass coupling to the ground, but a spiked tripod takes a while to get into exactly the right position. Only once the exposure is set and the photograph framed and focused should all the controls be locked.

Camera movement resulting from mirror slap (caused when the mirror in a reflex camera jumps clear the moment before the shutter blinds open) is less common on modern cameras but can nevertheless cause problems when a long telephoto is fitted. The problem is worst at speeds between $\frac{1}{15}$ second and 1 second, so if your camera has a mirror lock, use it. You can mitigate the effects by laying a beanbag along the top of the lens and camera.

Having gone to all this trouble, don't spoil your effort by triggering the camera by hand. A mechanical release is all right (if your camera has a socket for one) but an electric release, which causes no physical movement at all, is even better. Furthermore, when you trip the shutter, wait a few seconds between each exposure or a momentum builds up which starts to shake the camera.

Preventing subject movement

Stopping subject movement is altogether more difficult. Some small, upright plants can be staked with a knitting needle stuck into the soil at their side, just out of frame. The subject is then loosely secured

SYCAMORE LEAVES

To stabilise this attractive but highly mobile branch, I extended a tripod and taped the branch lightly to it, just out of frame. A long lens, with its narrow field of view, helped to ensure that the background was an even black. Had I used a shorter lens, its wider field would have included distracting dappling.
AF 180mm + 52.5mm extension tube, Fuji Velvia

to it by tape or Velcro®. Don't make this too tight or the plant will be damaged, and cut away the tape afterwards. A similar procedure, this time using an extended tripod (ideally *with* a central column) works well on taller subjects such as branches.

Sometimes it is best just to go with the weather. If there is a light breeze, the shelter provided by trees may allow you to work in a forest. On stormy days, you may have no option but to concentrate on ground-hugging, essentially immobile species such as mosses and lichens.

Handy equipment for close-up work

Once magnification approaches 1:1, focusing becomes tricky, and simply racking the lens in and out has little apparent effect. A focusing rail, which allows the camera to be moved by tiny increments,

helps, but ensure that it can accommodate a lens mounted via a tripod collar; the camera's motordrive may get in the way. Though lacking the precision of a focusing rail, a similar effect can be achieved with some of Gitzo's larger tripod heads (such as the G1570) simply by slackening the camera screw a little and shifting the camera along the channel until the point of focus is reached.

If you do a lot of low-level work (or if you like pointing the camera upwards), an angle finder makes the job more comfortable. Although some professional camera bodies can take a waist-level finder, these are of limited use since the camera cannot be used in the vertical format. An angle finder which screws into the normal viewfinder, on the other hand, revolves, so either format is possible.

Reversing a lens used to bring with it the inconvenience of manual stop-down. If you plan to use a reversed lens a lot, it would be advisable to buy into a system which offers an electronic coupling from the end of the lens to the camera's hot-shoe. This restores most of the functions.

Loss of light is significant at high magnification; a small mirror is useful for concentrating a beam of light onto the subject. This intense light is best diffused.

OVERLEAF: DREISH, GLEN PROSEN, SCOTLAND

Seeing how the day was shaping up, I set off after lunch to climb the 947m mountain, confident of a good sunset. The comparative lightness of 35mm gear speeded the ascent. At the end of the day, the light changed by the minute but, unencumbered by a big camera, I was able to move quickly around the summit, making a number of compositions before the sun fell below the horizon.
MF 20mm, -2 stop graduated ND filter (hard step), Fuji Velvia

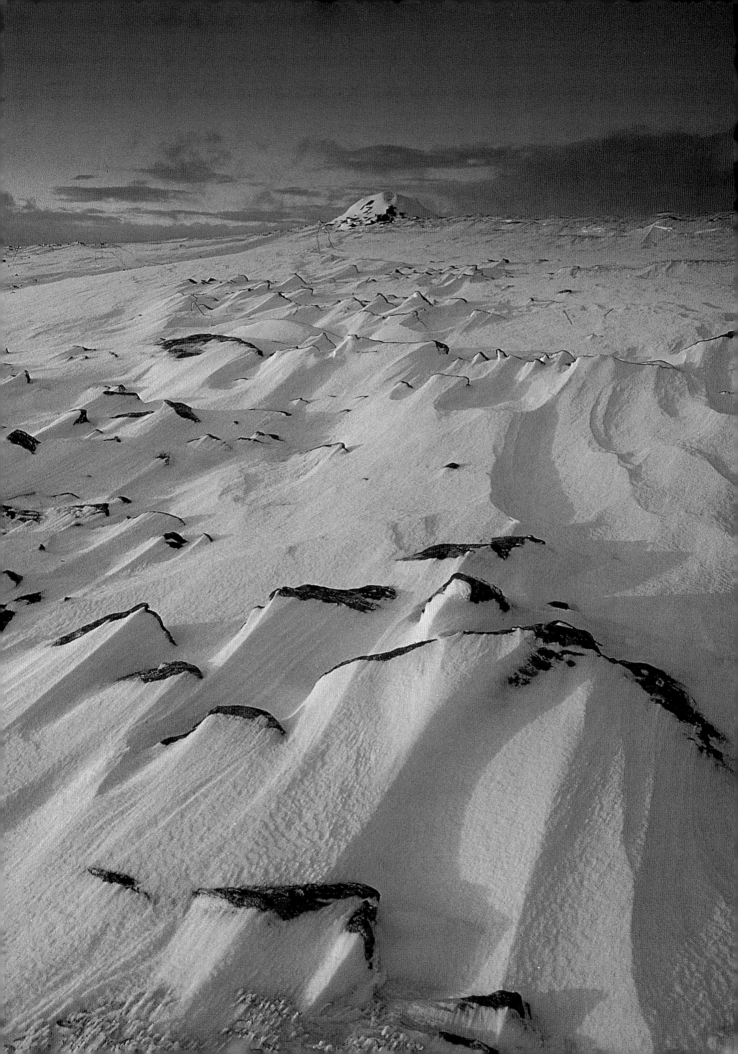

LASSITHI PLATEAU, CRETE

The car park for the Dikteon Cave gives a good vantage point over the unexpectedly lush Lassithi Plateau in eastern Crete. A 420mm lens allowed me to pick out those elements in the landscape which interested me most – the shades of green. In some larger formats, it is difficult or impossible to match the long focal lengths (and the perspective) available to the 35mm user.

MF 300mm + x1.4 converter (= 420mm), beanbag, Fuji Velvia

Top tips

- Contrasty sunlight hides many of the details we wish to show in close-up photographs. A diffusion sheet softens the light, bringing shadows and highlights into a range which film can record.
- Extremely dull lighting can be brightened up by mixing daylight and flash through a diffuser sheet. Done this way, a natural look is retained.
- The easiest way to make a fixed focal-length lens focus closer is to insert an extension tube between it and the camera. This method is unsuitable for zooms, and screw-in dioptre lenses are a better way to gain magnification with them. Macro lenses which use internal focusing do not suffer the light loss associated with adding extension to ordinary lenses.
- Always use as little extension as possible and focus the lens to its closest point instead.
- For high-magnification work, where the subject appears life size or greater on the film, preserve image sharpness by stopping down no smaller than f16, as read on the lens. Diffraction becomes acute at smaller apertures.
- Short focal-length macro lenses (or normal lenses on extension tubes) do not allow enough working space. Something in excess of 90mm is preferable.
- While it is relatively easy to keep the camera and lens steady, stopping subject movement is harder. Choose a subject to suit the day.

Shooting Landscapes

Landscape photography has many parallels with still-life and close-up work, and demands the same degree of care with regard to composition and the use of colour, texture and pattern. But unlike these other fields, the photographer lacks control over the light. And that's where the parallels with action photography begin.

I sometimes wonder if landscape shouldn't be classified as action photography. If you have done much work at dawn and dusk, you will know just how active the photographer becomes as the light changes from minute to minute. In technical terms, the approach is similar to close-up work, albeit on a larger scale and without control over the light.

While medium- and large-format cameras have long been favoured for their ability to render detail with unparalleled clarity, they are in many respects less flexible and responsive than 35mm. Add to that the huge range of focal lengths available for 35mm, coupled with the quality of modern film, and the choice between the formats becomes less clear cut. When light is changing rapidly at the edges of the

day, built-in light meters, 36 exposure film lengths and the ability to change filters and lenses quickly, undoubtedly gives the miniature format the edge.

The fast lenses available to 35mm photographers come into their own for aerial work. Vibration in small aircraft and helicopters demands shutter speeds in excess of $\frac{1}{1000}$ second for assured sharpness. The need to resolve distant detail sharply calls for a slow-speed, fine-grained film. Even allowing for uprating the film by 1 stop, to 100 ISO, only on very sunny days will it be possible to get $\frac{1}{1000}$ second with a f2.8 lens. For shooting when the light is more mellow or to use a polarising filter, try a f1.8 or f1.4 optic.

Simple cameras with sharp, manual-focus lenses are ideal for wide-angle landscape work. With some of the money you save on these I'd recommend that you invest in a professional set of graduated ND filters. As described in Chapter 5, these even up the contrast between sky and foreground, bringing a scene's tonal range into one which film can record. I use one in almost every landscape I take which includes the sky.

Screw-in graduates are too limiting to be of much use; you must be able to position the zone of graduation where it is needed, not at a predetermined area in the middle of the frame. Rectangular filters which can slide up and down in their holder are a much better option, and the best ones of all are long enough to allow you to position the graduation anywhere within the frame.

Professional-quality filters are normally made from optical resin, which is light though prone to scratch. Unlike their cheaper counterparts, they are completely colour-neutral so no unsightly casts creep into skies. They come in a range of densities – normally 1, 2 and 3 stop – with a graduation which is either 'hard stepped' or 'soft stepped'. While a complete set is desirable, these are expensive filters. I find that the 2 stop density covers most situations, and I have one of each sort. The hard-step filter, where the transition from clear to grey takes place over about 15 per cent of the filter's area, is perfect where there is a clearly defined tonal boundary, such as between a flat horizon and the sky. If a horizon is interrupted – as in a mountainscape, for example – the soft-step transition is more appropriate.

Top tips

- 35mm equipment allows the photographer to travel further, to photograph with a wider range of lenses and to respond more quickly to changing light than some larger formats.
- The equipment required is less costly than for high-speed action photography, especially if shorter focal lengths are used most of the time.
- Apart from a good tripod and head, the most useful accessory for landscape work is a set of professional graduated ND (grey) filters. These darken skies, bringing them within a tonal range which film can record. Those which are long enough to allow the positioning of the transition zone anywhere within the frame are best.

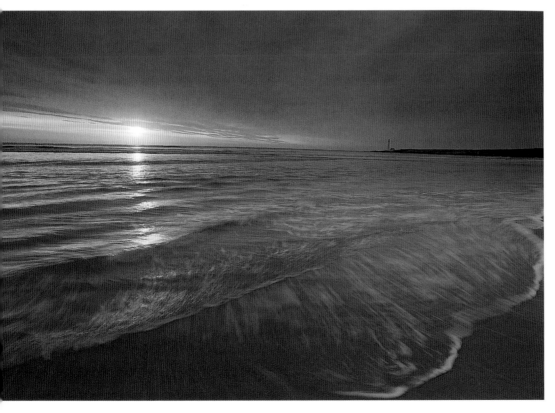

THE BEACH, MONTROSE, SCOTLAND

Lighting situations like this are quite challenging to meter – and very short-lived; the sun disappeared into the clouds for the day after just 5 minutes. A built-in light meter helps to speed your response to an opportunity and, with practice, is more reliable than a hand-held one since it takes account of extension and filtration. *MF 20mm, -2 stop graduated ND filter (hard step), Fuji Velvia*

9 Clever Ways to Use Lenses

There is no 'right' focal length for any particular subject; often it is the less obvious choice that produces the more compelling image. An eye-catching perspective, rather than ease of filling the frame, should be your first consideration.

MALLARDS ON A FROZEN POND

Coaxed into range by a handful of grain, these mallards on a snow-bound pond allowed me to photograph them from about 50cm away. A 28mm lens, with its wide field of view, enabled me to show the scene round about them in more detail than would have been possible with a telephoto lens.
MF 28mm, beanbag, Kodachrome 200

Using wide-angle lenses

Wide-angle lenses have a particular power to draw the viewer into a scene. He or she is not a voyeur, looking on from a distance, but is in the thick of the action, right at the photographer's shoulder. The exaggerated perspective, where foreground and background are thrown apart, creates a real sense of 'being there'.

Since a wide-angle can encompass a much broader view of the landscape than a telephoto, it is often used simply to 'get everything in'. Too often, though, this approach fails because the picture lacks a strong focal point. Dominant foreground elements, their prominence exaggerated by the lens's perspective, are useful to lead the viewer into the picture. But when there is a particularly interesting sky, it can be used instead to take the eye towards the horizon; the conventional 'two-thirds below the horizon, one-third above' composition is turned on its head. This technique is often employed by the celebrated Scottish landscape painter James

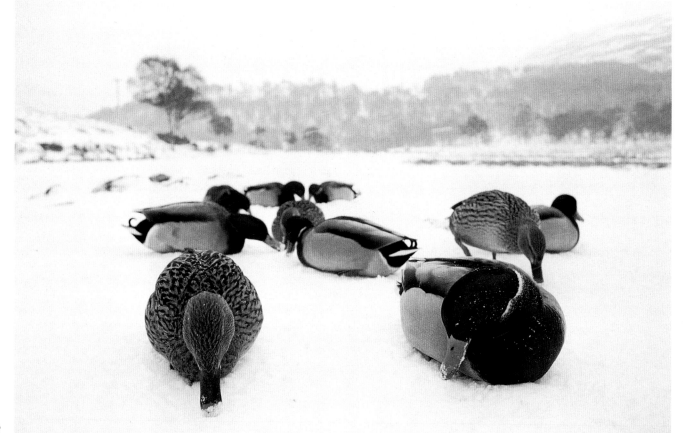

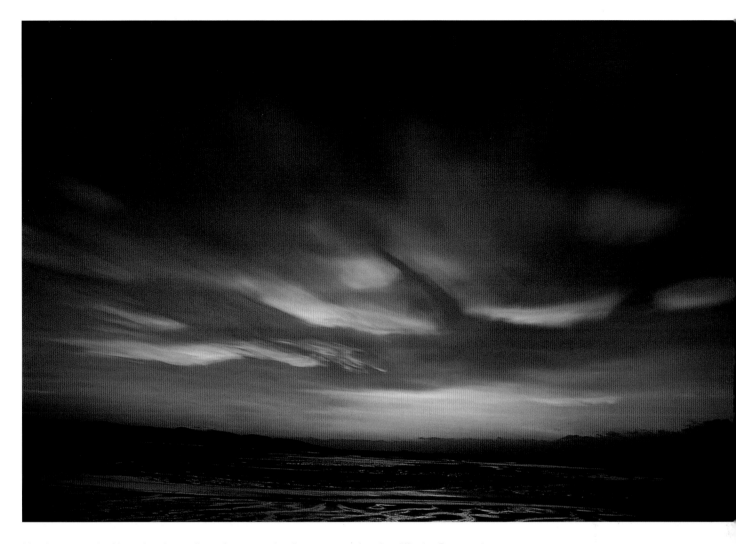

Morrison; overlooking the immediate foreground disengages the viewer from the scene – a comment on the relationship many people have with the land.

While distortion of depth is unavoidable with a wide-angle lens, distortion of line can be controlled to a certain extent by the photographer. Rectilinear lenses offer a high degree of correction, but with focal lengths shorter than about 15mm, significant

linear correction is difficult. Perspective-correcting lenses, available for 35mm cameras, provide an alternative – albeit expensive – method of controlling distortion. The same effect, but with more control, can be achieved in some image-editing programs, such as Adobe Photoshop.

The more the lens and film are in parallel with the subject's principal plane, the less the subject's lines are distorted, especially towards the centre of the picture. Photograph a tree from ground level, looking up its trunk, and its sides converge dramatically. If you back off and view it from an elevated spot about half its height, the same tree photographed with the same lens looks quite normal.

Nevertheless, distortion can be a positive feature, contributing to the impact of a picture. Just as foreground objects in a landscape are given prominence when the lens is close to them, so this is the case when the lens is positioned above a group of plants. My favourite way to emphasise a

NACREOUS CLOUDS, MONTROSE, SCOTLAND

This meteorological phenomenon, involving light refracted through high-altitude ice clouds, is rarely seen in the UK, but I was fortunate enough to be at an open location when I saw the sky developing. Here, the clouds are the main interest and they lead the eye into the picture, towards the horizon. The sky replaces a foreground as the device to draw the viewer into the scene.
MF 20mm, beanbag, Fuji Velvia

PAINTING BY DR JAMES MORRISON

73

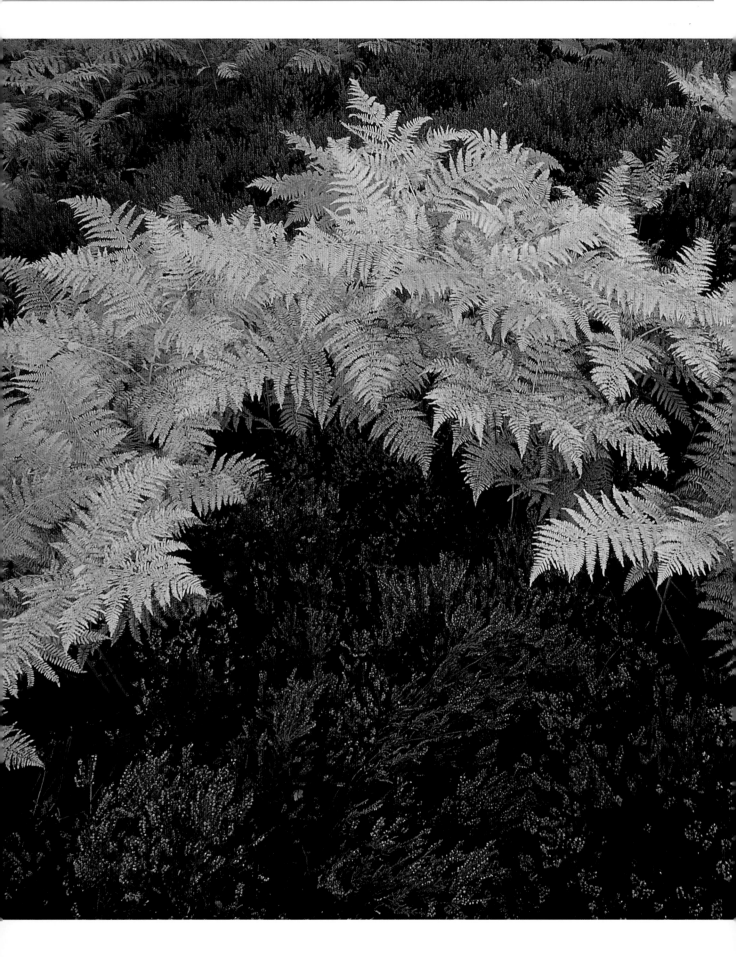

particular plant within a group is to set up the camera close by and then tilt it. The more out-of-parallel the camera is with the principal plane of the subject, the more dynamic the lines of the composition will be – and the more you need to stop down to achieve enough depth of field. However, since the magnification ratio is normally low, this is less of a problem than with close-up work. This technique is especially effective when the whole frame is filled with the plants, with no hint as to the extent of the colony.

LEFT: BRACKEN AND HEATHER

The arc of progressive colour created by the bracken in this picture could only be accommodated with a very wide lens. I needed a high viewpoint, not only to get far enough away from it but also so that I could look down on the scene and avoid the horizon.
MF 20mm, Fuji Velvia

Depth of field

There is a widely held belief among photographers that wide-angles *per se* offer more depth of field than telephotos. This is not actually the case. Imagine that you fill the frame with a subject by using a 200mm lens and take the picture at f8. Now replace that lens with a 20mm wide-angle and move closer, so that once again the subject fills the frame. At an f8 setting, the depth of field is just the same. Given a constant magnification ratio and aperture, depth of field remains the same whether you are using a 24mm or an 800mm lens (in the 35mm format). The illusion of a telephoto's shallow depth of field arises from the magnification of an out-of-focus background. Those elements distant from the main subject and therefore way beyond the zone which appears sharp are given prominence through the compression of perspective, heightening the delineation between sharp and unsharp parts of the photograph.

While depth of field remains constant, the field of view – the area of background taken in by a lens – is much greater with a wide-angle than with a telephoto, making it possible to show subjects in close-up within the context of their environment.

There are two ways to make best use of the available depth of field: by ensuring that the film plane and the subject's principal plane are paralleled

LEOPARDSBANE

The initial impression I had on viewing this scene was one of eruption, of the tall shapely leopardsbane and the sprouting lime saplings. I exaggerated this by photographing from a high viewpoint and angling the camera to distort the limes. By careful framing I was able to avoid reference to scale, suggesting that the colony of flowers went on and on.
MF 20mm, 81a filter, Fuji Velvia

75

particular magnification and aperture, which at that point of focus extends to infinity.

Top tips

- Wide-angle shots work best with a strong foreground element that leads the viewer into the picture.
- Alternatively, use an interesting sky to catch the viewer's eye.
- Distortion can be used positively by choosing your camera position with care; a high viewpoint, looking down, often works well with clumps of plants.
- Depth of field at a given aperture and given magnification ratio is constant whether you use a telephoto or a wide-angle lens. Telephotos magnify distant, out-of-focus backgrounds, giving the illusion of a shallower depth of field.
- Refer to the hyperfocal focusing setting on your lens to make the most efficient use of the depth of field available.

Using telephotos

Telephotos are more than merely lenses to magnify distant objects; they are also great distraction-control devices. As outlined earlier, they magnify out-of-focus backgrounds, showing only small sections of them. These features make them ideal for isolating subjects from their surroundings, and by ensuring that the background is sufficiently far away you can even stop down to quite small apertures to achieve all-over subject sharpness, whilst still maintaining an ill-defined backdrop.

Medium telephotos (in the 300mm range) are great for 'from the side' close-up shots for these reasons, but often an extension tube is needed to allow them to focus closely enough. Some of these cause the loss of some automatic functions and autofocus. For close-up work with inactive subjects this doesn't matter too much, but do ensure that full-aperture TTL daylight and flash metering is still possible.

I shoot most of my wildlife pictures from as close to subject eye level as possible. Very often, this means having the camera on the ground. Not only do I then see the world from my subject's perspective, but it also becomes easier to separate it from its surroundings because those areas immediately behind it are invisible from such a low angle. Only the distant, extremely blurred background appears in the shot. Importantly, too, this ground-level perspective introduces something we don't normally associate with telephotos: a foreground. Granted, it is a very ill-defined foreground, but it nevertheless has the same

CONEFLOWERS, PENNSYLVANIA, USA

Using a wide-angle lens from a high viewpoint gave both depth and a dynamic perspective to this mass of flowers. I moved the lens towards the bloom in the foreground to exaggerate its prominence.
AF 28mm, Fuji Velvia

(primarily a concern in close-up photography); and by focusing with reference to the lens's hyperfocal scale. This indicates the point of focus for the most efficient use of depth of field at a given aperture. For example, with my 20mm lens set on f11, the hyperfocal marks indicate that everything between about 70cm and infinity will be sharp. If a subject in the foreground is only 70cm from the camera and I focus on it, depth of field would extend only to about 2m behind it (and another 20cm or so in front of it). I would therefore 'waste' the available depth of field by making my point of focus directly on the subject. By focusing slightly past the subject, (in this example, to 1.9m) I can still keep it within the depth of field for that

effect as the clear one provided by a wide-angle – it draws the viewer in. The effect is most powerful when the foreground is completely indistinguishable; the resulting sense of intimacy with the subject that it conveys is hard to match. A low angle of view is also ideal for emphasising the height of tall subjects, with the added bonus (on clear days, at least) of the sky as a backdrop.

Top tips
- Extend a telephoto's useful range by fitting it with an extension tube to allow for close-up focusing.
- A foreground of sorts results when elements are present between the lens and the subject; if rendered softly enough, these do not distract from the subject and help to draw in the viewer.

YOUNG RABBIT

Young rabbits can often be photographed from just a few metres away by lying prone and absolutely motionless outside their burrows. Your scent must be blown away from them. At this low angle, short grass between you and the subject becomes a soft foreground; the distant background (that just behind the animal is out of sight) is equally diffused. *MF 300mm + x1.4 converter, beanbag, Kodachrome 200*

BERGAMOT, PENNSYLVANIA, USA

A 300mm lens was the natural choice here, not only because its narrow field of view allowed me to choose my background better, but also because I would have had to trample other plants to get to these ones on the edge of the patch. The gentle breeze called for a full-aperture shooting, resulting in a minimal depth of field. *AF 300mm, Fuji Velvia*

10 How to Make a Good Image Even Better

Learning to do a 'visual edit' in the field rather than at the light box saves a lot of film. In doing so, look for the four key elements which help to elevate an ordinary scene into something rather more special: life, light, precipitation and colour.

OPPOSITE: GREAT TIT IN SCOTS PINE, SNILLFJORD, NORWAY

Although the bird occupies only a very small part of the frame, our attention is drawn to it like a light bulb. Not only does its colour contrast with the surroundings, but it also occupies one of the 'eyes' of the picture.
AF 300mm, Fuji Sensia 100 rated at 200

Life

Perhaps as a legacy of our early days on the savannah, we are naturally attracted to life in the landscape. Even if the animal is far away and the land forms and sky are themselves dramatic, our eye is immediately drawn to it. This happens in photographs, too, and careful composition can make the creature a powerful point of interest.

Conveying animation takes a different form when the animal is large in the viewfinder. At this distance, the subject's gestures, attitude and expression are crucial to the impact of the picture. It is very tempting, as soon as exposure and focus are right, to run the motordrive, but this is a recipe for a roll of 'Nice, but so-what?' pictures. Waiting until the subject does something – cocks its head, yawns, scratches or calls – will make for a more dynamic image. By watching intently, you can learn to anticipate the animal's next move. Eye contact lets the picture viewer make a connection with the subject which is not possible when it looks off-camera. Eyes draw the viewer in and are the most powerful point of interest so should always be sharp,

PAIR-BONDING GANNETS

Gannets do lots of interesting things, but when there are so many so close together it can become bewildering. I concentrated on this pair for half an hour, witnessing a variety of behaviours.
MF 300mm + x1.4 converter, beanbag, Fuji Provia 100

OVERLEAF: RUM, FROM EIGG, INNER HEBRIDES, SCOTLAND

A commissioned shoot on the small island of Eigg gave me the chance to see the neighbouring island of Rum in all sorts of lighting conditions, normally in variations of grey. Nevertheless, one evening the clouds broke towards dusk which, fortunately, coincided with low tide.
AF 28mm, -2 stop graduated ND filter (hard step), Fuji Velvia

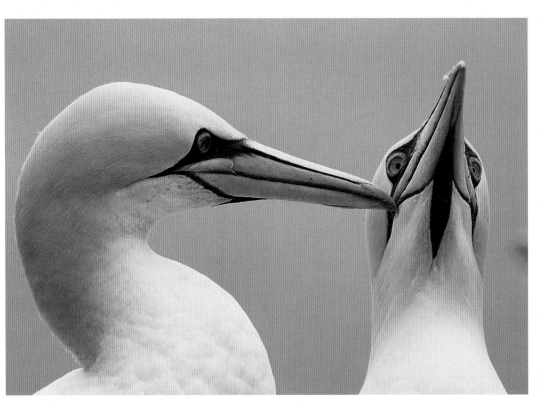

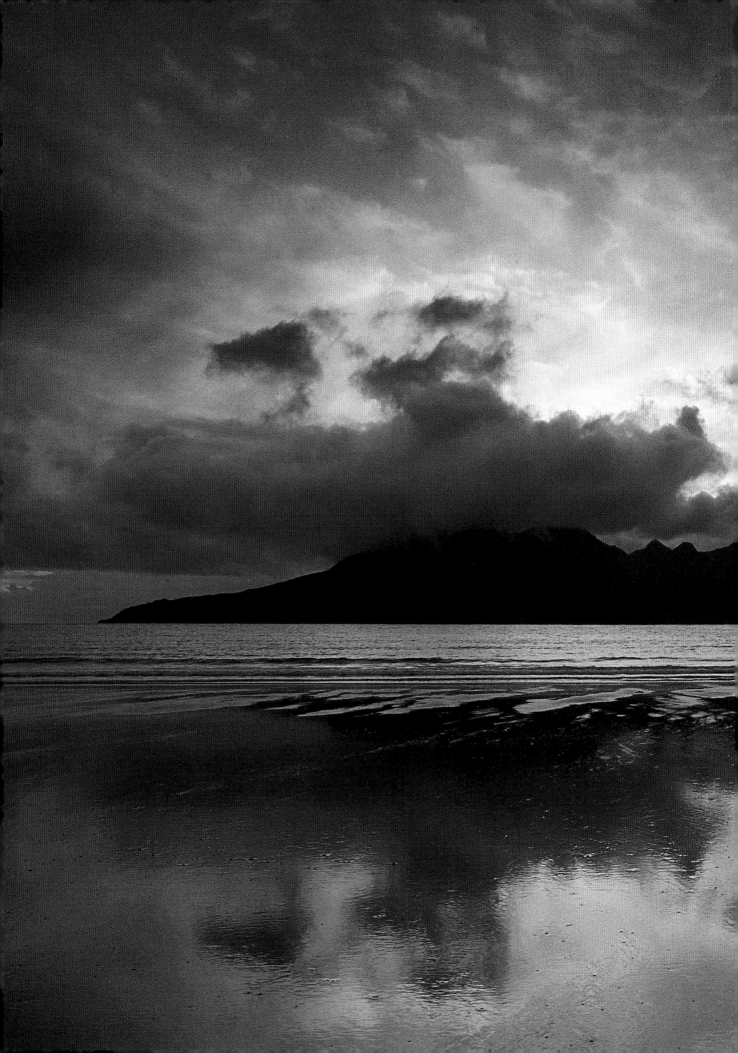

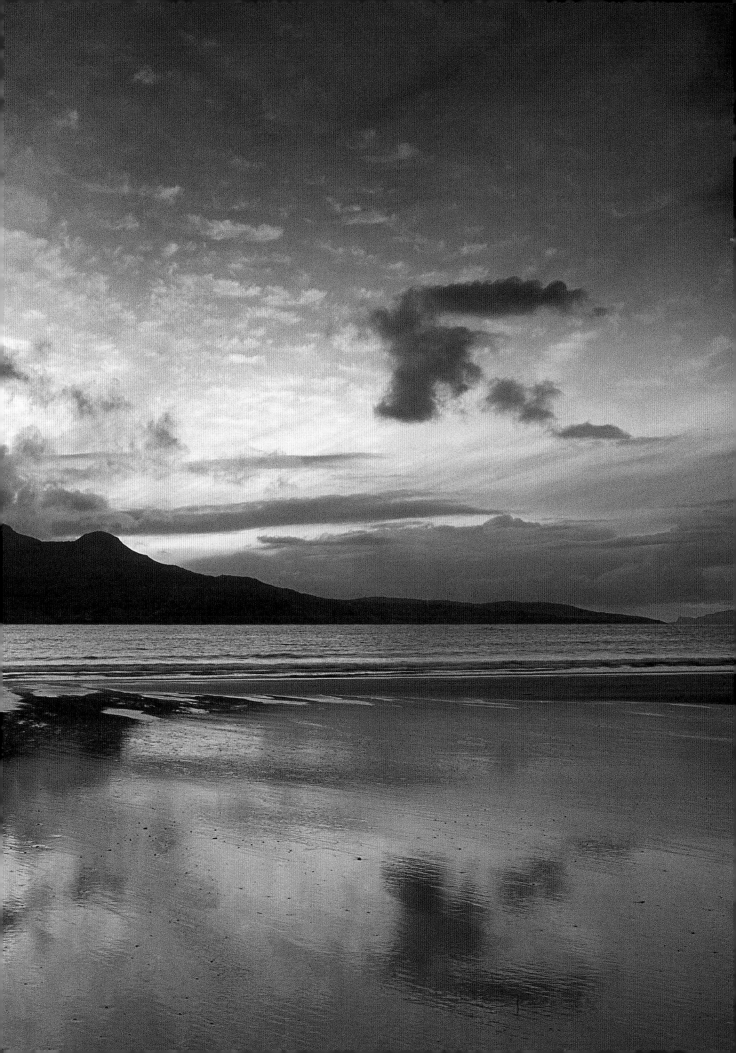

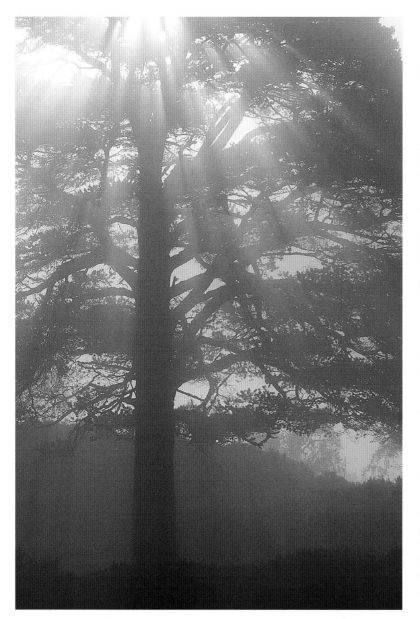

LIGHT STREAMING THROUGH SCOTS PINE

Extraordinary autumn lighting and early-morning mist created the conditions which transformed this unexceptional scene into something special.
AF 300mm, Fuji Velvia

Light

The mood of a picture is altered more by the character of the lighting than anything else. 'Glowering' skies are depressing for the photographer, mugging objects for their colours and denying shape the flattery of shadow. But in the 'sweet light' around dawn and dusk, subtle textures are coaxed out of the shadows. Cool and warm tones jostle side by side around the edges of even the most banal subjects. By working with the same film stock most of the time, you can learn to anticipate its reaction to particular forms of lighting. Fuji Velvia, for example, renders colours quite neutrally in heavily overcast lighting, but towards the edges of the day its ability to enhance subtle colours to a considerable degree is evident: shadows in snow which are seen as grey turn a rich blue, and weak sunrises become vivid.

Often it is not possible to shoot at the very best times of day; if forced to photograph an animal in bright sunlight, I often work into the light, filling shadows with flash. Whenever practical, I also choose a low viewpoint so that the sky in the background is a rich blue, rather than the pale hue near the horizon.

Precipitation

Rainbows, frost, fog and snow are powerful agents of transformation in the landscape. While rainbows and frost add an extra dimension of interest, snow can, and often does, completely alter the character of a scene. Its facility for simplification, for introducing uniformity and reflecting colour, make it a potent tool for directing the viewer's attention. Snow hides a lot of conflicting tones and shapes, and on sunny days its shadows are blue.

Shooting snow in bright sunlight is tricky, since there is normally a great disparity between the good exposure for the subject and that for the snow's highlights. Problems arise when some areas are in shadow, leading to a patchy background. I prefer to work in lightly overcast conditions: while the snow is still considerably brighter than the subject, in the absence of shadows it is uniformly so. Subjects close to the ground also benefit from the snow's reflective properties, and even on a gloomy day exposure readings can still be quite acceptable.

Frost is especially attractive in close-up photographs, etching detail on lightly textured surfaces. Often, though, it is more ephemeral than snow, forcing the photographer to work in the shadows where it lasts longest. If the day is sunny, an 81b warm-up filter will balance the strong blue cast, if it is unsympathetic to the subject matter. Use a lens which allows you to work from some distance back – I've spoiled pictures in the past by melting fine frost

even if the rest of the image is blurred. In the eyes, the subject's reaction to the photographer can also be read; I prefer to see comfort with the photographer's presence, rather than alarm.

Some creatures, no matter how long you wait, seem intent on listlessness. Common seals are often like this and it can be a long time to hang around between yawns. A reaction can often be elicited by squeaking, using either a piece of polystyrene against your car windshield or a reeded device clenched between the teeth. This is especially effective with predators, who believe they hear a creature in distress. Similarly, playing the calls of some birds can lure them quickly to within camera range. Be aware, however, that they may become anxious if this is done during the breeding season, and if the CD is played too often you run the risk of displacing the resident bird from its territory.

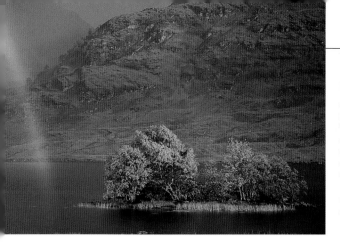

RAINBOW, ABERFOYLE, SCOTLAND
After this photograph appeared in a German photography magazine, a number of readers wrote in to protest that I hadn't captioned it as digitally enhanced, since the rainbow seemed just too good to be true. Well, this is as it appeared in nature; the light on the island came and went within ten seconds. I wouldn't have dreamed of making such an extravagant rainbow in-computer.
MF 90mm, Fuji Velvia

SEA EAGLE MANTLING PREY, TRONDHEIM, NORWAY
I love high-key images and I was relieved that, although the sky was bright, the sun didn't shine onto the bait site where I photographed this adult sea eagle. Shadows would have made for a confused background. I took a spot-meter reading from the middle of the eagle's wing, which I judged to be a good mid-tone.
AF 500mm, Fuji Velvia rated at 100 ISO

with the warmth of my breath, because I was using a 55mm macro lens rather than a 90mm or 180mm. You can avoid the expense of a longer macro lens by buying a snorkel instead, but expect some strange looks from passers-by.

Colour

One of the nice things about being a primate is having good colour vision. It evolved to help us recognise ripe fruit, and our stereoscopic vision made

it a little safer to swing through the trees. Few of us depend heavily on our sight for these purposes today, but it nevertheless enriches our lives tremendously. It is the case, however, in making sense of what we see, that we tend to rely more on the recognition of shapes than the colours they reflect. It takes a conscious effort for the photographer to look at the landscape as a set of colours and the relationships between them, rather than as a set of known objects. In other words, we use colour merely as a clue to the identity of an

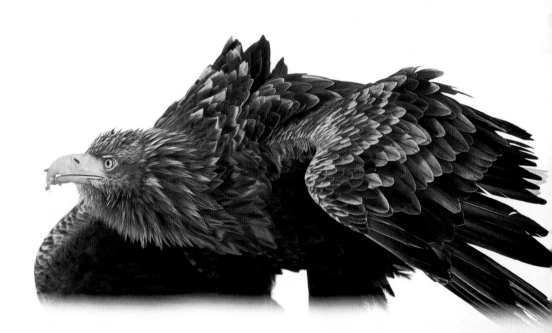

object rather than seeing it as the factor of primary interest. Yet this is what we must do in order to heighten our awareness of colour – we must make it a central, rather than an incidental, theme in our photographs.

Our perception of colour is complex and often diverges markedly from what film records. It was Edwin Land, founder of the Polaroid Corporation, who first demonstrated that our visual systems don't merely react to different wavelengths so that we 'see' things as green or red (as film does), but rather they use these wavelengths to assign colours to objects in conjunction with other visual clues to their identity. Our memories of the colours of particular objects are central to the process. This is why, even under heavily filtered light, we see objects we are familiar with as a particular colour, one quite different from that rendered by film.

RED CAMPION AND VIPER'S BUGLOSS.

I have made no attempt here to frame up a strong composition; the picture, instead, is all about colour. The combination is not perhaps one you would have in your home but in nature, the effect is striking. I used a long lens to compress perspective, for maximum colour impact. *AF 300mm; Fuji Velvia*

JUNIPER AND BELL HEATHER, BETTYHILL, SCOTLAND

On the windswept north coast of Scotland, most juniper grows prostrate. Here is a good natural complement of colours, the magenta of the bell heather helping to emphasise the green of the juniper and vice versa. *MF 55mm, Kodachrome 64*

The Impressionists painted colours not as people expected but as they actually appeared, a mix of the subject's known surface colour, its position in light or shade, and the colour temperature of the light striking it. Hence, in Monet's *Houses of Parliament, Sunset*, for example, the shaded grey stone of the buildings is rendered bluish green, the complement to the orange sunset. Photographers therefore need to look hard at a scene to assess how its colours will be rendered, rather than rely on knowledge of the colours of its component parts.

Maximum colour impact in a photograph results when two complementary colours are placed alongside one another. Complements are those colours which, when mixed together in their light (rather than pigment) form, produce white light: green and magenta; red and cyan; and yellow and blue are examples. Each appears to intensify the other as the eye moves rapidly between the two. You can determine a colour's complement in the following way: place it against a piece of black card, stare fixedly at it for as long as is comfortable, then transfer your gaze to a piece of white card. An after-image will appear for a few seconds, and its colour is the complementary colour.

It is unusual in nature to find perfect complements of the same saturation (the strength of a colour determined by how far removed it is from grey), so in the field it is often better simply to look for contrasting warm and cool tones – those which lie at opposite ends of the spectrum. For example, the deep blue shadows that appear in snow (which we know to be white) are ideal for setting off orange or red subjects. Single points of contrasting colour in an otherwise monotonal scene are also effective, powerfully drawing attention to the object.

MEADOW CRANESBILL
My first reaction when I saw this scene at the height of summer was, 'Someone must have put it there.' But no, this leaf alone had changed amongst the uniform green, creating a powerful contrast between warm and cool colours.
MF 90mm, Fuji Velvia

Top tips
- Wait for the connection to be made with the subject, rather than shooting as soon as it is in focus.
- If the location is one you can easily revisit, save your film and shoot only when conditions feel right.
- When the snow comes, be prepared to take advantage of it, and check out locations where frost lingers until late in the morning.
- Try to view the landscape as a set of colours, rather than objects each of which happens to be a particular colour.
- Keep an eye out for the juxtaposition of complementary colours, or at least, warm against cool.

11 Composition

Order helps us to make sense of the unfamiliar. Composition is, on one level, about the photographer ordering different visual elements into a form which pleases him or her, and on another, the presentation of those elements in a way which gives the viewer an insight into the experience. Composition is all about attracting attention.

WE MAY NOT be aware of it, but every time we focus our attention on something that interests us, we are composing a mental image. The process of 'visual editing', alluded to in the previous chapter, makes us aware of those things in a scene which conflict with the point of interest. We 'see' not by staring at one point, but by rapidly scanning, building an image in our minds (*not* on our retinas) as we do so. If we stare at a single point for long enough, it seems to disappear. The camera, on the other hand, lacks this facility for selective awareness and so we must do the 'editing' for it through the process of composition.

Making a pleasing composition feels intuitive. Once all the objects within the rectangle are arranged in a particular way, it just feels right – it is more than a purely visual sensation. Yet it is hard to be certain how much of the process is purely instinctive and how much results from cultural conditioning. The rule of thirds derives from the Golden Section, a mathematical formula dating from classical Greek times to describe a pleasing ratio of parts when a line is divided. When a rectangle is divided into thirds, horizontally and vertically, the intersections of these divisions, the 'eyes' of the picture, seem to hold a special power which attracts

HOUSE WREN, PENNSYLVANIA, USA

The house wren is in one of the 'eyes' of the composition and our attention is naturally drawn to it. I made sure that the space around the wren was filled with colour by moving the perch until I achieved the right degree of softness for the black-eyed susans: too close to the perch and they were too well defined; too far and they lost all form.
AF 500mm, Fuji Velvia rated at 100 ISO

FEALL BEACH, COLL, SCOTLAND

Where the elements in a scene are symmetrical, the rule of thirds rarely works well. Here I opted for a 50:50 split, which felt right.
MF 20mm, -2 stop graduated ND filter (hard step), Fuji Velvia

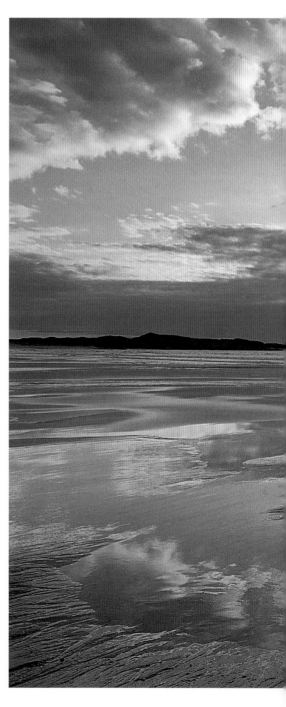

the attention of the viewer. Is this a learned response or something much deeper? Whatever the case, placing the subject (or an important part of it such as its face) at one of these intersections guarantees that it will hold the attention.

The rule of thirds usually fails when dealing with symmetrical scenes. In these situations a 1:1 rather than a 1:2 ratio, where the subject occupies each half of the frame evenly, is generally more appealing.

Don't be bound by compositional rules; they are there to help when you get stuck. And sometimes, no matter how hard you look, there just isn't a good composition to be had.

Putting the picture together

The first decision to make when a promising subject presents itself is whether it should be integrated with, or isolated from its surroundings. Do the elements around the subject contribute to its story? Can they be accommodated in an aesthetically attractive framework, or do they simply distract attention? If you plan to use the photograph as part of a digital montage later, then a subject which is clearly delineated from its background will make selection

OVERLEAF: ICICLES AND STREAM

This shot is loaded with tension: the tension between the clearly defined, smooth ice and the rough, streaming water; opposing flows within the waterfall itself; and the warmth of the ice-encased rushes against the coolness of the scene's other tones.
MF 300mm + x1.4 converter, beanbag, Fuji Velvia

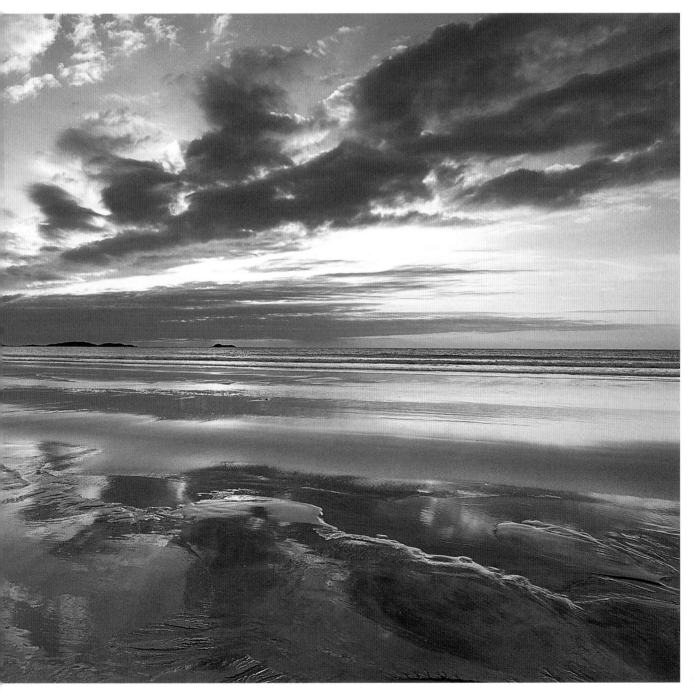

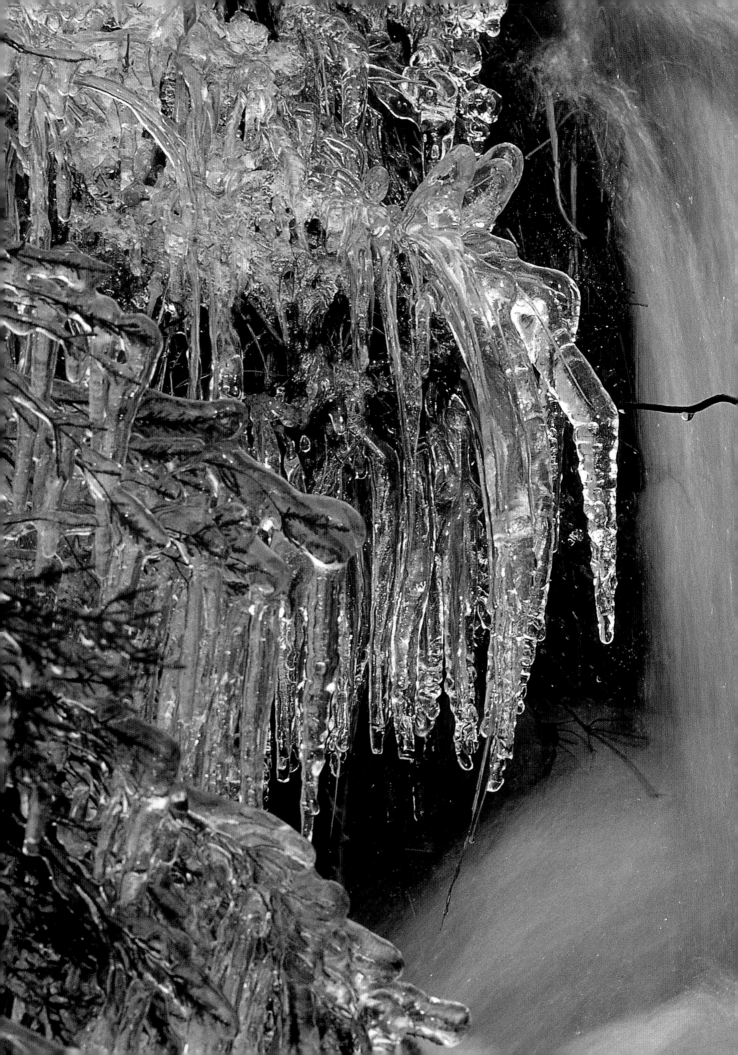

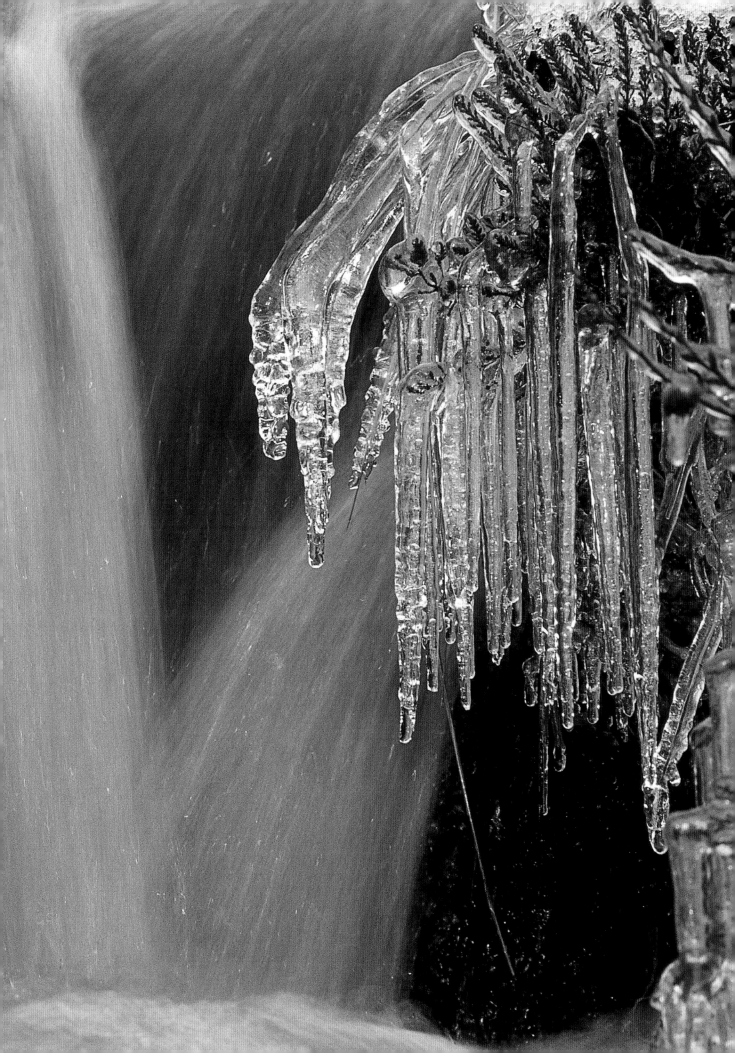

SLATE, PENNSYLVANIA, USA

The composition of this pile of broken slate in a Pennsylvanian quarry is not, perhaps, immediately apparent. Longer inspection reveals three main sets of diagonals, which provide a structure filled by the jumble of shards. The viewer is not directed towards anything in particular and instead can explore the image's contrasting lines and colours for him- or herself.
MF 90mm, diffusion sheet, Fuji Velvia

much easier. Before going any further, assess whether what excites you in three dimensions looks as good in two – which is how the camera will record it – by closing one eye.

Simple compositions, with just a few contrasting lines, textures and colours, have the most immediate visual impact. They are unambiguous and the viewer is left in no doubt as to the photographer's interest in the scene. In contrast, complex compositions, where the relationships between the numerous elements are less explicit, probably lack this immediate impact but they will have more enduring interest, with lots for the eye to explore.

For close-up work, compositional options may be limited by the need to parallel the camera with the principal plane of the subject, to make the most efficient use of the available depth of field. While this plane may be easily identifiable on, say, a tree trunk, with some subjects it is a much more arbitrary notion and can be estimated only once you decide on those elements (principally the ones occupying the 'eyes' of the picture) which need to be sharp.

While it is important to use the whole area of the frame, banishing the irrelevant as you do so, bear in mind that you might get less than you bargained for. Some top-of-the-line camera bodies offer 100 per cent viewing: the viewfinder image, in terms of its extent, will match perfectly what appears on the film.

Less expensive models tend to show slightly less in the viewfinder than is recorded. One hundred per cent viewing is all well and good, but if you frame too tightly you can be in trouble: once a slide is mounted, the edge of the film disappears. Scan that mounted slide into a desktop scanner, and another sliver is lost. Moreover if you plan to sell your work, space needs to be left around the subject to give the designer somewhere to place text, and so he can adjust the composition to suit the publication's needs.

Creating visual tension

Whether the composition is simple or complex, symmetrical or divided into thirds, tension will give it an extra edge. Tension is simply about the juxtaposition of contrasts: placing smooth beside rough textures; warm against cool colours; sweeping over jagged lines; and definite forms alongside ill-defined ones. Introduce a dynamic line for added interest – lines which run at a diagonal are somehow more visually interesting than those which are simply horizontal or vertical. This principle, however, doesn't work so well with known horizontals, such as horizons, or verticals, such as people. Also, diagonals look better if they don't appear from the very corner of the frame, but are slightly on the side or lower edge of the picture. The more of these types of tension in an image, the more eye-catching it is.

Abstracted images

There is one particular approach to composition which deserves special attention at this point, since it is so popular among outdoor photographers, and that is abstraction.

Strictly speaking, we should talk about 'abstracted' rather than 'abstract' images in the context of photography; the medium is firmly rooted in reality and this approach involves the presentation of parts in an unfamiliar way rather than the creation of novel forms.

The first stage in understanding abstracted pictures is to accept the idea that edges define objects in space. Our visual system has evolved to recognise objects by their outline – in other words, their edges. If an object is portrayed in a way which excludes its edges, the familiar becomes unfamiliar, even if just momentarily, as we are forced to examine its substance rather than its form. In abstract art, there is a good reason for doing this.

Perhaps you loathe alligators. If I show you a picture of the whole animal, including its outline, you quickly turn the page. A prejudice against the alligator as a species precludes any appreciation of its aesthetic qualities. If, instead, I exclude its outline

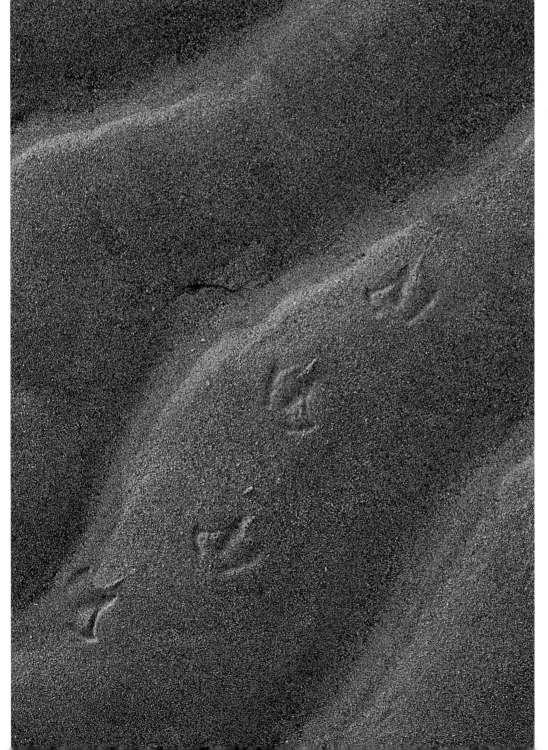

FOOTPRINTS ON SAND

I set the camera at an angle to these patterns so that they occupied a diagonal space within the frame. The fact that the ripples were wavy rather than straight added further interest, and the whole scene was improved even more by the colour tension which developed between highlight and shadow areas as the sun set late on this summer evening.
MF 90mm, Fuji Velvia

SKUNK CABBAGE

Sometimes abstraction is simply a response to being unable to find a better composition. Once I identified those elements in the scene which interested me most, I just kept moving in until the edges which defined 'leaf' and 'spathe and spadix' disappeared and I was left with a set of shapes and colours I liked.
MF 90mm, polarising filter, Fuji Velvia

and focus on the line of its mouth and teeth, there is a chance that you will enjoy its shapes and colours before you realise what you are looking at. Abstraction in photography is therefore a technique to bypass prejudice in order that the aesthetic qualities of a subject can be viewed dispassionately. An abstracted picture should be seen not as a puzzle where the subject's identity is in question but simply as a pleasing set of lines, colours, forms and textures.

Abstracts are often associated with close-up photography, but if you stick to the principle of avoiding edges they work at a larger scale, too. Using a very wide-angle lens, for example 20mm, to shoot down on a dense colony of flowers, you can hint that they go on to infinity, so long as the edge of the colony is excluded. If you don't already do so, train yourself to run an eye around the edge of the frame while the depth-of-field preview button is

depressed, to check for intrusions. The sense of abstraction is heightened if any visual reference points which would give an indication of scale are omitted from the composition.

The success of abstracts can sometimes be attributed to their quality of 'otherness', of not quite belonging to this world. That is simply because the familiar is presented in an unfamiliar way. In most cases, soft, diffused lighting is more effective at conveying this sense than bright sunshine. The quality of 'otherness' also arises when the colour of subjects appears differently on film to our memory of that subject's colour.

ALLIGATOR, PENNSYLVANNIA, USA [C]

Perhaps you saw straightaway that it is an alligator. But the object here is to give the viewer a moment or two to think, 'What a nice set of lines and subtle colours' before the 'I don't like alligators; I'm not going to look at it,' response kicks in.
AF 300mm, fill-flash set to -1.7ev, Fuji Velvia

DRYING COD, SNILLFJORD, NORWAY

Shooting in the shadows on a sunny day with lots of snow on the ground provided the right combination for the curious lighting in this picture. Filtration or fill-flash would have destroyed its subtlety, which recalls the feeling of the still morning by the fjord.
AF 300mm, Fuji Velvia

Top tips

- Composition is concerned with ordering visual elements to make them attractive to the viewer. This makes them easier for us to understand.
- While the rule of thirds works surprisingly often, do not try to apply it to symmetrical subjects. Rather, go with your instinct as to how a composition should be assembled.
- On finding a good subject, decide first where to integrate or isolate.
- Create visual tension by juxtaposing contrasts.
- Abstraction is a compositional technique; subjects aren't inherently abstract. Teach yourself to view the landscape not in terms of the objects it contains but as a mass of line, form, colour and texture. Focus on those elements which appeal to you most: the most wavy lines; the most striking contrasts of colour or texture; the most intriguing interplay of light and shadow.
- When framing your abstract composition, make sure you avoid edges and references to scale. Lichens can provide compelling abstract images, but the effect is spoiled if the edge of the tree or rock creeps in. Tree trunks look just like tree trunks if the sky comes into shot. Alternatively, shoot from a low viewpoint and use the sky as a uniform backdrop.

93

12 Things to Consider Before You Press the Button

You may be a skilled technician and have an eye for a picture but without discipline and application your idea may remain unexpressed.

OPPOSITE: ELK COW AND CALF, YELLOWSTONE NATIONAL PARK, USA

Photographers who go to Yellowstone's Elk Antler Creek meadow in autumn are generally after one thing: bugling bull elk. That's why I went there. It was soon apparent, however, that the action would be too far away for my longest lens, so instead I dismissed the images I had in mind and followed this elk cow and calf instead. *AF 300mm, beanbag, Fuji Velvia*

AFTER THE DAY'S workshop, we review our film. Some long faces tell me that results aren't as expected. I try to offer consolation. 'OK, it's not what you wanted, but can you work out whether it was a failure of vision or a failure of your technique? If it was a vision failure, if there wasn't a picture there in the first place, that's fine. We all take a lot of pictures which end up as rejects. Professionals especially. But if it was a failure of technique and a perfectly good image was spoiled by poor exposure or camera shake, then that's something you can avoid in future. Starting tomorrow.'

A fine nature photograph starts off as intuition and is completed through discipline. We can identify several stages in the conception of the image. Stage one is no more complex than having your eyes open; you are visually conscious, although nothing in particular is registering. Then the search begins – you begin actively to look for some visual 'hook', although you may not know what that will be. In the third stage of the progression, you begin to see things which have a common appeal – it may be a sunset over water, young animals or a dramatic rock formation. At the next stage, image perception, divergence begins. There is divergence between what the photographer perceives and what the camera is intent on recording. There is divergence, too, in how different individuals view something which has photographic potential. One person wants to capture the grandeur of the entire scene – sunset, water and birds – whereas another is drawn to a single tree silhouetted against the declining sun. The silhouettes of flying birds against the vivid sky attract others. This stage reveals individual preferences. What elevates particular images is the ability of the photographer to invoke a personal vision of the world and apply that to the scene. In this final stage, the photographer's style shows itself.

Ultimately, a responsive approach to image realisation opens the photographer to many more opportunities than one which relies on the pursuit of a preconceived idea.

It is all too easy, as you try to tune in to your response to a scene, trying to put into words what draws you in, and wondering how to portray that, to forget the limitations of camera and film. You may be excited, but the black box is quite indifferent. How, then, do you visualise the image as it will be ultimately captured on film?

To assess the scene, start off by closing one eye (to see in two dimensions), then half-close the other to mimic the contrast range of film. Try it, and see how the shadow detail disappears if it is sunny. I then use the depth-of-field preview to see how much of

GANNET, BASS ROCK, SCOTLAND

I lead a workshop most years which includes a trip to the Bass Rock, home to over 18,000 pairs of gannets and arguably the most exciting avian spectacle in Britain. The photographic opportunities are limitless, but landings on the island last only two to three hours. Furthermore, the white birds are tricky to expose well. Situations like this demand a disciplined approach – perhaps concentrating on one or two pairs of birds during the entire visit and taking time at the outset to figure out a good exposure. *MF 300mm + x1.4 converter, beanbag, Fuji Velvia*

MONTROSE BASIN AT DUSK, SCOTLAND

A group of photographers working shoulder to shoulder will each make a different picture of a complex scene like this. No picture is any less 'truthful' about the place than the next; each image simply describes an individual response to something with universal appeal.
AF 300mm, beanbag, Fuji Velvia

ASH AND CHERRY

On a personal level, this image encapsulates the excitement I feel every time I enter this old wood in the autumn. Yet others who visit the wood each have their own favourite vistas or tree. In a visually complex environment like a forest, there is no universal, definitive image to be found.
MF 90mm, Fuji Velvia

the scene will appear sharp. With your attention focused on literally one element of a scene, it is easy to lose sight of others which the camera will unthinkingly record. Try to get into the habit, whenever time permits, of running an eye around the edge of the viewfinder to check for distractions.

Common problems

During the workshops I teach, I have noticed a number of recurring problems encountered by students. Lightweight, over-elaborate tripods with heads inadequate for the load cause more heartache than anything else. A rigid tripod with rugged head need not cost a fortune; more expensive models simply offer more convenience and longer life. Many students also try to gain magnification for close-up work by combining extension tubes with their zoom lenses. This approach provides hours of frustration as the camera is moved back and forwards in an attempt to find a point of focus which coincides with a desirable composition. If you have to use a zoom for close-up work, buy one featuring macro focusing (though rarely do these come near 1:1), and then add a good-quality dioptre lens to it.

There is a more general problem, however, of knowing how the camera's key functions (such as manual metering, depth-of-field preview and flash operation) can be adjusted to the photographer's needs. The days when we could pick up a new camera and use it without any reference to the instruction manual are long gone; most of the answers are to be found in there. Enthusiastic as I am about technical innovation in photography, I have already emphasised that I think it should be used to allow us to do more, rather than to make easier that

which we can do already. In other words, leaving all the settings on automatic is just not good enough if you want to put your mark on the picture.

With the exception of unsharpness caused through subject movement or bad technique, more photographs fail on the technical level because of poor exposure than anything else. And that is something that can be remedied through practice, discipline and the manual exposure mode (see Chapter 4). Viewed in this way the goal of technical mastery doesn't seem so remote.

Top tips

- Even though each of us recognises the potential for a good picture, every photographer has their own 'angle'. There is no right or wrong picture to take – your style dictates what and how you photograph.
- Approaching a subject with a set of pre-conceived images in mind often blocks your awareness of other possibilities you hadn't considered. An open-minded approach works best.

- Good images come about by the photographer being rigorous at every stage in the picture's execution, from the moment you see the potential until the shutter is tripped. It takes both a good eye and good technical skills.
- Unless you plan to work on the photograph in-computer at a later date, you are forced, in the field, to work within the confines imposed by equipment and film; be familiar with them and try to see the world as the camera sees it before taking a picture.

97

13 In Pursuit of the Perfect Picture

Digital technology, used intelligently, is empowerment. Now colour photography can be a credible mode of artistic expression, freed from many of the technical limitations which have traditionally made it a poor relation to black and white and painting.

DIGITAL IMAGING cannot be learned in a day. For those photographers with only a casual acquaintance with computers, acquiring the skills may be hard work and time consuming. In other words, you will probably face the same learning curve you faced when you first picked up a camera, only this time you can employ your new skills to build upon your existing ones as a photographer, and become more versatile and expressive in the process.

If you are a reluctant computer user but see their potential, digital work is best reserved for those pictures you had high hopes for but which failed. Think of it as a cure for disappointment. Computer imaging is no substitute for good photographic technique and vision, but neither is it the last refuge of the incompetent photographer. Until such time as digital cameras are as good as their film equivalents (and of similar price), the image captured on a par with fine-grained slide film, and computer hardware and software intuitively easy to use, routine resort to digital enhancement will eat too much into field time. Nevertheless, digital imaging has a key role to play in allowing you to share your vision of the natural world, and to dismiss it in favour of traditional wet photography is to fit yourself with an expressive straitjacket.

Let's remember, too, that it is quite straightforward to prepare digitised images for up-loading to web pages or even for sending to a desktop printer; this is the level at which many photographers first discover the excitement of digital imaging. Only when we need to exercise more detailed control over all aspects of the image, such as when it is destined for publication or output to film or high-quality prints, do we need to be more exact.

Enhancement or manipulation?

Many of the techniques described in this section are concerned with the recreation of experience rather than the creation of something which was never there in the first place. As we have seen in earlier chapters, a photograph is at best only an approximation of reality – and a piece of film provides a rather arbitrary definition of that reality. Once we begin to work on the 'raw' film, we need to adopt some of the sensibilities of a painter. If we are intent on recreating the visual dimension of a memory, perhaps we should not be constrained by what happened in $\frac{1}{60}$ second. Perhaps there were a number of incidents taking place over a few seconds or minutes which imprinted themselves as the single memory. At this point a divergence occurs between what can be done with traditional photography and with digital imaging. How far is it legitimate to go in altering the original image? When does an 'enhanced' image become a 'fundamentally manipulated' one? At what point does the image, or 'digital illustration', cease to be about what was seen, and become only about the person who created it? There are no definitive answers. I try to follow the advice given to me by a respected landscape painter – to remain true to the *spirit* of the subject or the place or to the character of the light.

While I care little about whether or not nature photographers can be called 'artists', a number are assuming this title as justification for fundamentally manipulating their photographs. This may involve the combination of different elements from various pictures which have been taken at different places and at different times – there are some examples later in this chapter. There is no doubt that the resulting images, when done well, have a 'Wow!' factor and may convey more information about the subject than is possible in a 'straight' photograph. But a real danger exists for the photographer who wishes to move freely between the worlds of art photography and photo-journalism in that the question of authenticity – 'Was that wolf really there, or was it put there?' – then hangs over all his or her work, whether it is 'straight' or otherwise.

Red and blue carnations

Here's what I feel is inappropriate use of the technology in respect of nature photography. Plant breeders have, for years, tried in vain to raise a blue carnation. We made one in 20 minutes – but this is making up nature that doesn't exist.

After making overall adjustments to contrast and brightness in Levels (Image>Adjust>Levels) to ensure that the background would come out pure white, we did a Magic Wand selection with a very high tolerance setting (200) which selected the brilliant red of the flowers. This selection was put on a separate layer from the stem for ease of editing. Colour was changed using the Hue slider in Replace Colour (Image>Adjust>Replace Colour>Hue) and final tweaks were made to the shadow areas in Colour Balance (Image>Adjust> Colour Balance>Shadows). Since these jobs were done in separate layers, there was no effect on the stem or background. Digital work by Alan Imrie and Niall Benvie.

Original photo: MF 90mm, 2 x TTL flash, TTL sync cord, Ikelite Lite-Link; Fuji Velvia

Twite and machair, Isle of Coll

Scotland holds most of the UK's population of twite, and many of these live on the fertile coastal plain known as the machair on some of Scotland's Western Isles. Making a conventional photograph which shows both the bird and the machair in detail is almost impossible. This image falls squarely into the category of 'digital illustration' – this means that although what it shows is true to the bird and the place where it lives, it does not attempt to recall a single experience, nor does it have the look of a photograph.

The twite was cut out using the Magic Wand to select the background; the tolerance was adjusted until just the bird and wire were surrounded by the selection line. Since it was actually the background that was selected, we hit Inverse (Select>Inverse) to select the bird and wire instead (the analogue of the background selection). A small amount of feathering (3 pixels radius) was applied to the selection to make for a more convincing blend with the background. The selection was then cut (Edit>Cut) and pasted (Edit>Paste) onto the background. In composites like this it is important to ensure that the character and direction of light is similar in each element. Digital work by Alan Imrie and Niall Benvie.

Machair: MF 20mm, Fuji Velvia
Twite: AF 300mm + x1.4 converter,
Fuji Velvia

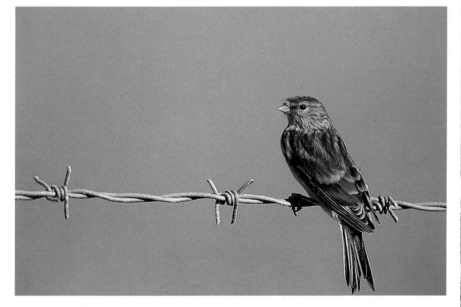

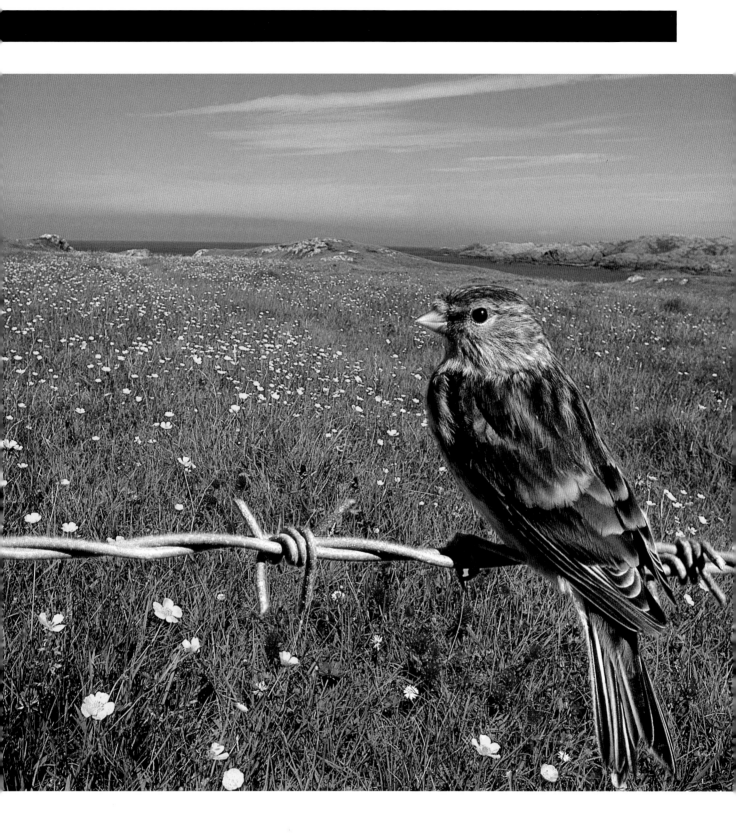

There are questions, too, over the endurance of 'too-good-to-be-true' images borne in Photoshop, the sort of pictures some photographers pursue for a lifetime. These images, in the raw form, encapsulate an idea and become icons of that photographer's vision of the natural world. Imitations can be knocked out in a day at the computer. Their impact is immediate and arresting but, I suspect, short-lived, especially as the 'once-in-a-lifetime' digital illustration becomes common currency. Picture viewers can take only so much of a good thing before saying, 'It's too obvious!' or, 'I've seen that before' (as we would expect with iconic images), or, even worse, 'I don't believe it!' Sadly, such scepticism is then translated to unmanipulated photographs, too.

Before you begin – avoiding the pitfalls

Image-editing programs, such as Adobe Photoshop, are powerful tools. But they are powerful without being intelligent, and if you want to make a really tacky image they will do nothing to stop you. Questions of taste aside, the creator has to ask him- or herself whether the image is convincing. When you are considering digital illustrations, most of the time the answer will be, no, it doesn't look real, but it does tell us something more about the subject than a conventional photograph does. But for simple enhancement work, the involvement of a computer, rather like lens filters, should be inconspicuous. Here are a few pitfalls to be aware of, especially when combining elements from several photographs.

Light A sidelit subject in a backlit landscape looks phony. Ensure that shadows all point the same way. Likewise, the temperature of the lighting can be a giveaway; if the landscape is bathed in lovely evening light and your subject has been photographed on an overcast day, the mismatch is obvious.

Perspective and viewing angles If you want to combine two pictures, it is best if they share a common viewing angle: an animal photographed from ground level set against the sky is unconvincing. If you want to place a bird in flight into a landscape, its position in the frame should reflect how you saw it. Other factors, such as its size in the final image, will determine how high or low it should be in the composition. Perspective is implied not only by size but by clarity and colour, too; a distant subject is normally less clearly defined, especially if moisture is present in the air. If the landscape is lit by bright sunlight then the distant subject should contain more blue than one which is closer to the camera.

Scale By all means exaggerate scale to increase the sense of depth in a photograph, but if the implication is that a small subject is at the same distance from the camera as a larger one, then it is important to ensure that it is properly scaled.

Film characteristics While differences in the colour balance between various film stocks may not be evident after scanning, the characteristics of their grain structures are. If you want to place an element shot on 400 ISO into a landscape taken on Velvia, an inconsistency arises. Although this can be remedied to a certain extent with Gaussian Blur (to smooth out grain) and Noise filters (to create a grain effect), it is simpler to avoid putting extremes together, unless a specific effect is sought.

Inconsistent point of focus Just think how often you need to photograph an animal with your long lens wide open. If you are quite close, the chances are that some of the subject will be unsharp, especially if it is facing you. If you want to tell the viewer something about the animal's environment, then you might decide to make a digital montage, and take a second photograph of the background alone. The problem comes, however, when you try to combine the two; only parts of the subject are sharp, yet the whole of the surroundings are in focus. This looks very strange. One way around the problem is to photograph the main subject with a shorter lens than you would normally use; the lower magnification ratio means that more of it will appear sharp. Remember, though, that you will not be able to mimic the effect of using a longer lens by enlarging the subject in-computer without losing image quality. This is because the film grain is, by proportion, larger at the lower magnification. Alternatively, you can decide to go for a more 'photographic' look and use the Gaussian Blur filter to soften the background. Although details become obscured, it can still be sharper than in a conventional photograph, but without ruining the effect.

Smooth fur and hair One of the trickier problems encountered in digital work is making selections of very fine details such as ruffled fur, hair or whiskers. Quick selection methods such as the Magic Wand (see page 112) sometimes cut corners and fail to retain the detail along ill-defined edges, resulting in a smooth edge where there should be a rough one. The task is complicated if the furry subject we wish to select is photographed against a pale background and we want to put it against a darker one. For suggestions on meeting these challenges, see Making selections on page 112.

If there is one simple rule concerning the digital enhancement of wildlife pictures, it is this: the less

you have to do, the easier it is to make a convincing image. When you try to make up things that don't exist, you expose yourself to all sorts of biological and aesthetic perils. I've seen a picture of wolves which had, apparently, flown into a snowy clearing, since there was no sign of trails. In another, a cougar managed to find its way into a gorgeous clump of alpine wildflowers without crushing any of them. Macintosh magic, used this way, does neither subject nor photographer any credit.

It is ironic, perhaps, that the more work you undertake in-computer, the more time you need to spend just looking at the natural world if your images are to appear authentic. You need to acquire the observational skills of a painter, to notice aspects of light which, as a photographer, you will sometimes record without being aware of them. You need to know how light plays around the edges of a silhouette, or how the fur ripples above a muscle, or how far a stem flexes before it snaps. Seeing on this level is an intimate art.

Top tips

- Digital technology makes it possible for us to tell a more complete story about the subject or our experience of it than can be achieved by traditional photography. Experiences rarely happen in $\frac{1}{60}$ second.
- In undertaking extensive manipulation, ask yourself if you are remaining true to the spirit of the subject.
- The less work you need to do, the easier it is to avoid pitfalls. Digital enhancement is no substitute for good photographic technique.
- Inspiration comes from being out in the field, not sitting at a computer screen.
- Digitally altered images are no less 'real' than the raw image on the original film – both are only approximations of 'reality'. Indeed, a digitally finished image has the potential to match the experience more closely than the raw film.

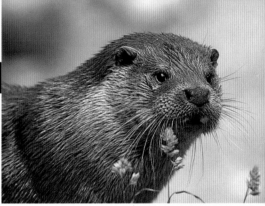

Otter

The original photograph, showing a captive otter against a brown background, was pretty uninspiring. However, since the background was changed to an attractive blue, the image has sold well. This is making up something that wasn't part of my experience; the picture is simply an exercise in commerce. Digital work by Steve Bloom.

Original photo: MF 300mm + x1.4 converter, beanbag, Fuji Sensia 100

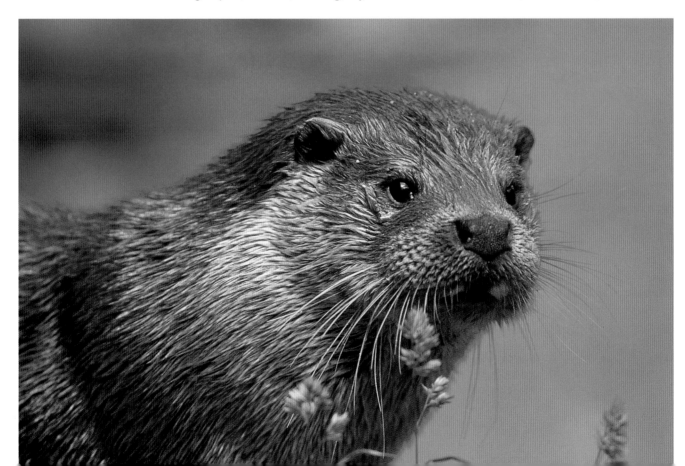

103

14 Essential Procedures and Techniques

I want to re-emphasise that, at the moment, shooting on film and then scanning the images is still a much better and more affordable option than using a digital camera. In time this may change, but computer-screen viewing can never compare to looking at a perfectly exposed transparency on a light box.

Taking the image into the computer

To convert the information contained in a continuous-tone photographic image into the string of binary code intelligible to the computer, transparencies (and negatives) need to be scanned. There are four main options: you choose depending upon the end use of the image, and how much you are able to pay in the pursuit of quality.

High-end drum scanners are still considered to produce the best quality results, able to resolve detail even in dense shadows and bright highlights, provided that they are present on the film. The piece of film is attached to a clear perspex drum which revolves at high speed. Since the film is flexed into a curve, a scan can be made of a uniform plane, which is trickier with a flatbed scanner. As the drum spins, a photomultiplier and its light source travel slowly over the film, reading its colour and density. This information is relayed to the computer and stored as digital files. However, these scanners normally require the film to be stuck to the drum with special oil, and many photographers have suffered the distress of seeing prized transparencies returned from magazines covered in 'scuzz' when post-scan cleaning has been unsuccessful.

While drum scanners are capable of producing outstanding quality, the scans are often expensive, and for some uses they provide more information than is needed. Imacon FlexTight CCD scanners, which also curve the film, are a little less costly than traditional drum scanners and, thanks to their sophisticated scanning software and wide dynamic range (4.1), provide a real alternative to drum scanning for top-quality reproduction. They do not require the film to be stuck down, but hold it in place in a flexible, magnetic metal mask. Running a close second are the top-of-the-range flatbed scanners which, with the software now available, can produce scans suitable for high-quality reproduction. However, the fact that the film surface is never completely flat (which flexing achieves) means that scan quality can vary depending on the state of the piece of film.

If your interest is mainly in making desktop inkjet prints, posting pictures to a website, or in lower-quality reproduction such as for newspapers, then a desktop film scanner should meet your needs. Like the FlexTight, these employ a charge-coupled device (CCD) chip (rather like an electronic film plate) to digitise the image. Good-quality machines offer an optical resolution of at least 2700ppi, with 36-bit depth sampling and a dynamic range in excess of 3.6 (see Chapter 3). Desktop scanners combine convenience with economy, and can produce top-quality images for the uses described above. I often try out ideas using my scanner and inkjet printer first, before going to a photo lab to have the transparencies scanned. From a business point of view, it is also invaluable for generating proposal sheets for magazines. These typically feature three or four photographs with text. Printed on glossy photo paper, an editor can view the images at least as well as they would appear in the magazine.

Kodak Photo CD

Although Photo CD failed to live up to the developers' expectations of mass-market appeal, the technology has been adopted by many professional photographers as a cheap alternative to drum scanning. Since the scan time is much shorter than a drum scanner's, the work rate is high, reducing scan costs. A Master Photo CD stores up to 100 images with a maximum resolution of 18Mb (Base 16), whereas the Pro Photo CD accommodates 25 scans up to 72Mb (Base 64) in size. Each image is stored in five (in the case of Master) or six different levels of resolution. Base 16 is a 70Kb file suitable for

Red Cuillins, Skye

The original slide was shot on neutrally coloured Kodachrome and had been projected to the extent that it was starting to fade. I set out to restore the colour and contrast in the picture.

I described to the scanning photo lab the look I was after; it is best if most of the colour and tonal changes are made at the scanning stage rather than later. The resulting scan was more lively than the original, but was also too blue. I used Curves (Image>Curves) to adjust overall contrast, making sure that the cloud didn't burn out, then selected the Cyan channel to enhance the red tones where the sun caught the top of the mountain. The blue in the shadows was selected with the Colour Range command (Select>Colour Range), and feathered to 20 pixels. I used the Colour Balance

controls (Image>Adjust>Colour Balance) (20 Yellow, 15 Red) to render the slopes more accurately. Finally, the foreground was selected with the Magic Wand

and a 10 pixel feather applied before darkening it in levels (Image>Adjust> Levels) to focus the eye's attention on the mountain.

Original photo: MF 300mm + x1.4 converter, beanbag, Kodachrome 200

Fox cub

Here is a straightforward problem we've all encountered: eye-shine. While I was generally pleased with the photo, the eye-shine (I'd had to use flash to lighten the shadows) ruined it because it was not what I had seen.

The 'good' eye was selected using a Magnetic Lasso, then copied over the other, using it as a position marker, and adjusted to size until it looked right. At the time I had the work done on the picture I had very few fox pictures and saw a commercial future for this image. It would have been hard to justify the expense of writing the image to film otherwise. Digital work by Steve Bloom. *Original photo: MF 300mm, TTL flash set to -1.7ev, Fuji Sensia 100*

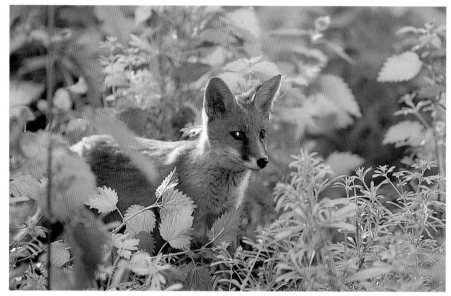

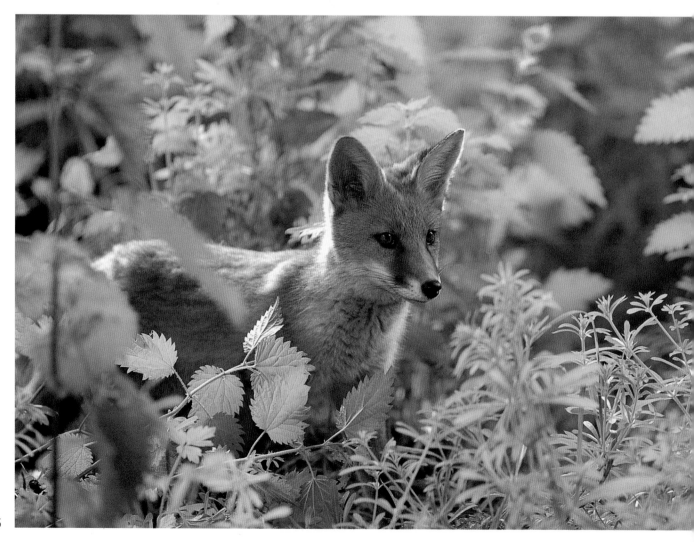

thumbnails and small images on a website. Base 4 resolution, at 280Kb, is adequate for layout roughs where the image will be used small. Resolution Base, with files of 1.12Mb, produces better quality output for presentations, while Base 4 (4.5Mb) has enough detail for high-quality inkjet printing of pictures up to postcard size. If you plan to have your pictures published, you really need to go up to the 18Mb Base 16 level. Assuming that the publication is being printed at 175 lines per inch (the so-called 'screen ruling'), this file size is adequate for images up to 14.5x21.6cm. The cost of having scans made onto Master CD is, in unit terms, very low, but you will pay quite a lot more to acquire that final level of resolution, Base 64. A 72Mb file will allow the use of your pictures up to A3 at a screen ruling of 175lpi.

Photo CD scans are versatile and represent good value for money. Unfortunately the scanners lack the dynamic range of a FlexTight or drum scanner, and slides with excessive contrast are not handled so well. Such differences as exist, however, may not be evident in print. Photo CDs also have the advantage that they can be read by a Mac or a PC, so you are not bound to one platform.

Once the scan is made, it has to be taken into your computer. Kodak Photo CDs are ready to load. Files created from a scan by a bureau are best loaded onto CD or a Zip disk. Only small files (less than 1Mb) will fit on a floppy disk. If you make your own scans with a desktop machine, they can go directly onto your hard drive, but don't let too many accumulate there (for further advice see Storing and Scanning on page 118).

Scan sizes

Bigger is not always better. In the case of images going to a website (see the Appendix), big files are definitely bad, since they take too long to appear on the screen and contain much more information than can be displayed. Big files take a long time to process, and unless your computer is armed with a great deal of RAM and a lightning-fast processor, you may wonder if you really needed a 72Mb file just to print a postcard (the answer, of course, is no).

A digital file's resolution is determined by the number of pixels – the little blocks of tonal and colour information – it contains. The more there are, the more detailed is the image. More pixels make for bigger files. Once each pixel is smaller than the film's grain, maximum resolution has been achieved; in practice, a 35mm (24x36mm) piece of fine-grained film would need to be scanned to 2280x3420 pixels. That equates to a scanning resolution of about 2400 pixels per inch. The number of pixels used to construct the image – expressed as pixels per inch – has a direct bearing on the output resolution. High-quality reproduction in magazines and books can be achieved with about 300ppi, so a high-quality 35mm

scan, output at 10x8in, would contain 342ppi. The larger you want the output to be, the fewer pixels per inch there are to express it; this is overcome by scanning at a higher resolution. To summarise, then:

pixel size = the dimensions of the output x the resolution in ppi (3420 = 10in x 342ppi)

Altering the image dimensions involves the process of resampling. If you want to make the picture smaller (and effectively have more pixels than you need because of the resolution at which the image has been scanned), resampling discards information that already exists. But if you want to make the image bigger, then additional pixels have to be invented – this is known as interpolation. Although limited amounts of resampling in either direction are not too detrimental to image quality, excessive application is, and it's best to scan with the size of the final output in mind. Kodak Photo CD scans, with their different levels of resolution, provide one convenient way to minimise the need to resample.

I have avoided referring to file sizes here because there are factors other than simply scanning resolution which determine final file size. For instance, if the file is converted from RGB to CMYK, its size will automatically increase by 25 per cent, owing to the addition of the black channel. Image editing also usually adds to its size.

But, as a rough guideline, the 2400ppi scan from the 35mm slide equates to about 22Mb of RGB information. If you scan at that resolution, therefore, you will have about 300ppi of information in a print whose long dimension is 10in. For much bigger outputs, a higher-resolution scan is called for.

Colour space

Slide film incorporates three layers of dye: yellow, magenta and cyan. These absorb red, green and blue wavelengths of light. The resulting image is a record of these colours, and is said to occupy the RGB colour space. When our pictures are drum or flatbed scanned, there is the option to have them saved as RGB files. In contrast, Kodak Photo CD scans are in the YCC colour mode, which is subsequently converted into whichever colour space you want to work in.

Working in RGB has a lot of advantages. The gamut of the RGB colour space – that is, the range of colours it contains – is enormous, even including some that are invisible to us. Desktop scanners work within the RGB colour space, so it should be possible to achieve a close match between the colours in the scanned image you see on your monitor, itself an RGB device, and those of the original picture. Output to reversal film, Pictrography or digital prints on photographic paper all require RGB files. And although desktop inkjet printers use (as printing

presses do) cyan, magenta, yellow and black inks (CMYK), they normally require the files to be exported in RGB form; the printer's software then undertakes the conversion. Finally, only within the RGB colour space can you have access to the full range of features in some image-editing programs, such as Adobe Photoshop.

Complications can arise when digital images are destined for the printing press. Since printing is done with cyan, magenta, yellow and black inks, RGB files need to be converted to CMYK ones. The CMYK gamut is much smaller than the RGBs. This is one reason why pictures in print rarely share the vibrant colour and tonal depth of the original transparency. Even when digital files are output as RGB files to reversal film, they will still need to be re-scanned and brought within the CMYK colour space before they can be reproduced. As you work within RGB on-screen, you will, initially at least, spend quite a lot of time switching to a CMYK preview to see how the picture would look in print and hitting the gamut warning command to see which colours, visible in RGB, won't appear in CMYK. And since different printing presses in different parts of the world use different types of CMYK conversion for different types of publication, and print on different papers, you might end up storing a large selection of CMYK versions of the same picture. Each CMYK file is also 25 per cent larger than its RGB equivalent because of the additional (black) channel. If you are required to work in CMYK, find out the particular CMYK ICC profile used by the printer before you make a conversion from RGB. Otherwise, present digital images in RGB form, without any unsharp masking, and let the user make the conversion. (Issues relating to output are discussed in more detail on page 119.)

Setting up your digital desktop

What appears on your screen must accurately reflect the digital information contained in an image file. If it does not, you cannot be sure how changes will affect it. A properly calibrated monitor is crucial to the success of the whole enterprise. I had my monitor calibrated by a service bureau, but Photoshop 5.0, in the Adobe Gamma Control Panel, enables the user to undertake the job him- or herself. Once the monitor is properly calibrated, the settings should not be tampered with. The monitor needs to be on for at least 25 minutes before calibration, to give it time to reach its full brilliance.

Siting is important, too; coloured walls affect our perception of colours on the screen, and direct light diminishes our appreciation of contrast. My office is out of direct sunlight, and has grey wallpaper and black blinds which I pull down when I'm working on

an image. It's a rather depressing environment for anyone who likes to be outdoors, but controlled lighting is necessary if our time in front of the screen is to be well spent.

If you use Photoshop, it is best to allocate almost all of your RAM (excluding, of course, that needed for the operating system) to the program. As we saw in Chapter 3, Photoshop borrows additional memory from the hard disk (so-called 'scratch disk' space) if it runs out of RAM, but some operations become slower. Macintosh users allocate memory by clicking on, but not opening, the Photoshop application icon, then selecting File>Get Info>Memory. You can then type in your preferred allocation to Photoshop. A Macintosh's virtual memory must be turned off to avoid conflicts with Photoshop's own version of it. It may seem time-consuming to have to shut down Photoshop to open another application, but such is its hunger for memory that on balance, you will save time by working this way.

Your hard disk should be kept as clear as possible and have at least as much space available as you have allocated to Photoshop in the RAM settings. Photoshop can use only as much RAM as is available in the scratch memory. So, if you have only 100Mb of free hard disk space left, even if you have 128Mb of RAM allocated to Photoshop, it can use only 100Mb. Ideally, 450Mb or more of free hard disk space is recommended. An alternative is to have a separate external hard drive used exclusively as a scratch disk.

You should also ensure that you have enough video RAM to display true colour at high resolution on screen. You could consider fitting a graphics card which will also shorten the time for an image to be redrawn on screen.

A number of photographers actually use two monitors when working in Photoshop: a large, high-quality one for the image itself, and a smaller, secondary one for the palettes. If you have the space and money, this is a good option, allowing you to make full use of a large screen.

Assessing and preparing the scan

Before doing any work on a scan, it is always prudent to save one version of it in its original form. If the image has been scanned to Photo CD, then you have that saved already. Otherwise, save the file, then save the first subsequent change with the Save As command.

Global adjustments to an image's colour balance and tonal values are best made during the scanning process; the fewer changes that have to be made afterwards, the less pixel information will be lost. Almost inevitably, however, you will want to tweak a bureau-scanned image.

Willows, Leeuwarden, The Netherlands

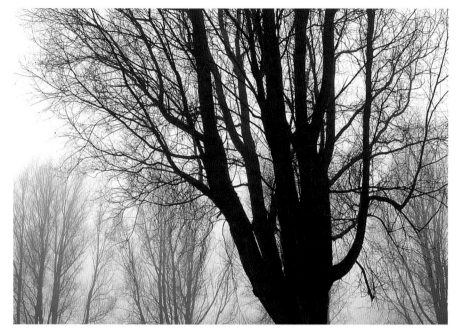

This image needed only a few minor adjustments to the colour balance and contrast to bring it into line with my memory of this cold and bleak December day in Friesland.

Using Levels (Image>Adjust>Levels), I increased contrast to ensure that the willow in the foreground would be rendered almost black and that the sky would come out a clean white. I then went to Colour Range (Select>Colour Range) to pick out the trees in the background. This I did by clicking on Selection in the dialogue box, sampling off the trees behind, then adjusting the Fuzziness setting until only they were selected. Using Colour Balance (Image> Adjust>Colour Balance), I increased the blue in the selected area to recall the coldness of the day.

Original photo: MF 55mm, Fuji Velvia

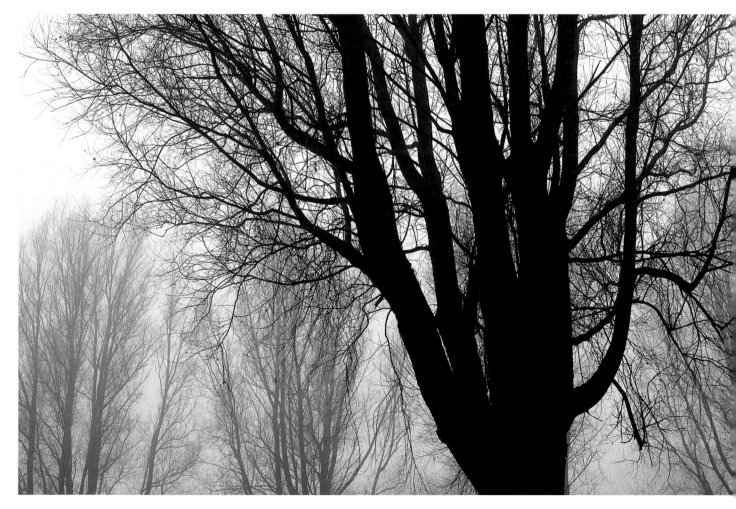

Snowy owl

Although the exposure was good for the bird, the photograph lacked impact because of a weak blue sky. The bird's left eye was also quite heavily shaded.

I started off by making a slightly feathered selection of the sky with the Magic Wand (tolerance 50), then enhanced its colour by increasing Contrast (Image>Adjust>Brightness/Contrast). This emphasised 'noise' present in the sky so, staying with the sky selection, I applied a Gaussian Blur (Filter>Blur> Gaussian Blur) to it with the pixel radius set to 4.0, which smoothed it away. With work on the sky complete, I used a Magnetic Lasso to select the bird's dark eye and then lightened it in Levels (Image>Adjust>Levels).

Original photo: AF 500mm, beanbag, Fuji Sensia 100 [C]

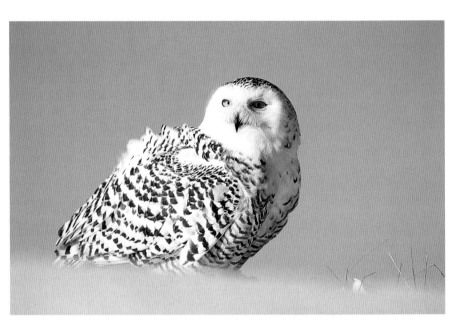

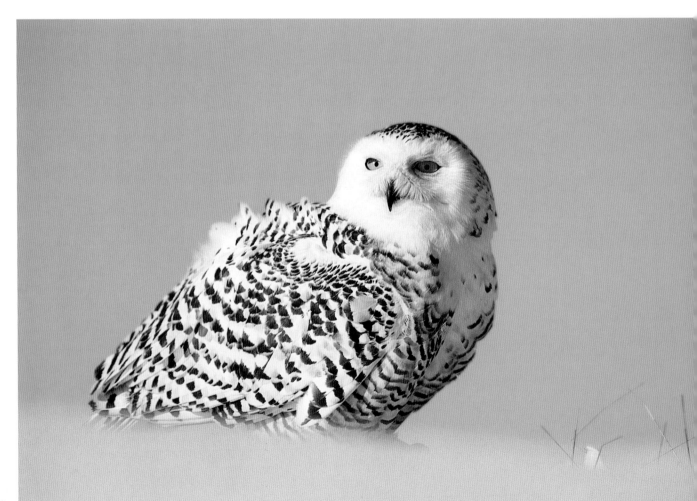

It is worth spending a few moments assessing the quality of the scan before starting to work on it. Allowing for the inherent differences between viewing the original transparency on the light box and the scanned image on screen, are there any marked differences in tonality or colour balance between the two? If so, these may have to be corrected. In Photoshop, select View>Actual Pixels and work your way systematically around the image, checking for dust; if there is an excessive amount, the bureau clearly hasn't taken time to prepare the film for scanning and you would be best to go elsewhere in future. Bear in mind that while previewing a scan is easy with a Kodak PIW, FlexTight scanner or desktop film scanner, this is not so with drum scanning, where such defects come to light only once the job is done.

Next, have a look at the image's histogram (Image>Histogram), with the whole area displayed. This will allow you to decide whether the scan has held shadow and highlight detail sufficiently well. The histogram's scale runs from 0 (pure black) to 255 (pure white), and the number of pixels at each one of these 256 levels of brightness is indicated. In a 24-bit colour image there are millions of colours, each represented at one of 256 levels of brightness (luminosity values). Spiky histograms suggest a discontinuity of colours resulting from a poor-quality scanner or bad scanning. An image with a full tonal range should be represented over the whole width of the histogram.

Check to see whether what appears black on screen will print as black. With the Info palette open, go to Info options and select Total Ink. As you move over a CMYK image, the colour values of the pixel under the cursor are given; the sum of these should exceed about 280 if that pixel is to print black. Decide which areas of the picture should be black and sample from there. If the total of the CMYK values doesn't reach that figure, get another scan made, by someone else.

If you are happy with the scan, it makes sense at this stage to crop and size the image (for final output) before carrying out further adjustments; there is no point in changing pixels which are only going to be discarded at a later stage.

Basic procedures

Setting levels

The first thing you must do to your cropped scan is to set highlight and shadow values. The object of this exercise is to maximise detail in all the tones in the picture. A good way to do this is in the Levels dialogue box (Image>Adjust>Levels) rather than the Brightness and Contrast controls, which are too imprecise for critical work.

The Levels histogram displays the number of pixels at each of the 256 levels of brightness in a normal 24-bit image. Paler tones are represented towards the higher end of the scale, darker ones at the lower. An image without extremes of light or dark will have most of its pixels bunched in the middle of the histogram. In order to expand the tonal range of an image, the Input sliders are moved so that they just touch each end of the histogram, where the first and last significant pixel counts occur. If the darkest pixels are at level 9, for example, adjusting the shadow Input slider to that point will then assign that to level 0 – pure black. All the levels between 9 and 255 are then reorganised accordingly. Similarly, if you move the highlight Input slider to level 240, pixels at that value now represent the other tonal extreme – pure white. Any stray pixels above and below these values are lumped in with the levels at which the Input sliders are set. Increasing the tonal range in this way does not alter the colour balance of the image. With the tonal range set, you can then use the mid-tone Input slider to adjust the brightness and contrast of these values.

While Levels can be used to correct most photographs, especially those without extremes of contrast, Curves offer the ultimate control, although they are more complicated to use.

Curves

The Curves settings offer the Photoshop user the most precise control over colour, contrast and tone in an image. Changes may be applied overall, to one or more colour channels (such as red or green), or to a specific range of tonal levels. With Curves, it is possible to modify highlight values without affecting mid-tones and shadows, and conversely, to reveal shadow detail (assuming it was present in the scan) without burning out highlights.

The default diagonal line in the Curves dialogue box (Command-M, or Image>Curves) represents the Levels histogram as if seen directly from above, where Input and Output values are the same. In an RGB image, the origin indicates level 0 and the end of the line level 255. In a CMYK file, highlights are to the left (this can be reversed by clicking on the grey ramp) and the values are percentage ones (again, clicking on the ramp changes these to 0–255). The Input levels (original values) are shown on the horizontal axis; the new ones (the Output levels) appear on the vertical one. Modifying the shape of the curve effectively makes three-dimensional changes to the image's colour, brightness and contrast characteristics.

By dragging the cursor over the image in the composite RGB channel or one of the CMYK channels, the tonal value of the pixels under the cursor is shown on the graph. That value, and up to 14 others, can be fixed by either clicking on the graph or typing in values. This way, you define those tonal values you want to remain unaltered, while

changing the others until they look right. This applies equally to making colour corrections.

Ideally, major adjustments should be made at the pre-scan stage using the scanner's own software, rather than afterwards in Photoshop; this will result in a tighter histogram with a more complete tonal range. If you contract out your scanning this is not always a practical option, so it is best to discuss with the bureau beforehand any significant changes you need made to colour or tone.

Making selections

Sometimes, the corrections you want to make apply to the whole image, but more often you need to pick out particular areas for attention. The method you use to select these areas varies according to their edge characteristics and tonal relationship to adjacent areas. Photoshop offers four main sets of tools for making selections: the Magic Wand; different forms of Marquee; the Colour Range settings; and the Pen, with which you draw paths.

You will discover very quickly that subjects clearly separated from the background are much easier to select than those which blend with it; good in-camera technique speeds up the job once the image is on screen. The Magic Wand tool, though not very sophisticated, often suffices; determine whether the subject or the background has more uniform tones, then click on it to select. A line of 'marching ants' appears, to indicate the boundaries of the selection. The selection can be augmented by holding down the Shift key and clicking on another area you want included. To deselect an area, hold down the Options key while clicking. If you have selected the background (because it was more evenly coloured) but actually want to select the subject, simply make an Inverse selection (for this use Select>Inverse or Command-Shift-I).

Marquees provide a way to select regularly shaped objects with ease. Along with the Lasso tools, they can be used to define a small area of the picture within which a more precise selection is made. Photoshop 5.0 introduced the Magnetic Lasso (and Magnetic Pen) which clings to the edge of a subject when it is clearly separated from its surroundings. These can be useful for selecting eyes.

The Colour Range method allows very complex selections to be made, based on colour values. In the Sampled Colour mode, the extent of the selection is determined by the Fuzziness setting. A low number means that only pixels very close in colour value to the sampled pixel are selected; the range of the selection is extended at higher settings. Hit the Selection button in the dialogue box so that you can then see the selected pixels. Add to the selection by clicking the sampler on the image, with the Shift key depressed. Colour Range is more sophisticated than it first appears. As well as the areas defined by

marching ants, application of a Quick Mask will show that many other pixels are also partially selected (seething maggots rather than marching ants...), within the parameters that have been defined by the Fuzziness setting. The result is a selection which appears to blend more smoothly with unselected parts of the picture, especially when feathering (see below) is applied.

If the subject is hard to define by these methods, a hand-drawn selection with one of the Pen tools might be the best alternative. Paths, even around curved objects, can be drawn with great precision and saved as selections. These in turn can be converted into masks, to allow work to be carried out on the rest of the image in that layer without affecting the masked areas. Selected areas can be saved as either mask or alpha channels, and this will allow you to return to work on the image at a later date without having to redo the selection.

Selection tools can be used in conjunction with others to refine a selection. For example, you may be dissatisfied with the edge detail resolved by a Magic Wand selection. Once saved as a mask channel (Select>Save Selection), it can be modified, perhaps by using a fine paintbrush to reveal some of the detail not included in the original selection.

Although Photoshop's selection tools are highly capable, some jobs are more easily accomplished with specialised software. Among the stand-alone programs, Ultimatte KnockOut is especially good for making selections of subjects with very irregular or ill-defined edges, such as mammals with hairy coats, or steam. The technique is as simple as drawing a rough circuit within the subject to be selected and one on its outside. After performing some clever mathematics, KnockOut generates a mask which results in a highly accurate selection that includes extremely fine detail. As with other selection procedures, low levels of 'noise' (such as film grain) improve performance. KnockOut is very RAM hungry (five, ideally eight times as much as the size of the file is recommended), so it is advisable to operate with all other applications closed. The file size, and hence processing time, can be reduced by cropping out as much of the background as possible before making the selection.

A selection normally needs to be feathered – that is, to have its edges softened – before being pasted onto a background. Although this results in a slight loss of sharpness, the blend is much more convincing. How much feathering to apply varies with each image. A setting of 1.0 or 2.0 is often enough to take the bite off the edge of a selection, but much higher settings are applicable when you want to soften the edge of a selection such as a sky, or values that have been acquired by Colour Range.

Problems can arise when a subject photographed against a pale background is selected and then

Raven, Yellowstone National Park, USA

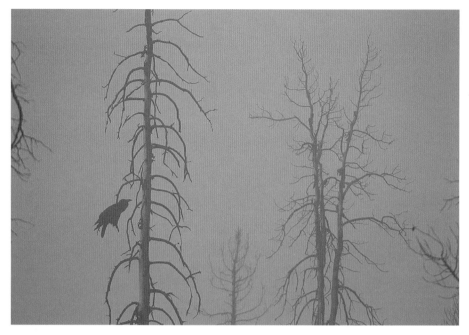

On a very still, foggy day high in the Washburns I was entranced by a pair of ravens as they moved between the fire-scarred lodgepole pines, croaking to each other as they went. Unable to get as close as I would have liked, I used the trees to fill the space around this bird.

The final transparency was messy, and the fog had robbed the scene of much of its colour. After cropping the image, I set Levels (Image>Adjust> Levels) and then made an overall colour change (Image>Adjust>Colour Balance) to boost the intensity of blues present on the original film. A little magenta was added. Removal of the unwanted trees and branches was done with the Cloning tool.

Original photo: AF 300mm + x1.4 converter, Fuji Sensia 100

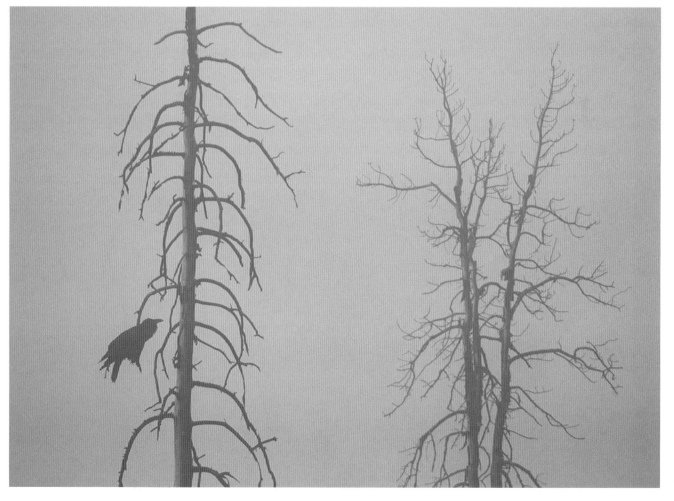

Solomon's seal

Wildlife photographers have traditionally been reluctant to borrow techniques from other fields to incorporate into their own. I used two from the fashion studio – a brilliant white background and soft focus – to give the original image the appearance of an old botanical illustration. The specimen was garden grown and photographed in the studio in front of a piece of white perspex. One light from behind gave it a quality of luminescence; this was balanced by reflectors, and another light placed at the front.

Once scanned, it was evident that the background was not as clean a white as it could have been. Uniform backgrounds like this make selection with the Magic Wand facility both practical and effective. Once all the white areas were selected, I used the Fill command to replace them with pure white (level 255) (Edit>Fill. Use: White, Opacity 100 per cent).

Softening the image involved duplicating the background layer (Layer>Duplicate Layer), applying a Gaussian Blur with a radius of 10 pixels (Filter>Blur>Gaussian Blur) and then taking the Opacity back to 65 per cent so that some of the sharpness of the

underlying layer was visible. The Darken blending mode in the Layers palette gave me the dark edges to the stem and flowers that I needed to suggest an illustration.

Original photo: MF 55mm, 2 x TTL flash, Fuji Velvia

pasted onto a darker one (or vice versa); extra pixels sometimes come along too and need to be removed. In the Layer menu, Matting options provide a number of ways to overcome this. Remove White Matt removes pale pixels from the edge of the selection, which now show on the background. Defringe has a similar effect. Previews are best viewed with the image highly magnified before applying the change. Contract (Select>Modify>Contract) shrinks the size of the selection by the number of pixels specified. As with so many procedures in Photoshop, there is generally no right or wrong selection method to apply. It is simply a case of picking the one which works best for a particular image.

Layers

Layers are arguably one of the most useful features included in today's image-editing programs, in that they allow for the easy, highly controllable montaging of elements taken from several photographs. They operate rather like sheets of acetate added one on top of the other, each containing different elements of one or more pictures.

When an image is opened for the first time in Photoshop, it appears as the Background in the Layers palette. If you make a selection, it can be put on a separate layer so that it is unaffected by changes made to the rest of the image. In fact, you can create up to 99 layers, each one separately controllable and linked to any others you want. With the Layer Opacity set to 100 per cent, any part of the top layer which is not transparent conceals everything beneath it; reducing the Opacity makes the next layer down more visible. Typically, you would select and cut a subject from one image file and paste it into another (Edit>Paste, or Edit>Paste Into if it is being applied to an area already selected in the first image). Those areas outside the selection boundary are now transparent, allowing the background to show through. The subject itself, now occupying layer 1, completely conceals part of the background image. As you add more layers, you can alter their sequence by making the layer active (clicking on it once in the Layers palette) and dragging it to the black line on the palette between two other layers.

Adjustment layers offer a convenient way to preview changes to colour and tone, as they would apply to all the layers in a file; the adjustment layer sits on top, effectively acting as a filter. This is faster than performing changes to layers individually.

The History palette in Photoshop 5.0 allows multiple undos, and saving different elements on separate layers may therefore seem a bit unnecessary. But you'll find out why you should the next time you save the unfinished file: the History goes. History is not saved with the file, but the separate layers are.

Photoshop offers a host of methods to blend layers, but Normal is the one I reach for most often. Blending should not be confused with flattening; it is concerned with how the different layers merge with each other. Flattening, on the other hand, brings the elements from all the layers into one. Until an image is flattened (Layers> Flatten Image), the file can be saved only in the native Photoshop format; this is the only one to support layers. It is good practice to save two copies of a file, one flattened in the appropriate format (for example, TIFF or EPS) and the other in the Photoshop format, with the layers intact. When, inevitably, you decide to make changes to the image in the future, you will not need to start from scratch again.

Blur and noise

Photoshop contains a large array of filters, and many more are available as plug-ins. Gaussian Blur, Add Noise and Unsharp Masking are the three that you are likely to use most often. Alternative blurring, noise and sharpening filters lack the refinement and control of these three.

I think of Gaussian Blur as the out-of-focus filter. With it, selected areas can be rendered in varying degrees of softness, mimicking the effect of depth of field. When I paste a subject into a new background, I often apply a Gaussian Blur to the surroundings. Not only does this give the image a more photographic appearance, but it can also make hard-edged selections look more acceptable, especially if a strong blur (greater than about 20 pixels radius) is applied to the background. The filter is also very useful for smoothing out 'noise' (such as film grain) and brush strokes. Beware, however, of using it in areas with graduated colour, since tonal transitions may become banded.

If you magnify a blurred area, you'll discover that Gaussian Blur has smoothed away all the grain of the original image. If this is done locally, rather like excessive Cloning, the effect stands out from the rest of the image where grain is still present. The solution is to recreate the grain using the Noise filter (Filter>Noise>Add Noise). The amount to apply varies with the film's grain characteristics; I use a setting of 5–8 when the original photo was shot on Velvia. More gritty films such as Kodachrome 200 require a higher value: monochromatic, Gaussian Noise is usually most appropriate.

The best way to assess noise needs is simply to magnify the image and compare your settings with parts of the picture which have not been blurred. Sometimes it looks better if the noise is faded slightly (Filter>Fade Add Noise) using the Opacity slider in the dialogue box. Likewise, you can use the Fade Gaussian Blur command (Filter>Fade Gaussian Blur) to allow more of the sharpness of the original image to show through. The result is an attractive soft-focus

115

effect that can also appear to reduce excessive contrast caused by directional lighting. The alternative method is to make a duplicate layer of the one to be softened, apply Gaussian Blur to it, then reduce that layer's Opacity so that some of the sharpness of the underlying layer is revealed.

Unsharp masking

Why should you want to apply an Unsharp Mask to an image? The answer is: to make it sharper, by increasing edge contrast. Even high-end drum scans need some degree of sharpening before reproduction. The process does not create sharpness which was not present in the original picture, but rather it compensates for the sharpness which is lost during scanning. Kodak CD images should always be sharpened, because the scan must be slightly soft so that it can be accommodated at the different levels of resolution on the disk.

In the Unsharp Mask dialogue box (Filter> Sharpen>Unsharp Mask) we are presented with three parameters: Amount, Radius and Threshold. Images for on-line use (for example, as an e-mail) require less sharpening than those for reproduction, and an Amount setting of around 50 is fine. It is easy to judge on screen how much is needed: apply too much and edges become jagged; for output to the printed page somewhere between 150 and 200 per cent is usually more appropriate. As a general rule, the higher settings should be reserved for very high-

Dog rose

The difference between animate and inanimate was heightened here by rendering the stones in monochrome while retaining the colour of the plant's leaves and petals.

I first selected the leaves and bud using Colour Range (Select>Colour Range), then set the Fuzziness to 20 and clicked on different parts of the leaves until I had selected all the green, without picking up any of the background. With the Shift key depressed (to add to the existing selection), I drew a tight freehand Lasso around the petals and did another Colour Range selection from within. By narrowing the selection area, the risk of including some of the tonally similar stones in the selection was reduced. The selection – leaves and flower – was saved as an Alpha Channel (Select>Save Selection). Selecting Inverse (Select>Inverse), I changed the rest of the image to monochrome in the Channel Mixer (Image> Adjust>Channel Mixer), adjusting Magenta and Yellow to get the contrast I was seeking. Returning to the Alpha Channel, I used Curves (Image>Adjust>Curves) to reduce the brightness of the highlights on the petals without affecting the shadows, and to alter their colour bias towards a warmer hue.
Original photo: MF 90mm, diffusion sheet, Fuji Velvia

resolution scans or you will end up sharpening the noise sometimes associated with lower resolution ones.

Radius refers to the number of pixels away from the subject's edge whose contrast will be increased. The default setting, 1, is normally ideal; go above 2 and unattractive 'haloing' can occur. The Threshold setting dictates how much difference in contrast there needs to be between neighbouring pixels before sharpening is applied. Hence, at a setting of 0 everything is sharpened, with the risk of introducing noise into areas where it was not already present. When a picture features large areas of smooth tones – for example, skies or out-of-focus backgrounds – select a higher Threshold value, perhaps 3 or 4. Note that a higher setting also prevents grain from being sharpened.

Unsharp masking can be applied to individual colour channels. In an RGB file, scanning noise (unwanted artefacts and streaking) is always most evident in the Blue channel. You would therefore apply the sharpening only to the Red and Green channels to avoid making the problem worse.

It is best to save the image without an Unsharp Mask, because once it's on, it won't come off again. When the destination and output size of an image is known, an appropriate mask can be applied and the file then saved using the Save As option, so as to leave the original unaffected.

Saving and storing

File formats

Photoshop supports a wide range of file formats, but there are only a few that need concern us.

While working on a picture, it is wise to save changes as you go. If it has several layers and you are not yet ready to flatten the image, there is no option at this stage but to save it in the native Photoshop format. Other commonly used formats such as JPEG, TIFF and EPS can, however, also save Paths within a flattened image.

Once the image is completed and flattened, the format you choose will be decided to some extent by the end use of the picture. In the Appendix, I describe how to save images as JPEGs (Joint Photographic Experts Group) for e-mailing and website use. For general applications where the need for data compression is less acute, JPEGing should not be the first choice because of the loss of data which occurs, especially at high levels of compression. Nevertheless, anecdotal evidence abounds to suggest that for desktop printing applications, the loss of information in a JPEGed image is not evident in the final print.

The digitised pictures in this book were presented to the designer as EPS (Encapsulated PostScript) files, the format preferred when the image is to be taken into a page-layout program such as Adobe Pagemaker (and its successor) or QuarkXPress. The EPS format option is available for both RGB and CMYK files. PostScript is a language created by Adobe to assist in proofing pages where images have been imported into a layout application. You may have read that EPS files will print properly only through a PostScript printer. In practice, if you want to produce a desktop proof of the image itself using an ordinary inkjet printer, it makes no difference whether you have saved the file as an EPS or as a TIFF; the printed results are indistinguishable.

TIFF (Tagged Image File Format) is a commonly used format which can be read by both Macintoshes and PCs. Magazines that are geared up to accepting digital files on CD or Zip disk normally request that they are saved as TIFFs. Similarly, if you send digital images to a bureau for output as film or prints, there is normally a preference for TIFF files. Although the degree of compression possible in a TIFF file is very small compared to a JPEG, it does make a difference and, importantly, there is no loss of data involved. Nevertheless, LZW (Lemple-Zif-Welch) compression does mean that the file takes longer to open and save so some photo labs prefer it if the files (with layers flattened) are supplied uncompressed.

FlashPix is a relatively new file format capable of high degrees of compression without the loss of data, and, in time, it may overtake TIFF in popularity.

Moving and storing files

While CDs (and more recently DVDs) are ideal for archiving finished images, not least because of their stability and low cost, once a file is burned onto CD that's it, unless you use the much more expensive rewritable CDs. If you are working on a number of images at once, haven't completed any of them and don't want your hard drive blocked up, then some form of temporary storage medium is called for. At the time of writing, Zip disks are very popular. Drives are relatively inexpensive and the disks themselves, though not as cheap as CDs, are still reasonably priced. Zip disks hold 100Mb or 250Mb of data. Alternatively, look at Jaz drives, whose disks can currently hold up to 2Gb. Here is a useful tip: if the Macintosh you use still communicates with its peripheral devices via a SCSI interface (these have been replaced on newer models by FireWire connections), ensure that the Zip drive (if you don't have an internal one) is first in the SCSI chain.

Writing files to CD is as simple as dragging the file name into a dialogue box. If you want to write more images to the same, non-rewritable CD in future, select the 'Write Session' option rather than the 'Write CD' one. Be aware, however, that if you do this on a Macintosh, the disk may not be readable on a PC, and vice versa. Similarly, computers with DVD drives which can read CDs may have trouble with

files written as sessions. It is best to wait until you have enough images to fill the CD, or simply half-fill and then lock it. CDs are not expensive.

Output

The majority of nature photographers have, over the years, become used to viewing and assessing their pictures in slide form. But the digital revolution is forcing a rethink. Digital files *can* be written to reversal film, producing an image scarcely distinguishable from an original transparency, but the cost is very high and we should ask ourselves why we are doing it. If the image is destined for publication, it will need to be re-scanned. Would it not make more sense to provide the user with the digital file, avoiding the need for another generation? If you or the user wants to see hard copy (rather than an image on screen), is there really going to be any difference in quality between a Pictrography print or a 5x4in transparency when both are made from the same digital file? There is, of course, a fundamental difference between a medium through which light is transmitted and one from which it is reflected, but when it comes to sharing that image with others, it is going to end up either on the printed page or on a projection screen – in other words, as a reflected image. The absolute quality of a transparency is seen by few other than the photographer at his or her light box. As picture libraries (and their clients) embrace digital technology, the demand for film of digital files will, we should hope, diminish.

Output to film

In Chapter 3, I briefly mentioned the different types of film writer (LVT and analogue) which are used to make a transparency from a digital file. I would simply reiterate that when you provide a photo lab with the file, ensure that it contains enough information so that pixel size is smaller than grain size. Once you have reached this point there is no more detail left to be resolved. In practice, a 5x4in output from a 35mm slide, written at 4000dpi, equates to an RGB file size of around 70Mb. Assuming that the original slide was top quality, and that standard has been maintained during scanning and enhancement, it should be possible to make perfectly adequate 70mm photographic duplicates from the 5x4in output film. Check with the photo lab for their requirements in terms of image format, whether the image should be unsharp masked (which it almost certainly will), if it needs to be 'flattened' (if it is composed of several layers), and its dimensions.

Prints

A desktop inkjet printer is convenient, relatively cheap to purchase and of remarkably high quality. But as we have seen previously, the inks tend to fade quite quickly and are slow for volume printing. Nor are the prints suitable for scanning for high-quality reproduction. If the cost of writing files to transparency film doesn't appeal, Fujix Pictrography prints are a much cheaper way to produce 'final art' – that which is ready for presentation to a repro house for scanning.

Pictrography is a process which exposes silver-halide donor paper to coloured laser diodes; the exposure is then transferred onto receiving paper. Pictrography machines are RGB devices (and therefore are best supplied with RGB files), using cyan, magenta and yellow dyes (rather than inks), and produce images with a continuous, photographic quality printed at up to 400dpi. Importantly, too, the glossy prints have a permanence on a par with regular colour prints – rather longer than inkjet prints. Print prices are broadly comparable with having an R3 or Illfochrome print made from a transparency, although of course the image has to be scanned in the first place.

Files can also be printed directly onto photographic paper using digital printers such as those from Gretag. Rather like LVT film writers and Pictrography machines, these belong in the photo lab. Prints produced this way are normally cheaper than Pictrographs and the print quality is very good, although under close inspection the lines which make up the picture can be seen. If you want to present digital prints as final art, for best results make sure that they are larger than the final reproduction size.

Top tips
- Take time to learn the basic procedures thoroughly before embarking on the fun, creative side of digital imaging.
- Get your monitor properly calibrated before doing any imaging work.
- Scan only as big as you need for the desired output – bigger is not always better.
- If you can, work in the RGB colour space rather than CMYK, but remember that once output to print – which uses CMYK inks – the colours may look slightly different.
- Do not allow your hard disk to become clogged up with half-finished images: download to Zip disks or even CDs, which are very cheap.
- If you want to hold the finished image in your hand, consider a Fujix Pictrograph output rather than transparency film – it is much cheaper and is suitable for scanning for reproduction. Although inkjet prints are good for reference proofing, they are generally unsuitable to scan for high-quality reproduction.

15 Creating Images Step by Step

In each of the following projects I first explain the concept behind the finished image, and then describe in detail the steps taken to achieve it.

ALL BUT ONE of the pictures accompanying this chapter were created specially for this book. It therefore made sense to prepare the digital files in a form which would make output to the printed page as straightforward as possible. The original slides were scanned onto Kodak Pro CD and then taken into PhotoImpress, which enabled batch conversions and overall corrections to be done quickly. Now converted to CMYK files, using the ICC profile suggested by the printer, the files were opened in Adobe Photoshop 5.0, where the enhancement work was carried out. Ultimatte KnockOut was used for one of the more difficult selections. Once completed, the files were written to CD and presented to the publisher along with reference prints from my Epson inkjet printer. In the normal course of events, without a specific end use in mind, I would work in RGB and present the digital files on CD as unsharpened RGB TIFFs for the user to convert. It seems likely that, as more and more photographers offer their work to publications in digital form, the current insistence on ready-converted CMYK files will be relaxed.

The procedures I have used to arrive at the final image are in no way the only ones, or necessarily even the fastest, that will achieve the desired result; learning Photoshop is an on-going process. The shortcut keystrokes mentioned are relevant to Macintosh users.

Black grouse

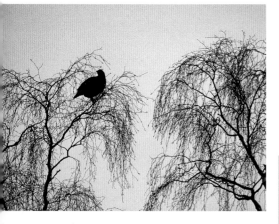

Concept: I find it hard to convey the impression of gathering night with conventional techniques. At that time, I perceive things as obscure and granular. The original transparency, even though it was made on grainy Kodachrome 200, failed to reflect that.

Procedure: We started off by adjusting Levels (Image>Adjust>Levels or Command-L) so that the bird and birch branches would come out as solid black and the background (sky) as white as possible. On another layer, we selected a dark blue from the Swatches (Window>Show Swatches) that was similar to the colour of a clear sky at dusk and then added a gradient to it, to represent the lighter horizon. Uniform, Monochromatic, Noise (Filter>Noise> Add Noise) set at 30 was applied to this layer lying below the one with the bird and trees on it. Working in layers, the grain (Noise) was added only to the background, rendering the shape of the bird and branches more clearly. Digital work by Alan Imrie and Niall Benvie. *Original photo: MF 300mm + x2 converter, beanbag, Kodachrome 200*

Drystane dyke

Concept: One of the appealing aspects of Eliot Porter's landscape work was the way he challenged our thinking about the colour of natural objects. In his photographs, rocks were just as likely to be blue or green as grey. Drystane dykes (built without mortar) are a common feature in upland Scotland, and in this image I aimed to highlight how lichens thriving in the clean air lend colour to stone. In making the original photograph, I spent an hour looking at this particular dyke until I found this arrangement of three heavily encrusted rocks.

Procedure: As usual, I adjusted Levels (Image>Adjust>Levels or Command-L) to expand the image's tonal range, in this instance moving the Input slider to 9. The three rocks were defined using the Pen tool, then the path was converted to a selection and feathered by 3 pixels to assist in blending those areas where selected and non-selected rocks overlapped. Working at 200 per cent, I

used the Navigator to keep track of where I was on the image. It is also a quick way to alter the image's magnification. Hitting Command-Shift-I selected everything except the rocks. For ease of viewing, I hid the path and selection in the View menu (View>Hide Path. View>Hide Edges).

In the Image menu I selected Channel Mixer, and checked the monochrome box, which converted the CMYK values to greyscale ones. The Output channel is by default the cyan one in CMYK files (this is where the other channels are mixed) and the dialogue box appears with a 100 per cent setting in that channel. Rather like using colour filters with black and white film, the Yellow and Magenta sliders affect the rendering of different tones and contrast between them; the Constant slider affects the overall brightness or darkness of the image. I worked at quite a high magnification so that I could see how detail in the shadows was affected.

Settings of +4 per cent Magenta and +2 per cent Constant gave the tonal quality I was after without sacrificing too much shadow detail. Finally, I selected the three rocks once more and, using the Yellow channel in Curves (Image>Adjust>Curves or Command-M), enhanced the colour of the lichens a little. All the work was done in one layer.
Original photograph: MF 55mm, Fuji Velvia

121

Four ostriches

Concept: The object here was to improve on the original composition; the ostrich behind the tallest one spoiled the line of necks and there was too large a space on the right side of the picture. Since I used fill-flash in the original shot, the direction of lighting was frontal, making it easy to shift and flip the offending bird to the right side of the frame for a more quirky composition.

Procedure: In Levels (Image>Adjust> Levels or Command-L), the shadows input slider was adjusted to 11, expanding the image's tonal range. I used Curves (Image>Adjust>Curves or Command-M) to get the colour balance and contrast I wanted. The original photograph was taken late on a summer's evening when the light was quite red and the sky (I was shooting pretty much into the zenith) a rich blue. The scan had restrained these colours and now I wanted to restore them. Anchor points were set so that highlights and shadows would be largely unaffected by changes to the mid-tones; then I moved the section of the curve between them until I achieved the look I was after. Once this was completed, I checked each colour channel (Channels menu) to make sure that no

posterisation of colours had occurred.

The Pen tool provided me with the means of making a precise selection of the ostrich I wanted to reposition. The work path was saved by dragging 'Work Path' over the New Path button, then converted to a selection and copied into a new layer. Here I flipped the image (Image> Rotate Canvas>Flip Horizontal), then rotated it to the correct angle and scaled it using Free Transform commands (Edit> Transform). The Move tool let me fine-tune the position of the bird's head.

I had copied the head rather than cut and paste it, so that there would not be a blank space left in the background. The easiest way to get rid of the original head and neck was with the Cloning tool, but I couldn't remove the head until the work path was dragged into the trash can. Double catchlights in the eyes, caused by the sun and flash, were also cloned out so that only the sun remained. While the Cloning tool is great for tidying up small problem areas,

you need to be cautious of using it for large-scale retouching. Heavily cloned areas can stand out because of their smoothness, since Cloning removes the underlying grain structure. The problem is easily remedied by applying a Noise filter to mimic grain.

Even at a fairly low magnification, a problem with pixel clumping in parts of the sky was evident. I selected the sky using the Colour Range command (Select>Colour Range) and sampled from the middle blue tones with a high fuzziness setting of 140. This gave me a perfect selection of the sky, something evident even at 800 per cent.

A Gaussian Blur often works well as a way to smooth out clumpy areas, but in this instance – even at quite a low setting of 15 – banding, particularly in the dark corners of the image, became apparent. Moreover, the edges of the birds were becoming distinctly blurred. I modified my selection using the contract option (Select>Modify>Contract) set to 5 pixels, then applied a small amount of monochromatic Gaussian Noise (10 pixel setting – as much as can be justified with a fine-grained film). The pixel clumps disappeared and I retained good detail of the ostriches' necks.
Original photo: AF 28mm, fill-flash set to -1.7ev, Fuji Velvia [C]

Olive grove, Crete

Concept: The history of civilisation on Crete, and therefore the manipulation of its landscape, is very long indeed. Early one evening, after visiting archaeological remains, we passed this grove of ancient olives. Just for a moment, the sense of time was almost palpable. The original Velvia slide had none of this feeling, so I tapped into a universally recognised association of age with sepia tones to introduce that dimension.

Procedure: Checking Levels (Image>Adjust>Levels or Command-L) showed the width of the histogram, indicating a full tonal range in the image. I converted the image to monochrome by selecting Channel Mixer (Image>Adjust>Channel Mixer) and checking the Monochrome box. I tweaked the contrast by sliding Yellow to +8, Magenta to +6 and moving the Constant slider to +4.

The sepia tone was introduced in the Hue and Saturation dialogue box (Image>Adjust>Hue/Saturation or Command-U), where I checked the Colourise box and then moved the Hue slider to 29 and the Saturation to 20. The Lightness setting was untouched. To render the harshly lit scene more softly, I made a duplicate of the background layer (Layer>Duplicate Layer), applied a Gaussian Blur (Filters>Blur>GaussianBlur) set to 10 pixels, and then reduced the Opacity of that layer to 60 per cent in the Layers palette so as to allow some of the sharpness of the background to show through.

I decided to finish the picture by fading its border. This involved drawing a rectangular marque (from the toolbox) within the borders of the picture. Its feather setting, made in the Marquee options palette, was 10. In order to select the border, whose inner limits I had defined with the Marquee, I hit Select>Inverse (Shift-Command-I), then feathered the selection to 20 pixels (Select>Feather) and applied a Gaussian Blur (30) to it. Finally, I needed to make a new layer and fill it with white (Edit>Fill). I left the Opacity set to 100 per cent so that the image would fade into the rest of the page.

Original photo: MF 20mm, Fuji Velvia

Musk ox, Dovrefjell, Norway

Concept: The instinct of musk ox is to stand their ground. Sometimes photographers misinterpret this as tolerance, go too close and pay the price. Mindful of the experience of others, I maintained a respectful distance from this young male, filling the frame with a 500mm lens. This lens, however, showed nothing of the exposed, windswept locations where musk ox winter in Dovrefjell. The following day I took another picture, with the same slightly downhill perspective, of the animal's habitat with a view to montaging the two images.

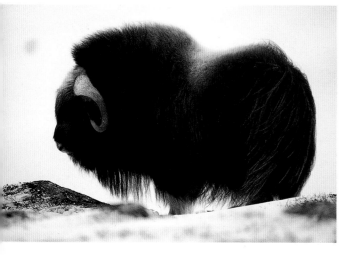

Procedure

Landscape: To save a lot of unnecessary computer work, I fitted a hard-step -2 stop graduated ND filter over the lens to balance exposure between the brightly lit peaks and the shaded valley. Fine adjustments to Levels (Image>Adjust> Levels or Command-L) expanded the tonal range a little.

Musk ox: Even though most of the musk ox stood out well from the bleak and snowy surroundings, the extremely pale guard hairs on the animal's back and forehead made a satisfactory selection with Photoshop tools very difficult, even with the Colour Range fuzziness set to a low value. Close inspection of the hairs on the underside of the musk ox showed a lot of unwanted pixels accompanying the selection. Instead Ultimatte KnockOut was used, a specialised masking program for making difficult selections like this. The image was cropped as tight as possible before doing the 'knockout' to reduce file size and hence speed up the procedure. I hit Command-A to select all (in this case, the knockout) and Command-X to cut it. The Remove Black Matt command in Photoshop must always be applied to the knocked-out image when it has been selected using this program. With the background file open, Command-V pasted the finished knockout into its new home. I rescaled the musk ox with the Free Transform command (Edit> Free Transform>Scale), maintaining proportions by holding down the Shift key as I dragged the corner handle of the transform box at the same time.

The musk ox needed quite a lot of tonal and colour adjustment; in Levels, I used the Gamma slider to reveal more detail among his dark hair and a combination of Colour Balance (Image>Adjust> Colour Balance) and Curves (Image>Adjust>Curves or Command-M) to introduce cooler tones. The Dodge tool, with Opacity knocked back, reintroduced some light to his eye and the Shade tool was used to take the brightness off his horn and his back.

I then set out to incorporate the animal into the landscape. Returning to another file of the musk ox, I drew a Pen path around the foreground, converted it to a selection and then applied a relatively wide feather of 20 pixels. This introduced a faint hint of the musk ox's legs. This selection, occupying a new layer, was cut, pasted and scaled in front of the animal, where the feathering helped to achieve a good blend. Its snow, however, was too white. Using the eyedropper, I sampled the colour of the snow in the background and made that my foreground colour. With the foreground layer still selected, I used the Fill (Edit>Fill) command to colour it. With Opacity set to 100 per cent and the Preserve Transparency box in the Layers palette unchecked, the whole of the layer is simply filled. I checked the box so that only the selection would be affected and reduced Opacity to 30 per cent, which coloured the snow to match that in the background. Nevertheless, the rocks were still not the right colour; these were corrected in the Magenta channel using Curves. Finally, I applied a Gaussian Blur (20 pixels) to the foreground to make it more ill defined, and then restored the grain with a Noise filter (Gaussian, Monochromatic, 7).

That was a lot of work, but still the image lacked the look I was after. There is something not quite believable when both the subject and all the surroundings are rendered sharp; we just don't see things that way. I therefore applied a Gaussian Blur (10 pixels) to the background and returned the grain with the Noise filter. This technique is especially sympathetic to sharply defined selections, such as the musk ox.

Landscape: MF 90mm, 2 stop graduated ND filter (hard step); Fuji Velvia
Musk ox, AF 500mm, Fuji Velvia rated at 100 ISO

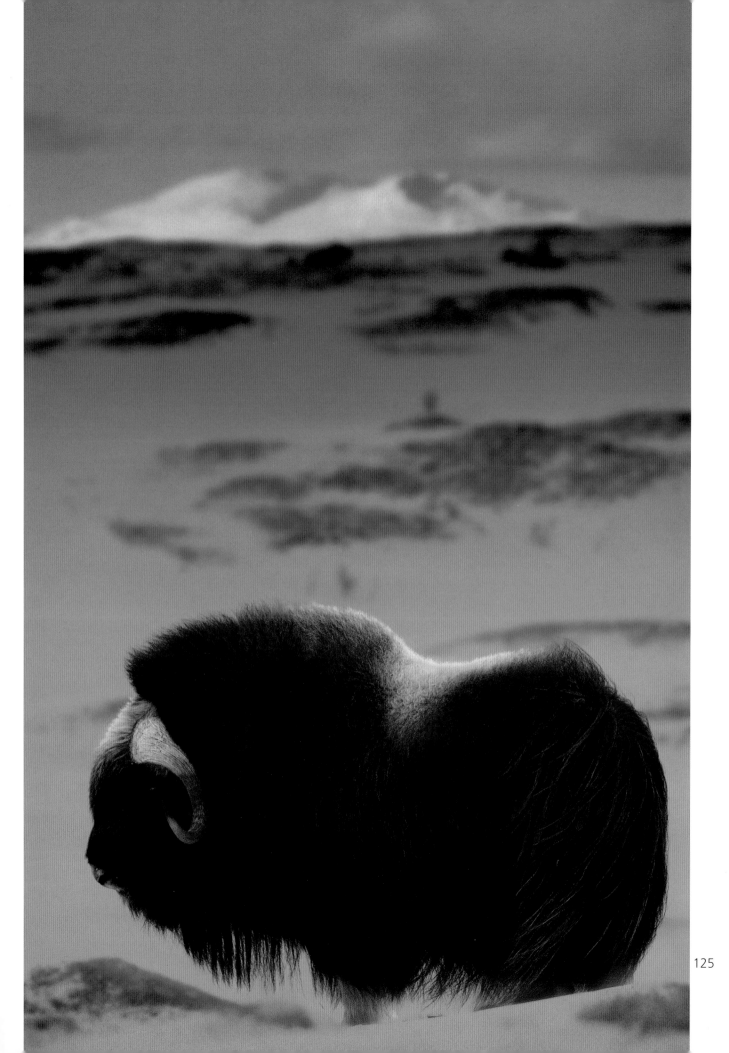

Stag against skyline

Concept: Although it looks like a 'straight' (and very lucky) photograph, this is a digital illustration. It is a montage: a stag silhouetted against a grey sky in the Scottish Highlands, and a dramatic sky above the island of Islay. Although the picture is an imagined one, I was nevertheless anxious to maintain a look of authenticity; it is something which, after all, I have seen but never been able to photograph.

The direction of light was the same in each shot. Both original photographs were taken with the camera pointing towards the sky, and I used telephoto lenses for each. I chose to blur the sky, which in the original slide is sharp, to lend the image a more photographic look. And finally, I let the stag's left antler tip merge with the black clouds, rather than try to separate it, in an attempt to avoid the 'gilded lily syndrome' which often signals a digital illustration.

Procedure

Sunbeams: In Levels (Image>Adjust> Levels or Command-L), I set the Input sliders so that they just touched each end of the histogram, but set the Output slider to 13 to lessen contrast. The original scan showed a very slight green bias, which was removed with 6 units of magenta (Image>Adjust>Colour Balance). I then checked that the areas I wanted to print black would do so by sampling the clouds at the top of the image with the

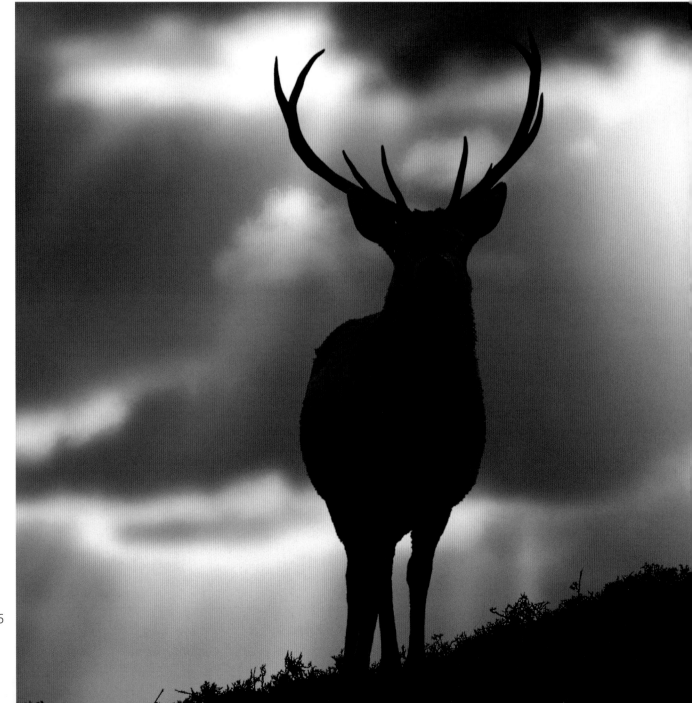

eyedropper. With the Information palette open and the Total Ink option selected (Info>Info options>Mode>Total Ink), the sum of the CMYK values for the pixels under the eyedropper exceeded 300 per cent where I wanted them to; this value guarantees deep black.

The edges of the clouds in the original slide were clearly defined but I chose to soften them, for the reasons set out above. The shortcut Command-A selected the whole picture. In the Filters

menu I dragged down to Blur, then selected Gaussian Blur and set it to a radius of 20 pixels. I achieved the look I was after by going back to Filters and this time selecting Fade Gaussian Blur, with the Opacity set to 80 per cent. I also realised that the sky would fit around the stag better if it was flipped first (Image>Rotate Canvas>Flip Horizontal), so did this as a final touch.

Stag: No adjustments were necessary to the levels of this picture, and since it was clearly separated from the background, selection using the Magic Wand was a practical option. Nevertheless, I set the tolerance to only 20 (an initial setting of 60 introduced too many fringing pixels) and made a number of selections off different parts of the silhouette (using the Shift key to add to selections), until I had a continuous line around the stag and hillside. Feathering radius was set at 1 pixel (Select>Feather). This selection was cut (Edit>Cut or Command-X) and, with the image of the sky active again, I pasted (Edit>Paste or Command-V) the stag into position, making fine adjustments

with the cursor keys. Since the stag had been lifted from a light background and placed onto a dark one, it had the look of a paste-on; this was overcome with the Remove White Matt command (Layer>Matting>Remove White Matt), making for a more convincing blend, without softening the edges.
Sunbeams: MF 300mm, beanbag, Fuji Velvia
Stag: MF 300mm + x1.4 converter, beanbag, Fuji Sensia 100

Pink-footed geese at sunset

Concept: Each autumn, Montrose Basin in eastern Scotland attracts a significant percentage of the world's population of pink-footed geese. I have spent many hours looking over the basin at sunset when the geese come to roost, but have never been able to combine, in-camera, a fine sunset with a flight of geese in a pleasing composition. Both of the photographs used to realise this vision were made from the same spot, at the same time of day, but two years apart.

Procedure

Sunset sky: One advantage of working in the CMYK colour space is that you don't have to keep checking back and forth to ensure that colours are in gamut. Nevertheless, the colours in the converted Kodak Pro CD scan still looked a bit lively, and were certainly more vivid than I remembered. Checking the Levels dialogue box (Image>Adjust>Levels or Command-L), I needed to move the shadows Input slider to 15 before there

were any significant pixel counts, making the image darker. I moved the Gamma slider to 1.3 to restore some lightness; an Output level setting of 15 finalised overall adjustment to brightness and contrast; and I muted the vivid reds using the Cyan channel in the Curves (Image>Adjust>Curves or Command-M) dialogue box.

Geese: The uniform background colour of this picture made selection of the silhouetted geese easy with the Colour Range tool. In the Sampled Colours mode (Select>Colour Range), I clicked on the sky (Fuzziness setting at 100), which selected everything except the birds, then used Inverse (Select>Inverse) to select the birds themselves. A similar result could have been achieved simply by clicking on the birds to select them; normally you have to assess whether the subject or the background has more tonal variation, choose the one with less, and then adjust the Fuzziness setting for the most precise selection. No feathering was applied here; it is sometimes inappropriate for silhouettes. The geese were then cut and pasted onto the background, occupying their own layer.

I wanted to retain a photographic look to the image, so I blurred the background layer with a Gaussian Blur setting of 20. This helped the birds stand out more clearly.

Sky: MF 90mm, beanbag, Fuji Velvia
Geese: AF 500mm, fluid head, Fuji Sensia 100

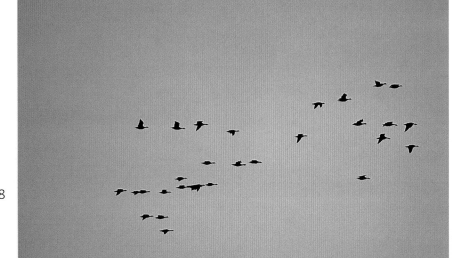

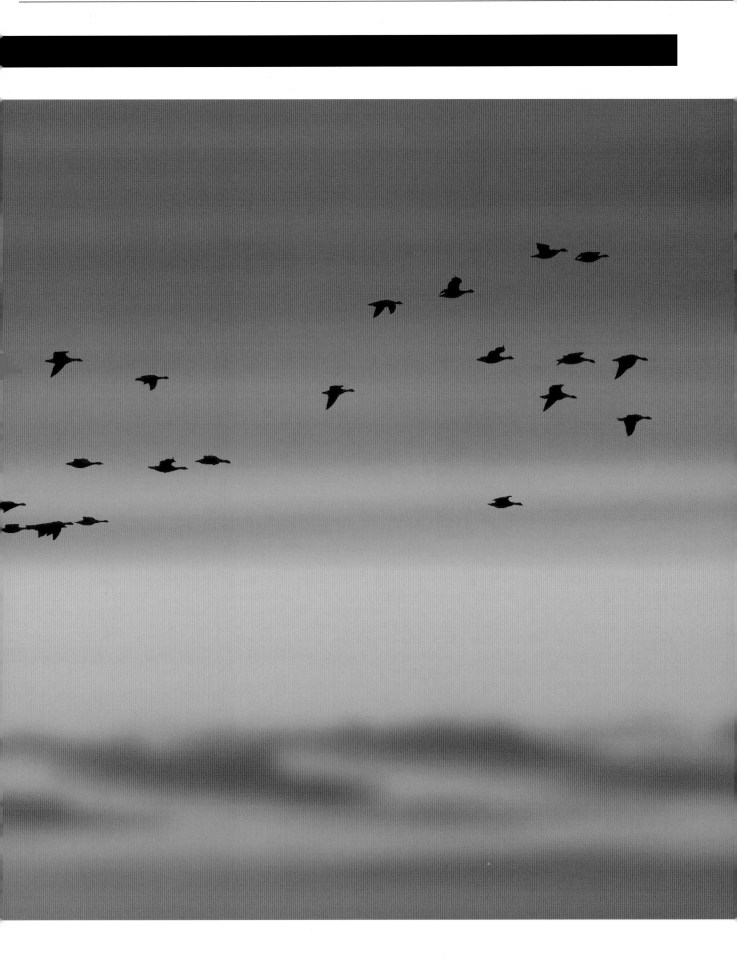

Pink-footed geese and full moon

background. In Colour Range (Select>Colour Range), I sampled from a bird. The Fuzziness setting was high (150) since the undersides of the birds were catching a glow from the setting sun. With the Quick Mask option selected in Selection Preview, I confirmed that I had a clean selection of each bird. With the birds selected, I went to Edit>Fill and filled with black to make silhouettes without any detail.

Moon: I wanted to crop away a lot of the night sky so I started with the Base 64 version of this picture on the CD. Had I used the Base 16 version, I would have lost detail as I increased the relative area of the moon in the frame through cropping. When cropped the 86Mb file reduced to 18Mb.

The black sky was unacceptable, since the geese which didn't fall into place over the moon would have disappeared altogether; this is not how I see things on a moonlit night. I selected the sky with the Colour Range tools again and then filled it with a dark violet I chose from the Colour Picker (click on the Foreground Colour icon in the toolbox). For a photographic look, I decided to make the moon a little out of focus. The sky was deselected (so that the whole frame would be affected) and Gaussian Blur (Filter>Blur>Gaussian Blur) applied at 15 pixels radius; grain was restored with the Noise filter (Filter>Noise), set to 4 pixels, Gaussian and Monochromatic. The geese were then simply cut and pasted (Edit>Cut, Edit>Paste) onto the background of the moon, and the new layer moved around until I was content with the position of the skein.

Concept: Here is a scene I've observed on several occasions as geese fly over my house on their way to feeding grounds. As a single, in-camera exposure, the shot is pretty much impossible. A good exposure for the moon on 100 ISO film would be ¹⁄₁₂₅ second at f5.6. That might, if you were lucky, stop the movement of the geese. The problem lies in getting a big enough moon. I used a 500mm f4 lens with x2 converter (an effective maximum aperture of f8) and still the moon was nowhere big enough. An 800mm with x2 converter might have done the trick, but its effective maximum aperture of f11 would mean ¹⁄₃₀ second exposure time – too slow to stop the geese in flight.

Procedure

Geese: Both pictures, of course, were taken from the ground, looking up, making it easy to match perspective. The geese were easy to select from the

Geese: AF 300mm + x1.4 converter, beanbag, Fuji Sensia 100
Moon: AF 500mm + x2 converter, beanbag, Fuji Velvia rated at 100 ISO

St Cyrus Beach, Scotland

Concept: This is a straightforward salvage operation. Faced with an attractive dark foreground and bright sky, I reached into my bag for a graduated ND filter. There was none. The only option was to make two exposures – one for the sky, and one for the foreground – and combine the well-exposed parts of each picture into one. The lesson: don't leave home without graduated ND filters. Incidents like this over the years have taught me to carry most of the camera equipment that I own, everywhere I go.

Procedure

Foreground: Since I was interested in using only the beach from this image, I selected it roughly in the first instance with a rectangular Marquee, then more precisely along the water's edge with the Magnetic Lasso. The high contrast between the dry and wet sand made it easy for the Lasso to follow the line. Holding down the Alt key, I completed a loop around the upper edge of the Marquee, deselecting it. Levels were satisfactory, but I decided to increase the overall brightness of the beach and rock by moving the Gamma slider to 1.08. Finally, I checked over the whole area for blemishes, pulling the image up to 200 per cent, at which point individual pixels could be discerned. I removed dust with the Cloning tool; I moved around the image by holding down the spacebar, which makes the Hand tool active until the bar is released.

Sky: I used the same procedure to select the sky and sea as I did the beach. This

time, in Levels (Image> Adjust>Levels or Command-L) I moved the Gamma slider to 0.8 to darken (and enrich) the sky's colours. It, too, was tidied up with the Cloning tool. In the Edit menu, the selection was cut and then pasted into the beach file, over the existing sky. With the Opacity of the new sky set at 100 per cent, the old one was invisible. Fine adjustments to the position of the new sky were made with the cursor keys, paying particular attention to the edges and top of the frame.
Both photographs: MF 20mm, Fuji Velvia

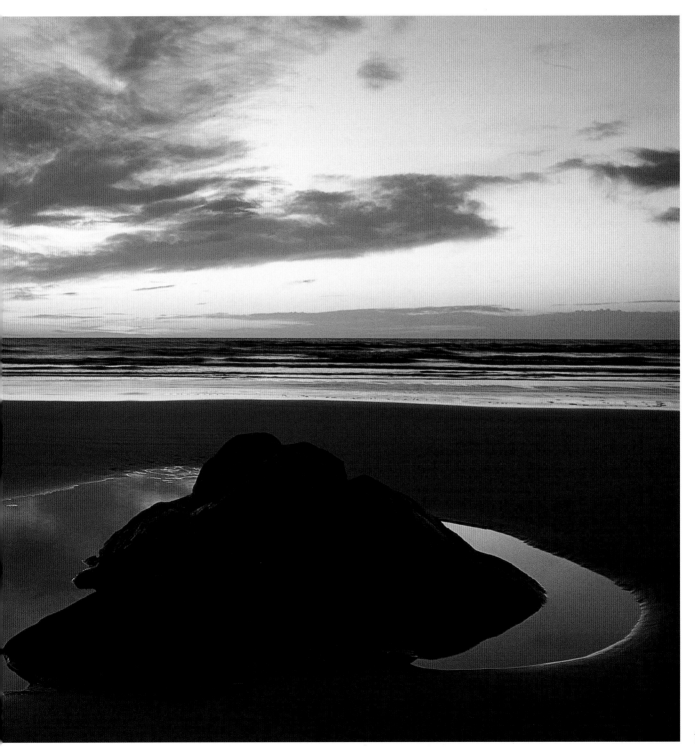

16 Inner Country/ Outer Country

Fine nature photography makes great demands on our skills as naturalists, especially if we use computers to finish or even create images. But it is not a purely scientific pursuit, intent on mere record. It requires us to feel, too.

I LIVE IN an intensively farmed area of eastern Scotland. Fields are large, the land productive and very little natural forest remains. Nevertheless, the mountains are half an hour from home in one direction and the coast 20 minutes in the other. Within this county, Angus, there is just about enough habitat to support populations of many of the key Scottish species: in the mountains there are red deer, wild cats, ptarmigan and golden eagles; the glens have red and black grouse; the planted forests of Scots pine are home to red squirrel, capercaillie, Scottish crossbill and, now and again, an itinerant pine marten; the lochs are fished by ospreys and otters; and the coastal mudflats attract huge flocks of waders in winter along with about 20 per cent of the world population of pink-footed geese.

Yet for very few Angus residents, or people anywhere for that matter, are these creatures part of everyday experience – most have never seen a wild otter, let alone been close to one. So although we occupy the same tiny geographical space, between the mountains and the sea, we lead parallel but entirely separate lives. I think of this split in terms of an 'inner country' – the wild animals' – and an 'outer country' – ours.

Drawing this distinction helps us to understand why nature photography in those parts of the world away from the honey-pots such as Yellowstone, the Masai Mara and the Falklands is so challenging. Few of us can simply walk out of the front door and start taking great photos. We need somehow to find ways to cross from the outer country to the inner country. We can use various ploys to lure animals to the edge of their world, such as providing food or nest sites or playing them their own calls. With regular exposure to people, some may even become habituated to us. But few surrender their wildness.

Time and place

Most successful wildlife photographers started off as field naturalists; the photography followed later. To have any hope of finding a way into your subject's world, you must first be prepared to spend time just watching and waiting. You need to be able to read its behaviour as a way to anticipate its next move. This doesn't require formal training or specialised study – just a desire to be outdoors and to learn, through observation, about the natural world.

There is a saying among nature photographers that good images are more time than location dependent. That is why work done in your local area has the potential to be more substantial in its insight than pictures that are taken on a flying visit to a foreign location.

It is also true that the same species is often much easier to photograph at some locations than others. While red deer are plentiful in the Angus hills, they are

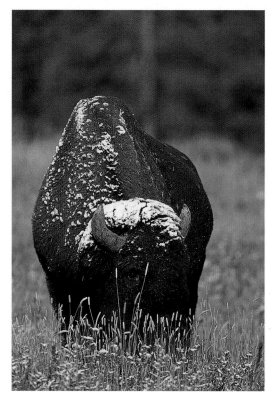

BUFFALO, YELLOWSTONE NATIONAL PARK, USA

On a two-week visit to Yellowstone National Park, I took more photographs of mammals than I would in a year of working at home in Scotland. But while some overseas locations offer the prospect of abundant, approachable subjects, getting under the skin of a new place in a short space of time, to produce work with a fresh insight, is not easy.
AF 300mm x1.4 converter, Fuji Velvia

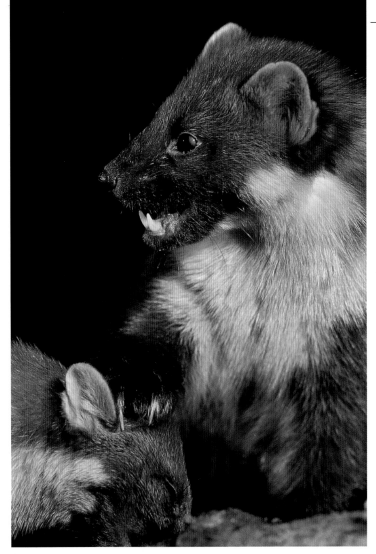

If the trend towards restriction and regulation of access to some high-profile wildlife sites continues (because of visitor pressure), so the importance of building relationships with private landowners will grow. Apart from anything else, it is easier to produce a set of fresh pictures from an unknown location with unfamiliar backdrops, and ultimately more satisfying than going to a place where everyone else also goes.

Finding ways into the inner country, into the lives of our subjects, doesn't require just time and imagination; often we have to rethink our normal time schedules. The times when most people are most active rarely coincide with rush hour in the natural world. You may sit all day long outside a beaver lodge, watching and waiting, but it's not much use if the beavers habitually remain inside between 7am and 7pm. A great deal of animal activity is concentrated at the edges of the day, and if you want to share in it, you will have to set your alarm for early rising. When I work away from my home area, I use a camper van. Whether under canvas or in a van, living on location is the quickest way to fall in with the rhythm of the animal or place.

PINE MARTENS FIGHTING

For three years, I followed up leads as to where I might photograph wild pine martens. None turned up any animals. Then I heard of another one where the martens were so used to the householder that they entered the house to take their favourite food. It was a very special moment when I slowly reached out and touched the fur of an old male marten. He was too busy gorging himself on chocolate Swiss roll to care. *MF 300mm, 2 TTL flash, flash sync cord, Ikelite Lite-Link, Fuji Sensia 100*

HOUSE SPARROW UNDER CAR TYRE

Early on a Sunday morning is about the only time I'd crawl about a town-centre car park, as I did for this image of a sparrow sheltering from a chill wind. The man-made features which fill the rest of the composition provide a foil to the wild bird. *MF 300mm + x1.4 converter, beanbag, Kodak Panther 100x*

extremely wary, making it exceptionally difficult to take good pictures. Over the mountain range and into Deeside, however, the animals feed by the roadside and can be photographed easily from a vehicle. Pine martens are extremely elusive, not least because they are mainly nocturnal, but there are several locations in the Highlands where they succumb to their sweet tooth and visit people's houses to feast on jam, raisins and cake. A situation such as this represents the best chance most of us have of getting close to a wild pine marten. Even the wildest of recluses can be brought to the edge of the outer country if we know them well enough.

Finding good locations needn't be all hard slog and endless hours in the field. When I started on a project to photograph red squirrels some years ago, I placed an advertisement in my local newspaper requesting help in locating a garden where squirrels visited regularly. Not only was there a big response to my appeal, but I was introduced to a location which I have visited many times since and which has been the most productive of any I have photographed. Local radio stations are often keen to run interviews about wildlife and I have used them in the past to ask for help with finding other subjects.

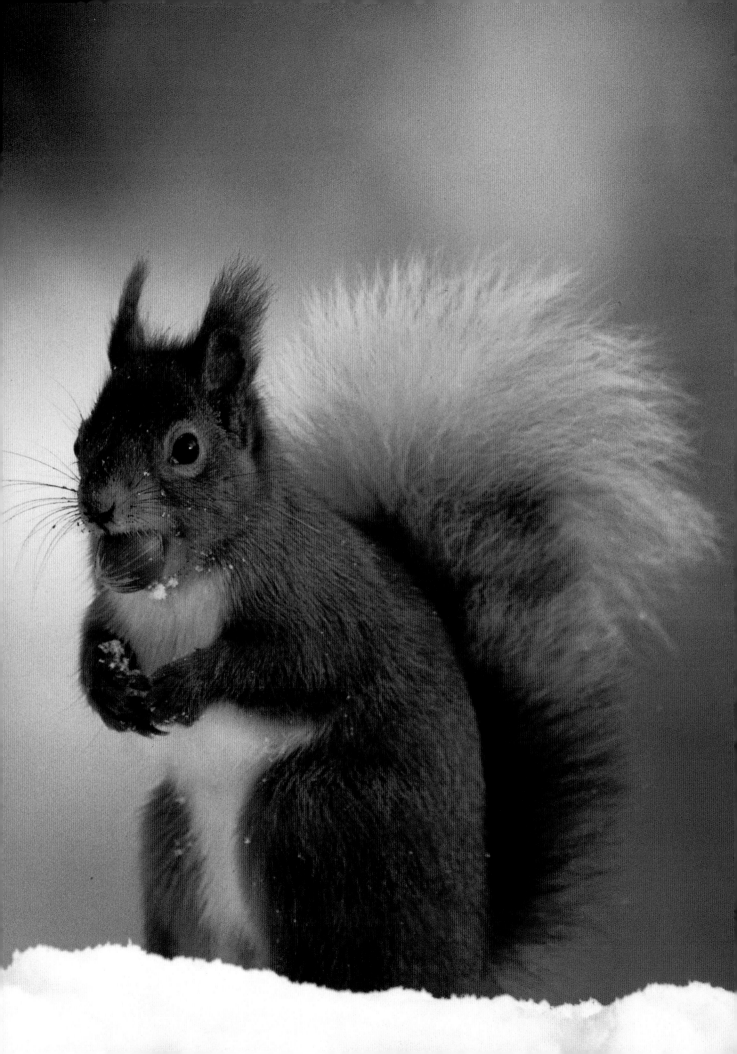

PREVIOUS PAGE: RED SQUIRREL IN SNOW

I was introduced to this location by a lady who had seen my request in a local newspaper for help in locating habituated red squirrels. It has subsequently become the one I've worked from more than anywhere else, for a variety of subjects. Having seen the routes used by the squirrels as they crossed the country garden to the feeding station, I set out hazelnuts at strategic points. I have since worked with unhabituated squirrels, but never as productively.
MF 300mm + x1.4 converter, beanbag, Kodak Panther 100x

RIGHT: FULMARS ON RED SANDSTONE CLIFF, MONTROSE, SCOTLAND

The Lower Old Red Sandstone cliffs which form a section of the Angus coastline reach their highest point at Red Head, south of Montrose. While the lower ledges are crowded with auks, the upper sections of the cliff are short of nest sites, and those are occupied by fulmars. This pair, as chance would have it, had taken a grassy ledge on a particularly well patterned section of cliff.
MF 300mm + x2 converter, beanbag, Kodak Panther 100x

Animals in context

An animal is a product of its environment; that is a basic evolutionary principle. It is shaped by the landscape it lives in and is entirely dependent on it. Yet most of us cannot resist getting in close and filling the frame with the subject, thereby rendering the environment as no more than an ill-defined blur.

The fact is that close-up portraits with uncluttered backgrounds *are* impressive, largely because they describe exactly what a subject looks like, down to the last hair or feather. But do such portraits describe what an animal *is* – as defined by its environment?

It is interesting to see that in some countries which were late to industrialise, such as Finland and Norway, the prevailing style of nature photography reflects a more integrated view of wild nature than elsewhere. The subject is frequently portrayed as just another element of the landscape, often small in the frame, but nonetheless a compelling presence. In these countries, the majority of the people lived on the land as recently as two or three generations ago, and the popular experience and collective memory of wild nature is therefore somewhat different from that in long-industrialised

countries like the UK. Here, in a landscape radically altered by man over thousands of years, and especially post-Industrial Revolution, there is a tendency to pick out subjects and isolate them from what is often seen as an unnatural, undesirable setting.

Making strong pictures of subjects in their environment is often more challenging than shooting the frame-filler. The task is made easier if the creature is one with which we are familiar; we need only a hint of its identity – a distinctive profile or a particular colour – and can then fill in the rest of the information ourselves. The picture goes well beyond simple description of appearance.

If the subject is small in the frame, then there will be a lot of space to fill. The key to the success of this approach is to fit the subject into a composition of interesting shapes, so that although it doesn't fill the frame, it still occupies the 'eye' of the picture (see Chapter 11). The smaller the subject appears in the picture, the more recognisable must be its shape and the stricter the compositional framework into which it fits. Some habitats lend themselves more to this than others: bare trees; reedbeds; patterned cliffs and rock formations contain many more shapes to work

with than tundra or mudflats, especially if viewed from ground level.

You may rightly contend that, except in wilderness areas, it is often impossible to exclude evidence of human intervention in the landscape. But this is the reality of the world these creatures, as well as ourselves, occupy. We may dream of wilderness, of landscapes where natural processes are uninterrupted by people, but we risk deceiving our viewers and misrepresenting our subjects by peddling the wilderness illusion in all our photographs. The crucial point made by nature portraits which include evidence of man is that, in the words of American environmental philosopher Gary Snyder, 'Wilderness may temporarily dwindle, but wildness won't go away.' Wild animals can and do survive in managed habitats. Pictures which show wild creatures living in a managed landscape are messages of hope, an indication that some sort of reconciliation can be achieved.

A tight close-up of a wild creature often indicates great skill on the part of the photographer, but when surroundings are indistinct such an approach does nothing to validate the animal's wildness. Similar

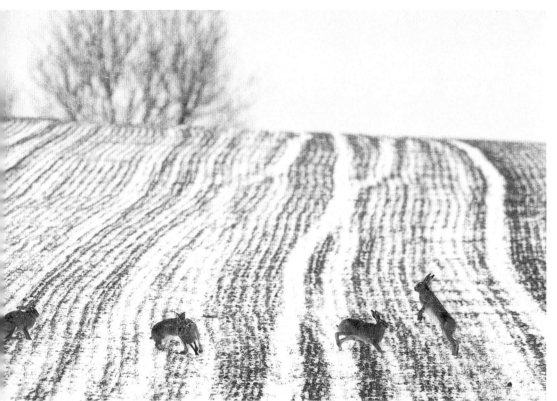

BROWN HARES COURTING IN WINTER CEREAL FIELD

Hares are fond of open country where they can see predators coming from afar. During their courtship, where the female, or jill, boxes males while she is unreceptive, groups of animals can roam far and wide. These came close enough to my car to let me make an image showing them carrying on their lives, not in a wilderness, but in an ordinary agricultural landscape.
MF 300mm + x1.4 converter, beanbag, Kodachrome 200

BUFFALO, YELLOWSTONE NATIONAL PARK, USA

In an act of restraint out of keeping with the times, Yellowstone was declared the US's (and the world's) first national park in 1872, before the buffalo was brought to the edge of extinction. It was in the high-altitude valleys of the park that the species made its last stand and, through rigorous protection, staged its recovery.
AF 300mm + x1.4 converter, beanbag, Fuji Velvia

results can be achieved with a controlled subject, although from the photographer's point of view the thrill of being close to a wild creature is absent. The bigger story about an animal, where it fits into the web of life, is less readily told in a controlled set-up.

Showing the subject in its environment – this fusion of science and art – is the logical next step after the novelty of frame-filling has worn off, and, done well, is every bit as satisfying. As picture viewers become more sophisticated they want more information and feeling in a photograph. A record of appearance is no longer enough.

Top tips

- The nature photographer's biggest challenge is to find ways into the inner country, into the lives of wild creatures, so that you know where and when to find them and how to get close to them.
- There is no substitute for spending time in the field, but try to find those locations where individual animals are more habituated to people by working with biologists, or by advertising for help in locating such places.
- Be prepared to alter your own time schedule to fit in with that of your subject.
- Think beyond the obvious close-up if you want to convey information about where the subject lives.
- Give equal weight in your pictures to the elements of the landscape that surround the

subject. The smaller the subject in the frame, the stronger must be the compositional framework using these elements.
- The central message of 'environment portraits' is that wildness endures in man-altered landscapes. This approach may be considered as an antidote to the romance of images of apparent wilderness.

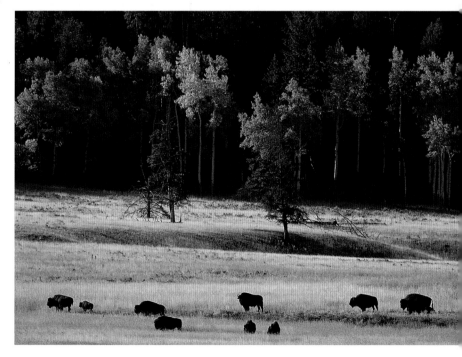

17 You, as a Photographer

When does an amateur photograph become a professional one? When it sells? If that's the case, then the files of most 'professionals' are made up of mainly 'amateur' photographs. In fact the distinction is abitrary, and undermines an appreciation of the value of amateur work.

EASTERN CHIPMUNK, PENNSYLVANIA, USA

Once this chipmunk discovered the black sunflower seeds set out in a stump in my friends' garden, there was no keeping it away – at least until the heat of the day forced retiral. I positioned the log so that a clump of coneflowers would provide some background colour. *AF 300mm + x1.4 converter, angle finder, Fuji Velvia rated at 100 ISO*

I READ AN ARTICLE not so long ago which stated that in North America a career in nature and outdoor photography is one of the most eagerly sought-after of all. This may be an exaggeration, but there is no doubt that a large number of enthusiasts who devote weekends and holidays to their passion would make the career change if they thought they could earn enough to sustain themselves and their families. The job, after all, has a lot of lifestyle appeal. But nevertheless it remains a job, or more specifically, a business that requires the same skills and single-mindedness as any other in order to operate successfully. It is not too hard to sell pictures and stories now and again, but would you want to go searching for business week-in, week-out, especially if it meant that photography had to take a back seat for some of the time?

In praise of the amateur

There is an implication in a lot of the advertising surrounding outdoor photography that 'pro' is good and 'amateur' should be aspiring 'pro'. In truth, these distinctions are not only arbitrary, but fail to acknowledge the value of amateur photography practised with passion and individuality.

Professional nature photography is all about supplying clients with what they want. Few of these clients are themselves naturalists and their interest in the subject may extend no further than where it fits into a page mock-up. Of course, good professional photographers put a personal stamp on a picture which makes it identifiably theirs, but ultimately a personal image filled with insight which does not sell has to be subsidised by a predictable but eye-catching one which does.

Amateur nature photography, on the other hand, should be done for no one other than the photographer – not to please judges or editors or designers, but simply to express a vision of the natural world. I mentioned in Chapter 16 that time, rather than location, is the most important element in nature photography. On the face of it, the professional would seem to score ahead of the amateur in this respect. In fact, except for those photographers earning a substantial income from stock (photographs held on file by agents) or working

on increasingly scarce assignments, it is not practical or affordable to spend several weeks following the same animal, however much we would like to. The photographer who doesn't rely on picture sales for a living can indulge the time required to produce fresh insights. He or she is not constrained by market whims or the particular 'look' currently in vogue. The amateur photographer putting in the time may not have the breadth of coverage that a professional has, but this is often more than made up for by its depth.

A problem faced by both – let us say instead – full- and part-time photographers is continuity. If you are restricted to weekend shooting or there is a particularly heavy work load in the photographer's office, weeks might elapse when hardly a single picture is taken. Not only is this frustrating, but it takes a while to get back into the way of seeing pictures again. The sort of responsiveness to the natural world needed to make successful photographs cannot be turned on and off like a tap. I have often found my most productive spells come after three or four days away from the office, camped in the field. The reconnection with the natural world is made, and that is when the images begin to flow.

FIGHTING WOODPIGEONS

While at university, I used part of the long holidays to build up my portfolio. With cash in short supply, I spent a lot of time working in my local area and learning where to be under certain conditions. With snow on the way, I headed into my hide at a bait site used regularly by pheasants and pigeons.
MF 300mm + x1.4 converter, Kodachrome 200

BIGHORN SHEEP, YELLOWSTONE NATIONAL PARK, USA

The abundance of ungulates in Yellowstone, and their frequent indifference to people, is a revelation to anyone used to pursuing shy, scarce mammals. If your work limits you to only a few weeks in the field per year, the attraction of sitting in a hide hoping that your subject will show is bound to pale alongside a visit to one of the international honey-pots.
AF 300mm, beanbag, Fuji Velvia

OPPOSITE: TREE IGUANA, PENNSYLVANIA, USA [C]

Tree iguanas spend much of their time high up in trees, and making attractive portraits of them in the wild is on the dangerous side of difficult. Working with a controlled animal was not only a happier experience for both man and reptile, but it also allowed me to shoot in the first light of dawn when the iguana was still fairly inactive.
AF 180mm + 27.5mm extension, Fuji Velvia rated at 100 ISO

RIGHT: SEA EAGLE, TRONDHEIM, NORWAY

Sea eagles are doing very well in central, coastal Norway, but finding a location to photograph them is another matter. I called a friend who'd written the script for a programme about the birds and asked if he knew the researcher. He did. He in turn put me in touch with the Norwegian naturalist who had established the bait site, and only then did I feel confident about committing time and resources to the trip.
AF 500mm + x 1.4 converter, Fuji Sensia 100 rated at 200 ISO

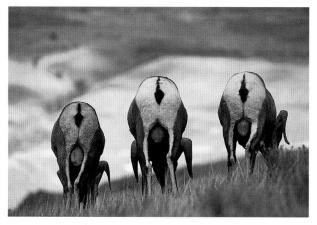

Top tips

- Amateur nature photography is done for the photographer only and so has the potential to be more distinctive than that done professionally, where market demands inevitably play a part.
- Time spent working a few subjects in great depth is generally more satisfying than pursuing a large number and ending up with mere record shots.
- By concentrating on your local area, it is easier to maintain a connection with your subjects.

Fuelling the creative drive

Many people, not just artists, have a deep need to be creative. I don't mean by that simply a conscious wish, but rather a physical urge which demands satisfaction. It is the force which drives productive artists and photographers, and which is responsible for innovative work. Maintaining productivity is no easy task for the wildlife photographer reliant on the vagaries of weather and unco-operative subjects, and sometimes other tactics are needed to maintain the flow of pictures.

Travel

For many full-time stock photographers, productivity comes through travel. Not only do 'honey-pot' locations guarantee encounters with wildlife, often in a dramatic setting, but the stars are frequently the species most sought after by picture buyers: penguins, elephants, polar bears, bald eagles or dolphins. While it is true that they have all been photographed countless times before, the demand for fresh, ever more stunning imagery is unending. If your work allows you only three or four weeks' holiday a year, then you, too, may be tempted to make the most of it by going to some other location that offers better immediate prospects than your own neighbourhood.

But it is not enough to know that, for example, Norway is a good place to photograph sea eagles. Where exactly do you go when you get there? How do you get around when you arrive? When is the best time to go and where will you stay? Without meticulous planning, an overseas trip, sometimes with little prospect of a return visit, can be a dismal waste of money and time. Indeed, I go out and work in a new country only after I have made contact with biologists who live there and are willing to be involved in my project. That way, it is possible to be productive on a short trip, assuming that both the weather and the animals are co-operative.

A good, if costly, alternative to tapping into local expertise is to join a photographic tour. These vary in their quality, but the best ones are completely focused on providing the participants with the greatest number of photographic opportunities at the best times of day. While photographic workshops are centred on tuition, the leader of a tour is there first and foremost to take you to locations and organise food, accommodation and travel, allowing you to concentrate on the business of taking pictures. For first-time visits to a new area, tours can provide an ideal introduction, but you should also use the opportunity to do the research and make the contacts for future visits by yourself.

BARN OWL [C]

Barn owls like old farm buildings to nest in. I wanted to show a bird in the sort of place they naturally frequent, and by using a controlled bird I was able to make a composition which said more about the bird than a tight close-up portrait could.
MF 90mm, Fuji Velvia

Many photographers travelling overseas for the first time are apprehensive about packing their gear and film. As security consciousness grows and hand-luggage regulations are more strictly enforced, so it is becoming increasingly difficult to carry all your gear and film into the aircraft's cabin. Even more concerning is the new generation of X-ray machines, introduced in the late 1990s, to scan hold luggage. Before the arrival of the CTX-5000 scanning machines, it was (normally) quite safe to put slow-speed films in with your hold luggage, so long as they weren't X-rayed an excessive number of times. But in one infamous case in 1998, five weeks' movie footage shot in New Guinea for a BBC Natural History Unit series was fogged by the machines at an English airport. These machines begin by making an initial scan at a relatively low power, but should anything suspicious show, such as a lead-lined film bag, the power automatically increases three-fold – more than film can tolerate. At the time of writing, the machines used to scan hand luggage are mostly safe for slow- and medium-speed films, but be aware that their effects are cumulative; the fewer times your films have to pass through them, the better. On no occasion when I have asked for a hand search of my films have I been granted one.

Not only are we normally restricted, on reasonable grounds of safety, to one main item of hand luggage, but its weight should not exceed around 8kg. If you use long, fast telephotos, those 8kg don't go very far. It goes without saying that you take an enormous risk by placing any item of photographic gear in among hold luggage. My tripod and two heads go in, simply because they are too bulky to take aboard. I would never take that chance with a lens. The rest, including my film, goes in the cabin with me.

Here's how I pack to conform to regulations. If I need both the 300mm f2.8 and 500mm f4 lenses, they go into an otherwise empty Tamrac backpack of regulation size. The combined weight is only a little in excess of the allowance. The rest of my gear and as much film as I can fit goes into an Xtrahard vest. Though maligned by some as a deeply unstylish form of exhibitionism, vests are ideal for carrying a lot of gear without it counting as hand luggage – so long as you are prepared to wear it for the duration of the flight. Up to 150 rolls of film can be stashed in the rear pocket out of its boxes but still in its airtight plastic canisters for protection from dust and grit. Other necessities such as passport, tickets, currency, contact details, a phone, a book and a notebook are stowed in the vest too.

I also carry an empty beanbag in my cabin luggage, to fill on arrival. Though not as versatile as the tripod, it may save the day while waiting for bags to turn up, should they go astray.

Top tips
- Travel is worthwhile only if you have good information about exactly where to go when you reach a destination.
- Joining a well organised photographic tour or working with local biologists provides the best chance of making contact with the animals you wish to photograph.
- If you feel you need a lot of help with technique, attend a workshop before joining a tour; tuition is normally given a lower priority during tours.
- Always take your most valuable items of photographic gear into the aircraft's cabin with you, and never put your film in the hold.
- Maximise the amount of equipment you take on board by using a photographer's vest, but ensure that your one item of hand luggage does not exceed the regulation dimensions or weight limit.

Controlled subjects
There is little to match the thrill of photographing a wild creature in its natural environment. This is nature photography in its truest sense, yet chance encounters which yield outstanding pictures are rare. Often we witness amazing spectacles which prove impossible to record on film. Sometimes it is not possible to show a subject in the detail it deserves because of the risk of disturbing it.

Little owl [C]

Only the most steady birds can have their jesses removed for photography. Expect them to be left on. While they can often be concealed behind prey or vegetation, it is a little trickier when the subject is perched on a post. Here I chose a low viewpoint – to include an all-dark background – and tilted the post away from the camera, which hid the owl's legs.

AF 300mm, Fuji Sensia 100 145

Working with falconer's birds, or animals that have been rehabilitated just prior to their release in a wild location, can be a way to meet your photographic objectives without causing the subject stress. Indeed, a remarkably high percentage of professional wildlife photography features controlled subjects.

Some species are under such pressure in the wild that the less they are visited, the better. With proximity guaranteed, close-up portraits which in the wild would be either impossible or extremely intrusive, become practical, and aspects of behaviour which are central to the story of the species can sometimes be more readily revealed in a controlled situation. And of course, we can exercise greater control over lighting and composition.

Coming clean in captions

One of the joys of looking at outstanding nature photography is the hope, unconsciously nurtured, that given the time and resources, we could have the same experience as the photographer. The cynicism that pervades many aspects of modern life has, thus far, left nature photography relatively unscathed.

There remains an intuitive trust in the authenticity of pictures of the natural world – we want to believe in nature's perfection and beauty. This naive trust in the integrity of photographs is betrayed when an image is the product not of experience, but of the photographer's imagination – and, crucially, is not declared as such. I am not against the creation of

imagined pictures, either with controlled subjects or made in-computer, but as in a library, there is a place for fact and a place for fiction, and the viewer should not be in any doubt about which category applies.

In reality, the photographer usually has no control over whether or not his or her published pictures declare a subject's captivity. Often the attitude or condition of the animal (sometimes overweight) is a giveaway to the informed viewer. An increasing number of wildlife publications, following the lead of *National Wildlife* and *International Wildlife* in the USA, do draw the reader's attention to controlled subjects. But for the vast majority of publications, this still doesn't seem to be an issue.

Even when pictures are destined for a publication which does not acknowledge when a subject is a controlled one, I routinely label all my pictures of non-wild subjects as such. You will see the icon [C] beside a number of pictures in this book and this I do to protect the integrity of my pictures of wild creatures as much as anything else.

Some photographers, quite rightly, question the nature of control. Does bait put out to attract a subject into camera range not make that animal a controlled one? My own feeling is that so long as the subject is free to come and go, to seek natural food sources, and is not solely reliant on those provided by the photographer, it is wild. Some of the wild animals I photograph become quite used to me and allow a close approach, but the choice to come and go is ultimately theirs.

Getting it right

In theory, working with controlled subjects should be very easy. But just as the problems of getting close enough at the right time of day have been overcome, we then come up against the challenge of making the picture biologically accurate and true to the subject. It is fundamental to the success of this approach that, through research or preferably observation, we are familiar with the biology of the species. We are, after all, trying to recreate something which could be seen in the wild. If in doubt, simplify the composition to its most basic elements.

It is best to work with subjects in prime condition. Worn primaries or tail feathers and damage to the fleshy area at the base of a raptor's bill, the cere, are not the marks of a wild bird. Allow half an hour for the subject to settle down at the beginning of a shoot and treat it with the same caution and respect as you would a wild one.

While it is useful to have some general images in mind before you begin shooting, I've always found that it is better to let the subject take the lead, to perch or walk where it feels most comfortable and to work around it. Operating in this way introduces some spontaneity and the subject appears more comfortable. Working with a conscientious handler

HEDGEHOG IN WOODLAND [C]

This hedgehog had been brought to a rehabilitation centre at the start of the previous winter, having failed to meet the critical 600g weight which would see it through hibernation. By late spring it was fit and well and ready for release. I let it go in an attractive piece of woodland and simply followed it around. *AF 28mm, beanbag, flash set to -1.7ev, Fuji Velvia*

also ensures that you don't, however unwittingly, push the tolerance of the animal.

For work with controlled subjects in the summer, consider planning your photography for the evenings; few handlers will want to rise for first light. Owls, in particular, become more alert towards the end of the day. Most birds of prey love the feel of the wind under their wings and become frustrated if they are prevented from taking to the air. On breezy days, I prefer to photograph in the relative calm of a forest, so long as it is the right habitat for the species. Flight photography in the uplands can be rewarding, provided that you can conceal the telemetry equipment used to track the bird's movements, but if you know that there are wild raptors in the area, draw this fact to the attention of the handler since they sometimes kill unwary falconry birds.

Although a poor substitute for wild animal photography, working with controlled subjects does allow you to hone your skills, keeping you in practice for that special encounter in the wild. And you can help rehabilitation centres by donating in exchange for photographing their patients.

Top tips

- **Working with a controlled subject gives the opportunity to convey information about the creature in a way which may not be possible with a wild one.**
- **Know the biology of the subject beforehand so that your pictures are truthful to the species.**
- **Honest labelling of pictures of controlled subjects protects the integrity of your pictures of wild ones.**
- **Allow the subject to do what it wants and follow it; the pictures are more spontaneous and the subjects look relaxed.**
- **Since you have a high degree of control (compared to working with a wild animal), choose only the best time of day, the best lighting conditions and the best location to take the pictures.**

RACKWICK BAY, ORKNEY, SCOTLAND

Rackwick Bay on the island of Hoy in the Orkney group is justly famed for its rugged scenery. This is an edge in space, where the land meets the sea; the picture hints at the power of the one and the resistance of the other.
AF 180mm, Fuji Velvia

LOCH FLEET, GOLSPIE, SCOTLAND

When I looked out of my camper van on a grey morning in late autumn, I decided there was no hurry to get up; the sky looked completely overcast. Half an hour later, over breakfast, a gap opened between the horizon and the low cloud base and extraordinary light flooded over the landscape, catching the hill at the far side of the loch. The sun was out for two minutes, then disappeared for the rest of the day. Things happen quickly at the edge.
AF 180mm, Fuji Velvia

OPPOSITE: MOON AND HAWTHORN, MONTROSE, SCOTLAND

Driving along the coast the previous night, I had noticed how brightly the nearly full moon was reflected from the North Sea. I set out the next evening in search of a subject I could silhouette against the golden sheen and found this wind-gnarled hawthorn. Because of the widely different exposure times required (1/125 second at f5.6 for the moon, 4 seconds at f5.6 for the tree), I made a double exposure. At times like this you become aware how quickly the moon moves across the sky; I needed to move every minute to keep the tree against the brightest part of the sea.
MF 300mm; Kodak Panther 100x

RIGHT: ROWAN AND BIRCH, STRATHERRICK, SCOTLAND

Peak autumn colours often last for only a few days in the Highlands, particularly in exposed glens such as this one near Loch Ness. The transition from autumn to winter can be a swift one.
MF 300mm, beanbag, Fuji Velvia

The concept of edges

The search for great photos starts at the edge. The concept of edges provides most of the recurringly popular topics in nature photography; your dedication to the search for edges will be reflected in the quality of your photography.

Some years ago, I tried to figure out why some pictures of nature moved me so powerfully when others didn't. Why did some strike a very definite chord while others, which were seemingly just as impressive, left me cold? I have now come to believe that a commonality exists between evocative images of the natural world, a commonality that is bound up in the concept of edges.

Edges, for our purposes, are zones of transition in time or space or being. More simply, they are places where change occurs and contrasts arise. Edges are the extremes, distant from the middle, the everyday, the usual. The concept of edges, literal and metaphorical, is at the root of most of the recurringly popular topics among nature photographers, from sunsets and autumn colours to penguins and bull elk. There seem to be three broad categories into which most of the topics fall: edges in space; edges in time; and, in a metaphorical sense, edges in being. Let's put some meat on the bones of this idea, and consider its implications.

Edges in space

The places where the land meets the sea are zones of great biological productivity. They represent one of the edges in space. Such places are peripheral to the centres of human activity and man's control of the environment here is less complete and more vulnerable. Man is also out of his element in the sky, and where the land meets the sky represents the other great edge in space. This is the realm of the silhouette and the bird in flight and there are few outdoor photographers who are not drawn to these

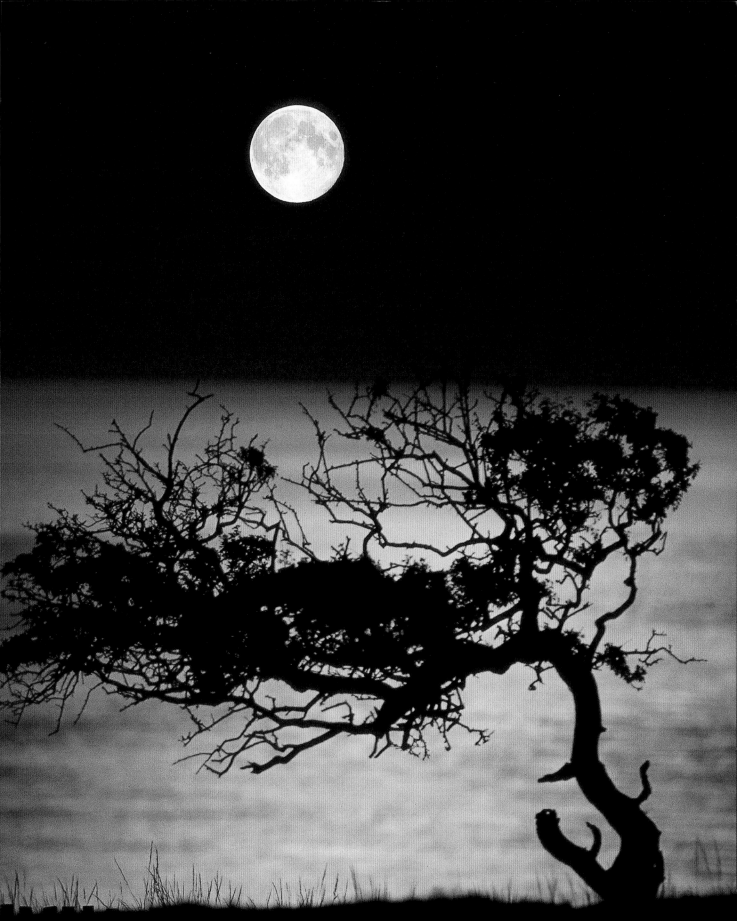

FOX CUB [C]

In the UK, there exists a strong polarisation of attitudes towards foxes. Some people vilify them as ruthless vermin, while others do all they can to help them; this orphaned cub was fortunate to end up in a rehabilitation centre until it was old enough to fend for itself.

AF 300mm, Fuji Sensia 100

topics sooner or later. Geographically remote areas represent the spatial edge on a greater scale.

If even at this stage you doubt the validity of the edges concept, ask yourself why people prefer to walk along the sea's edge rather than in the fields behind the sand dunes. Why are people drawn to the mountain's summit rather than to a shoulder half-way up? Why do we like to scare ourselves by edging up to the rim of a crater rather than walk a safer distance back? Why, for that matter, jump from a tower with an elastic cord around your ankles? I don't really know the answers to these questions either; it's just what people are like. But it is the very same instinct which draws the nature photographer, even unwittingly, towards edges.

Edges in time

Sunrise and sunset are among the most popular topics of all. These are the edges of the day, when the quality and temperature of the light can even affect our mood. Similarly, spring and autumn often yield more stunning pictures than high summer, in temperate latitudes. Times of transition; edges in time. These peaks of activity in the natural world don't necessarily coincide with ours – how often have you witnessed a glorious sunrise all by yourself or enjoyed the first bud of spring while others are hankering after summer? Once again, photographers go beyond the boundaries of everyday human experience to glimpse the natural world at its most lively.

Edges in being

Edges in time and space are easy to recognise, but what of edges in being? Well, consider the appeal of the young elk calf or the massive old bull. Aren't most of us drawn to these individuals rather than the mass of the population that lies between? The seedling of a pine juxtaposed with its aged, gnarled parent is

compelling. One way to interpret this tendency is an attraction to the edges of life – lives which have only just begun and those soon to end. Hence, perhaps, our macabre fascination with pictures of 'the kill', particularly where cubs feature. Likewise, we are drawn to creatures and plants which live in extreme environments, be they emperor penguins in Antarctica or saguaro cactus in the Sonoran. More prosaically, the saxifrage growing out of gneiss rock contrasts not only living and inert matter but also extremes of time – Lewisian gneiss of the northwest of Scotland has a 3500 million-year history whereas the yellow mountain saxifrage sprouting from a fissure may have been there for only a couple of years or so. Wherever the hold on life appears to be tenuous, or life itself seems incongruous, we can find edges in being.

Seeking the picture

So much for the theory; but the concepts don't always come readily to mind in the field when you're searching for the picture. At these times, it is more helpful just to think of edges as 'the most': the sandstone with the most wavy lines; the most brilliantly coloured part of the sky; the squirrel with the most curly tail. These, too, are extremes; you haven't just settled for the first example you've come across. This attraction to extremes would also explain why macaws are regarded as more attractive subjects than rooks (they are more colourful and do more interesting things – unless you are another rook), and red-faced macaques in Japan draw more attention than gibbons in Africa. There is just something out-of-the-ordinary about seeing monkeys in the snow.

It seems, then, that what we do as nature photographers is simply an extension of how we behave as curious animals – we have a deep-seated need to explore the boundaries of our world, even if that is just the neighbourhood spinney, and an inherent urge to discover our personal limits. Creative success comes from being able to channel these instincts into our photography.

Top tips

- To find 'the edge' you may have to push yourself physically and creatively, but the resulting pictures are distinctive.
- When in the field, think of edges as 'the most' – as extremes or contrasts; don't settle for the first example you come across.
- Remember that edges close to home can be just as dramatic as those in remote locations; personal commitment to finding and sharing them is everything.
- If you are at a loss over what to photograph, start by thinking of going out at the edge of the day to a place which is little visited, and when you are there, seek out 'the most'.

BELOW LEFT: CALOCERA FUNGUS
Sometimes in the field it is easier to think of edges simply in terms of 'the most'. In the old beech forest, I had a choice of several specimens of this colourful fungus and selected the most vividly coloured one with most branches against the plainest background.
MF 90mm, Fuji Velvia

BELOW: YELLOW MOUNTAIN SAXIFRAGE, SCOURRIE, SCOTLAND
Here are two edges in time: the rock featured here, Lewisian gneiss, is some of the most ancient in the world, with a 3500 million-year history. The yellow mountain saxifrage is a recent colonist of this particular fissure.
MF 90mm, Fuji Velvia

Organising All Those Pictures

You've gone to a lot of trouble and expense to build your slide collection and digital files. I'm going to conclude by describing how I protect, organise and share my pictures with other photographers and editors.

GOLDEN EAGLE AGAINST THE SKY, BORDERS, SCOTLAND [C]

Although I took many pictures of this falconer's eagle on this particular rock, there was only one frame in which the bird's attention was distracted from the rabbits on the distant slope behind him. This was the one which suggested the eagle's character best. The picture has been published on many occasions, always from 70mm duplicates. The original stays in my portfolio. *MF 55mm, flash set to -1.7ev, Fuji Velvia*

I STARTED TO TAKE wildlife photographs when I was about 15. After a couple years, I began to think they were really quite good. A few years on and I could see how awful they were. Over the 20 years I've now been taking photographs, this process has continued to repeat itself. The issue here is to do with film longevity: does it really matter if your slides don't last a lifetime when their appeal, on either a personal or commercial level, is measured in years rather than decades? In any case, are traditional concerns over fading dyes not made irrelevant by the CD, onto which our finest photographs can be archived?

The fact is that digital storage technologies will continue to evolve while film remains the ultimate, cheap, viewable medium. It therefore pays to look after it, particularly when you consider that even second-rate images can sometimes be given a new lease of life, in-computer.

General procedures

Ensuring long life starts from the moment the film goes into the developer at the laboratory. I use non-process-paid film because it allows me to choose the lab (I've used the same one for 15 years now) and specify how I want the film treated.

Processing at a professional laboratory may be a little more expensive, but you know that your film is receiving the full process and is being properly handled. I ask for my films to be returned uncut and unmounted; typically, I will keep fewer than half of the images and there is no point in wasting slide mounts. Reviewing the film on the light box is also quicker if the slides aren't mounted. The film is uncut so that it can be dropped (not slid) into a continuous acetate sleeve for temporary protection. Acetate sheets which take five or six strips of film can, in my experience, be a source of scratches as the strips are fed into them. The continuous acetate sleeve, on the other hand, can simply be opened up and then zipped together once the film is inside.

On the light box, I review each film under a x4 loupe and mark those frames I want to keep. The film is then cut into strips of five frames and captions are printed with the Cradoc CaptionWriter programme. After mounting, captioning and individual sleeving with archival polyester sleeves, the pictures are set aside in the fireproof filing cabinet for a few days before I review them for portfolio selects. Kodak Photo CD scans, then 6x9cm duplicates are ordered from these pictures and the remaining photos are divided between my library files and those of my agents. New portfolio pictures are e-mailed, one at a time, over a few weeks, to regular clients and friends, and inkjet cards are prepared from the Photo CD scans for those who don't want to receive pictures electronically.

Film longevity

Kodachrome has long been renowned for its dark-storage longevity, estimated to be in excess of 100 years at 75°F at low humidity (40 per cent RH). But put it in a projector and after just one hour (cumulative), the dyes in the magenta and cyan layers are noticeably off colour. Fuji E-6 films, such as Velvia and Sensia, on the other hand, can take up to five hours of projection before the magenta layer starts to go. In dark storage (for long-term storage, Fuji recommends a temperature below 50°F at between 30 and 50 per cent RH), Velvia's life – like that of many modern E-6 films – is most likely to be longer than Kodachrome's, under ideal storage conditions.

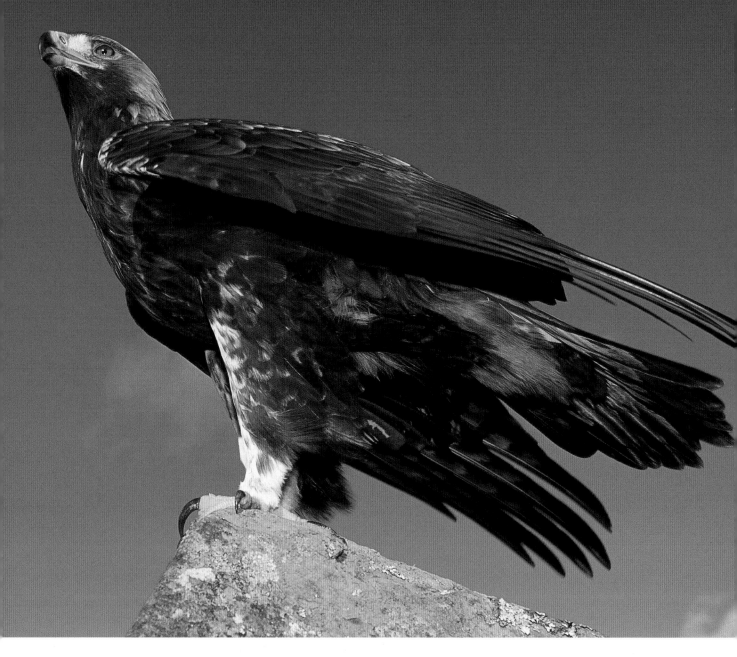

Storage and handling

Slides are best stored in hanging filing-cabinet sheets (the ones I use take 24 pictures each) made of polypropylene, with each slide inside a polyester sleeve. These prevent it from being scratched as it is removed from the filing sheet, and help to keep off dust and finger-marks. Both these plastics are chemically inert and so, unlike PVC, give off no gas which can harm the transparency. Ensure, too, that there are no sources of formalin gas in the slide storage area; these vapours come from, among other sources, the glues used in plywood manufacture and some modern furniture. Take heed of the film-maker's recommendations with regards to average temperature and relative humidity, and avoid jamming the sheets of slides tightly together in the filing cabinet, so as to reduce the risk of physical damage during handling.

I keep my strongest (many best-selling) 600 pictures ('The Portfolio') in a fireproof filing cabinet. Photographs in this selection, which is under constant review, are rarely sent out as originals unless I have a lot of extras from the shoot. In-camera extras are always preferable to duplicates, not least for reasons of economy, but there is now acceptance among many picture editors of reproduction-quality 70mm (6x9cm) dupes of one-off pictures. For the same reasons that it is always better to have digital files written to a large piece of film, so too should 35mm originals be duped up; a bigger piece of duping film means relatively smaller grain.

If you send out 70mm dupes, it is worth reminding the user that the image has already been magnified about four times (therefore it does not need to be magnified so much to reach its final size on the page). I have had clients in the past complain that the dupe didn't look sharp under a x8 magnifier. When I

CHRISTINA'S HANDS WITH CHANTERELLES, SONGLI, NORWAY

Some pictures defy easy classification. Does this go under 'People', 'Cantharellus cibarius'(chanterelle) or 'Research and recreation'? Eventually it went into 'Research and recreation' in the environment section under the 'Norwegian lifestyle' sub-section. There was a certain irony in this, since the model is Swedish and the pullover, though Norwegian style, is made in Taiwan. The fungi, at least, came out of an ancient Norwegian forest.
AF 28mm, Fuji Velvia

point out that if they examined the original 35mm slide under a x32 lupe, it probably wouldn't look sharp either, they appreciate straightaway that it is perhaps an unfair assessment.

A good lupe is essential if you are to be able to judge the sharpness of the slide. Projection is a poor alternative because it involves another complex set of optics and a variable viewing surface. If a professional-quality lupe is beyond your budget, take a 50mm lens, rack it out to its closest focusing and use it reversed to examine your slides. You may not be able to see the whole area, but it does yield some magnification and is optically excellent.

Keeping track of your photographs

On the face of it, a computerised database of your (thousands, if not tens of thousands of) pictures is a great idea. But how long is it going to take to catalogue all those images electronically, especially if you need to make thumbnail scans of them? Does your current system for finding slides, checking them in and out, and returning them to the correct sheet, work? Can it easily accommodate new categories and change existing ones? If so, I'd be inclined to stick with it. I've found that the following simple, manual system works well, even with quite a large file.

- Birds and mammals are categorised by species, or groups of related species. When the number of sheets for a category grows to more than eight, it is divided into whatever sub-categories are appropriate. Hence, eider ducks used to be lumped in with ducks and geese, but now have a separate category of their own under 'e'. When the need arises, 'eiders' will be further sub-divided. The hanging sheets have tags which instantly identify what's in that section, and are arranged alphabetically.
- Landscapes are initially categorised by country, then alphabetically by location. Those locations of which I have a lot of pictures are dedicated their own sheets.
- Similarly, plants are sorted alphabetically by their scientific names and divided as the need arises.
- I invent categories for environmental topics such as industry, agriculture, recreation, hunting, research and rehabilitation as required.
- 'Inanimates' covers subjects such as sand, stone, ice, shells, feathers and clouds.
- 'People' is a broad, ever-dividing category which features pictures that don't fit comfortably into the 'environmental' sections.
- Finally, my collection of pictures of subjects with more than four legs or fewer than two is the smallest, so these are lumped alphabetically by scientific name and divided into appropriate sub-sections when there are a lot of pictures of one class, order, family, genus or species.

The beauty of this system is its simplicity and the easy accommodation of new subjects. To work efficiently, though, it is important to keep sub-dividing and naming these sub-divided categories, so that you never have more than eight sheets (just under 200 slides) to glance through to find the picture you are after. The disadvantage of going directly to the right sheet (as you would if you used a database programme) is that you can forget the other pictures you have of the same subject; having to look through a few sheets reminds you of the coverage. More than eight sheets, however, and searches take too long.

This system is weaker, however, when I need to make a more themed selection. I may want to assemble a slide show on winter wildlife, or a client might want to see pictures illustrating dramatic lighting. A computer programme enables cross-reference searches (so long as the caption information you input is comprehensive). But remember 'The Portfolio'? These 25 sheets contain the pick of my entire collection and provide a quick overall reference for theme selections. Once an initial selection is made from these pictures, I can more easily find related material in the working file.

Captioning

The key to any filing system is good captioning, especially if other people work with your collection of pictures. Making captions at the time the slides are mounted is vastly more efficient than doing so on a piecemeal basis when submissions are being assembled. It is just as easy to print ten as it is one. The inexpensive Cradoc CaptionWriter program makes the job easy and fast; I can generate up to 300 labels per hour, if there are quite a lot of similar pictures. It is easy to change just one or two words, and the program can provide five lines of text on a label for a 35mm slide as well as writing bar codes. Most photo-management programs usually include a caption-writing application.

Electronic distribution of photographs

There are two major ways in which the digital revolution is benefiting nature photographers. One is the greater control which we can exercise over the appearance of the final image, and the other is in getting that image seen by other people.

Let's be clear here: there is no comparison between viewing the original transparency on a light box and seeing it on screen, but if you want that image to be seen by several dozen people in different parts of the world at the same time, that's just not an option. Put a good scan up on a high-resolution 32-bit monitor, and the effect is still impressive.

The easiest way to distribute photographs is as e-mail attachments or enclosures. Scan the picture you want to send, save it as a JPEG file, create a new e-mail message, and then, using the enclosures option, append the file to the document. Then simply type into the CC field the e-mail addresses of the other people you want to receive it.

There are a number of issues to consider here. If you plan to keep editors posted with your latest work, bear in mind that other photographers will be doing the same thing and the recipient may not welcome having to download several megabytes of e-mailed photographs before they can get to their mail. It is better to send one image a week for a few weeks and then check if the editor is willing to receive any more. If you e-mail images to your friends, you may have trouble in sending batches of files, since some mailboxes can hold only a limited amount of data. If you exceed their capacity, none of the pictures will be received.

It is essential, of course, that the recipient has some sort of image-viewing application on their computer, although it doesn't necessarily have to be the same as the one in which the image file was originally created.

Make the scan with a desktop film scanner (or use a low-resolution one from a Kodak CD), as you would for any other use. Crucially, though, the resolution need not be higher than 72 pixels per inch. This is the screen resolution of most monitors (although a few monitors for PCs and UNIX computers resolve at 96ppi) and the benefits of a higher-resolution scan will simply not be seen. A 72ppi resolution equates, roughly, to a 950Kb file from a 35mm slide (the exact figure depends on the work which has been carried out on the image), appearing on the screen at about 10x6.4in. If this size is unsuitable, in Photoshop simply undo the link between proportions and file size (Image>Image Size) by unchecking the 'file size' box, and resize the image. While some unsharp masking will improve the appearance of the picture on screen, it is easily overdone; I set the amount to about 50, (Filters>Sharpen>Unsharp Mask).

A file size of 950Kb is, of course, too large to send quickly via a modem; it needs to be compressed. For e-mailing and website use, JPEG is the most convenient compression method, although some data is lost. Once the file has been saved at a particular compression ratio (say 3 in Photoshop 5.0, or Medium quality in Photoshop LE), it is inadvisable to compress it further. With quality set to 'Medium', a file which contains 975Kb of data ends up as a 43Kb JPEG. That can be sent in a matter of seconds. Once received, the file is de-compressed for viewing. It is essential that when you name the file, there should be no gaps left in the name and that it is appended by '.jpg'. Failure to do this will normally result in the file being unopenable.

Not only is e-mailing a great way to share pictures with friends and colleagues but it saves a lot of time and money as well. Here's one application of the technology which I've found very useful: a designer calls me for a picture. She has a particular image in mind and I think I might have something which fits the bill, but I'm not certain. I scan and e-mail the picture. Within minutes she can say, 'That is exactly what I'm after,' in which case I mail the film for a final decision. If the picture isn't right, I don't have to waste time doing the submission, and she can get on with trying to source the image from elsewhere, saving both of us time.

Creating a website

Having a presence on the Worldwide Web in the mid-1990s was a cool, savvy thing to do; a few years later it was already an integral part of the marketing strategy of hundreds of thousands of businesses worldwide. At the time of writing, smaller picture libraries and individual photographers have yet to see the full benefits of a presence in terms of sales, and the majority of editors (much less so designers) still feel more comfortable seeing a piece of film than receiving images down the line. But as more and more of the major picture libraries develop large, on-line catalogues, so things will change and the benefits should trickle down.

I find my website particularly useful as a way of introduction to new clients and when I'm establishing contacts in a new area. It sets out what I do and the pictures I have, shows numerous examples, describes recent projects, and provides a lot of information which I think might be of help to other photographers and naturalists. Rather than trying to explain on the phone to a new customer what I have in terms of stock, I simply invite them to visit my website, which they can do at their convenience. In years to come, I am very keen to see picture credits in the form of the photographer's URL (website address) or e-mail address because this will make it easier for picture researchers to contact us.

Creating and, importantly, maintaining a website is a time-consuming business. There are several very good programs available, such as Adobe's PageMill, which relieve the photographer from the drudgery of writing HTML code, but nevertheless they take time to learn. One alternative for the professional photographer is to commission the work. If however, you go to a company which specialises in producing websites, you will be relieved of a lot of money. An alternative is to approach your local technical college or a university computing department. Students training in this field often welcome the chance to put their skills to use on a 'real world' project; if they do it well, it looks good on their CV and they receive some remuneration. You save money, too.

Plan carefully in advance exactly what you want to go on your site, and how it all links together. Please refer to my site to see just one way of organising the information (see Website Addresses). Ensure that the home page, the first one that opens when someone logs on to your site, is as concise as possible and doesn't have overly elaborate graphics which take ages to download. Likewise, if you include a gallery, provide thumbnails (typically about 17Kb each) of the pictures and link them to the higher-resolution images which are accessed by clicking the thumbnail. Remember that if the gallery takes a long time to appear on screen, the visitor is likely to go elsewhere rather than wait.

Not only should there be many links within your site (to help the visitor move around it more quickly) but you should consider linking to other sites as well. When, for example, I post an equipment review, a link is made across to the manufacturer's site, where ordering information and detailed specifications can be obtained.

Once the pages are uploaded to your server, make sure that the site is registered with as many search engines (such as Altavista and Yahoo) as possible to increase your chance of exposure to casual surfers.

The security of images on the Web has been a matter of much concern amongst photographers. A number of on-line picture libraries and individual photographers apply a watermark or other type of encryption to identify their origin. Unmarked images on the Web are vulnerable to theft from those who want to use them for on-line viewing and claim the photographs as their own. But remember that most of these pictures, even in their uncompressed form, are under 1Mb in size. For commercial publication, they are simply non-starters. My personal feeling is that if someone wants to use a picture off my website for a personal, non-commercial use which respects the subject, they are welcome to it. I am more interested in raising the profile of the subjects I photograph. Realistically, there is little that we as photographers can do anyway to prevent 'borrowing'.

TEGENARIA SPIDER ON MAGAZINE

Since house spiders live in houses in the winter, it seemed legitimate to set up a picture reflecting this environment. The choice of magazine was not entirely coincidental. The spider arrived on-set with one leg missing.
MF 90mm, TTL flashes through diffuser, flash sync cord, Ikelite Lite-Link, Fuji Velvia

Website Addresses

If you would like to register to receive updates to the information in this book, as well as details of courses and new products, please e-mail me at: **niallbenvie@sol.co.uk**

Here are some websites you may find useful or interesting. Products referred to in the text appear in parenthesis. My own website is at: **www.niallbenvie.com**

Equipment, materials and software manufacturers

Adaptec (Toast software for writing CD on a Mac):
www.adaptec.com

Adobe – general site (Photoshop, Photo Deluxe, Page Mill etc):
www.adobe.com

Photo Shop information page:
www.adobe.com/prodindex/photoshop/main.html

Apple (Macintosh G3 computers, iMac): **www.apple.com**

Ben-V beanbags (camera/lens supports):
www.niallbenvie.com

Canon (camera equipment, image-stabilising lenses):
www.canon.com

Claris (word-processing and database software):
www.claris.com

Cokin (filter holders and filters): **www.cokin.co.uk**

Epson (Stylus Photo inkjet printers, ink and papers):
www.epson.com

Formac (Trinitron displays): **www.formac.com**

Fuji (films): **www.fujifilm.com**

Fujitsu (Pictrography machines):
www.fujitsu-europe.com

Gitzo (tripods and fluid heads): **www.gitzo.com**

Hewlett Packard (inkjet printers): **www.hp.com**

Ikelite (Lite-Link): **www.ikelite.com**

Iomega (Zip drives): **www.iomega.com**

Kodak (Kodachrome): **www.kodak.com**

Kodak (Photo CD):
www.kodak.com/daiHome/products/photoCD.shtml

Kirk (specialist accessories): **www.kirkphoto.com**

Lee (filter holders and filters): **www.leefilters.com**

Live Picture (image-editing software):
www.livepicture.com

Lowepro (camera packs): **www.lowepro.com**

Manfrotto (tripods): **www.manfrotto.com**

McDonald Wildlife Photography (photography tours and workshops): **www.hoothollow.com**

Microsoft (Internet Explorer, Internet Mail and News):
www.microsoft.com

Nikon (cameras, lenses, flashes, desktop film scanners):
www.klt.co.jp/nikon

OpTech (neoprene camera straps): **www.optechusa.com**

Perfect Niche (Cradoc CaptionWriter): **www.perfectniche.com**

Polaroid (desktop film scanners and film writers):
www.polaroid.com

P.T.S. Imaging (scanning services):
www.btinternet.com/~ptsimaging

Sachtler (professional tripods and fluid heads):
www.sachtler.com

Singh-Ray (graduated ND/colour-intensifying filters):
www.singh-ray.com

Scharlau Programming (website design):
www.scharlau.co.uk/scottiedog

Tamrac (equipment bags and backpacks): **www.tamrac.com**

Ultimatte KnockOut (professional selection software):
www.ultimatte.com

Vested Interest (Xtrahand waistcoats):
www.vestedinterest.com

Wacom (graphics tablets): **www.wacom.com**

Photographers
Niall Benvie: **www.niallbenvie.com**

Steve Bloom: **www.stevebloom.com**

Frans Lanting: **www.lanting.com**

George Lepp: **www.leppphoto.com**

Joe and Mary Ann McDonald: **www.hoothollow.com**

Kennan and Karen Ward: **www.kennanward.com**

Art Wolfe: **www.artwolfe.com**

Magazines
Outdoor Photographer: **www.outdoorphotographer.com**

Orion: **www.orionsociety.org**

Bibliography

Allan, B. *Digital Wizardry*: Creative Photoshop Techniques (Amphoto 1998)

Blacklock, C. & N. *Photographing Wildflowers* (Voyageur 1987)

Evening, M. *Adobe Photoshop 5.0 for Photographers* (Focal Press 1998)

Fitzharris, T. *Virtual Wilderness: The Nature Photographer's Guide to Computer Imaging* (Amphoto 1998)

Hill, M., & Wolfe, A. *The Art of Photographing Nature* (Crown Trade Paperbacks 1993)

Lopez, B. *Crossing Open Ground* (Vintage Books 1989)

McDonald, J. *The New Complete Guide to Wildlife Photography: How to Get Close and Capture Animals on Film* (Amphoto 1998)
Designing Wildlife Photographs (Amphoto 1994)
Photographing on Safari (Amphoto 1996)

Oelschlaeger, M. (ed). *The Wilderness Condition* (Island Press 1992)

Rowell, G. *Galen Rowell's Vision* (Sierra Club Books 1995)

Shaw, J. *John Shaw's Close-ups in Nature* (Amphoto 1987)
John Shaw's Landscape Photography (Amphoto 1994)
Focus on Nature (Amphoto 1991)
The Nature Photographer's Complete Guide to Professional Field Techniques (Amphoto 1984)

Sontag, S. *On Photography* (Anchor 1990)

Wade, N. *Visual Allusions*: Pictures of Perception (Psychology Press 1990)

Acknowledgements

Of the dozens of people who have helped me, directly or indirectly, to make the pictures in this book, I would like to acknowledge, in particular, the following:

My father, the late Donald Benvie, who instilled in me a passion for the natural world which is a lifelong gift. The late Dr Gordon Burgess, who set me, as a teenager, on the path of good photographic technique, and Laurie Campbell, who showed me what could be achieved by perseverance.

In Scotland:
David Alston; Colin Baxter; Alex Boath; Shirley Bowring; Andy and Gay Christie; Rick Goater; Hessilhead W.R.T.; Alban Houghton; Neil McIntyre; Julie Ross; Charlie Self; Steve Towell; and of course, all the members of the Benvie clan, including my wife, Rachel.

In Norway:
Duncan and Sachiko Halley; Allard and Saskia Martinius; Torgeir Nygard; Livar Ramvik.

In Latvia:
Zanete Andersone; Janis Ozolins.

In the Netherlands:
Addy de Jongh; Alfred Melissen; Marianne van Oostrum; Mirelle de Ronde; Otterpark Aqualutra, Leeuwarden.

In the United States:
Joe and Mary Ann McDonald; Kennan and Karen Ward.

My editors at David & Charles, Susanne Haines and Freya Dangerfield, who patiently fielded many lengthy telephone calls.

Niall Irvine and Chris Pearson at PTS, Aberdeen; Donald Nisbet, MNS Photocolour, Glasgow; and Steve Bloom, Wye, for advice on things digital and scanning services.

Chris Head of Polar Graphics, Harrow, for assistance with Ultimatte KnockOut.

Andrew Gove, who helped keep my office running during this project.

Giles Laverack, for featuring in the equipment photos.

Bruce Scharlau, for looking after my website.

Adobe Systems Europe Limited, who supplied Photoshop 5.0 and PageMaker 6.5.

My readers deserve special mention for diligently ploughing through the unedited text: Roddy McGeoch; Andy Reynolds; Neil McIntyre; Susanna Roland. Talk about testing friendships...

Dr James Morrison RSA RSW gave kind permission to reproduce his painting on page 73.

My special thanks go to AP, for inspiration when it is needed.

Index